Early Connecticut Silver, 1700=1840

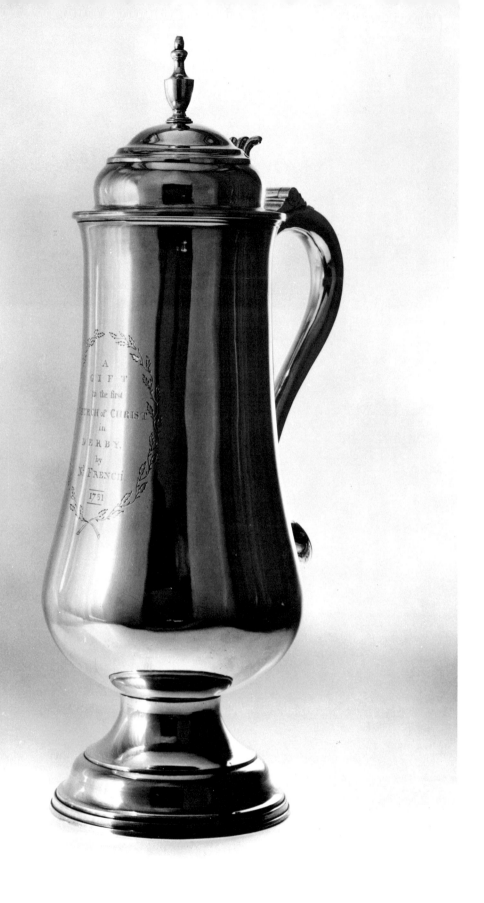

Early Connecticut Silver, 1700-1840

By PETER BOHAN *and*

PHILIP HAMMERSLOUGH

Wesleyan University Press

MIDDLETOWN, CONNECTICUT

The authors gratefully acknowledge permission to reproduce drawings of some of the marks of silversmiths.

Mr. Stephen G. C. Ensko of New York kindly permitted us to copy some marks from his *American Silversmiths and Their Marks,* Volume II, 1937, and Volume III, 1948 (both privately printed).

The New Haven Colony Historical Society allowed us to copy several New Haven marks drawn by F. Farney Eilers, Jr., for the catalogue of "An Exhibition of New Haven Silver" held at the Society in January 1967.

Mr. Robert Graham kindly allowed us to reproduce drawings from *Early American Silver Marks* by James Graham, Jr., privately printed in 1936.

Drawings from *Marks of Early American Silversmiths,* 1938, by Ernest M. Currier, are used with the permission of the publisher, The Anthoensen Press.

SBN 8195 4008 0

Library of Congress catalog card number: 76–82543

Manufactured in the United States of America

FIRST EDITION

Contents

List of Illustrations

Preface

GEORGE MUNSON CURTIS' *Early Silver of Connecticut and Its Makers,* published in 1913 by the International Silver Company of Meriden, Connecticut, was the first comprehensive study of this subject. His book dealt, however, not only with silver made in Connecticut but also with that made in Boston, Newport, and New York City for the communion services of churches in the state. Like many works from around the turn of the century, it gave evidence of extensive research and was rich in anecdote. Curtis illustrated a number of Connecticut pieces, but did not reproduce the silversmiths' marks. Nevertheless, one cannot help being amazed at the thoroughness with which he treated his subject at such an early stage of knowledge about it.

Since 1913 there have been three important exhibitions devoted to the silver of Connecticut. "Early Connecticut Silver, 1700–1830" was held in 1935 at the Gallery of Fine Arts of Yale University as part of the celebration of Connecticut's Tercentenary. John Marshall Phillips, Curator of the Mabel Brady Garvan Collection at that time, brought together 166 pieces for the exhibition, including works by a number of hitherto unrecorded Connecticut silversmiths. These pieces were discussed in an accompanying catalogue.

In 1954 Philip Hammerslough organized an exhibition of more than one hundred pieces of Connecticut silver at the Wadsworth Atheneum of Hartford and prepared an accompanying checklist.

Most recently, the New Haven Colony Historical Society held an exhibition of about 160 pieces of New Haven silver, including many spoons, in January of 1967. The exhibition and its catalogue were prepared by a committee under the chairmanship of John Devereux Kernan.

The accompanying photographs of almost two hundred pieces of early Connecticut hollowware represent most of the known examples, although more will undoubtedly continue to come to light. The countless spoons, sugar tongs, and similar items of flatware were not tracked down. Although these are invaluable for recording silversmiths' marks, especially since some smiths

made *only* spoons, the authors have chosen only a representative few in order to avoid tedium in the illustrations.

Curtis recorded more than 260 Connecticut silversmiths. It is possible now to extend this number to more than 475. If a man did not appear actually to have worked in Connecticut, his name was not included in the Biographical Index, although he may have been born in the state, or even trained there before working elsewhere.

Likewise, with but few exceptions, only pieces made in Connecticut have been illustrated. Again, it has not always been possible to determine that a piece was actually made in the state when a man worked in or travelled to other states, or that his mark was the one that he was using while working in Connecticut. The piece was included if its style suggested that it fell within the silversmith's Connecticut period.

Up to a few years ago, it was considered undesirable to reproduce photographs of silversmiths' marks because of the possibility of accurately reproducing them in order to fake silver. This policy has now been abandoned with the appearance of recent books that have included photographs, rather than drawings, of marks, but with no dimensions or scale indications given. Advantage has been taken of this new approach to reproduce here approximately 495 marks. When photographs of marks were not available, drawings from a number of sources were copied in order to make the index as complete as possible.

It should be emphasized that this is a book on handmade silver. No examples made by mass-production techniques in use toward the middle of the nineteenth century have been included. The many partnerships established in the early nineteenth century and the application of water power to raising techniques, such as spinning on a lathe, paved the way for Connecticut's silver industry. But it was the mass demand for less expensive silver-plated ware that really established this industry, especially after 1847 through the Rogers brothers in the Meriden-Wallingford-Hartford region.

A reference work of this kind depends, more than most, on the cooperation of many individuals willing to take the trouble and time to supply information or to have a piece photographed. The authors wish to express their gratitude for such help to the ministers of the churches and the staff members of the museums and historical societies whose pieces are illustrated, as well as to many private collectors. For particular assistance we wish to thank Carl R. Kossack and John Devereux Kernan of New Haven; Marcella Putnam of West Hartford; Milo Naeve, formerly at Winterthur, now at Colonial Williamsburg; Ross Fullam and the late Ralph Thomas, present and past curators of the New Haven Colony Historical Society, as well as Catherine Fennelly, formerly with the same institution; Helen M. Schlatter of Winterthur; Graham Hood, formerly with the Yale University Art Gallery, now at the Detroit Institute of Arts; Edward Stebbins and Alexander O. Vietor of the Yale University Library; Henry Schnabel, Jr., of the Museum of Fine Arts,

Boston, and Kathryn C. Buhler, formerly with the same institution; Mary Glaze of the Metropolitan Museum of Art and James Biddle, formerly of the same institution, now President of the National Trust for Historic Preservation, Washington, D.C.; Jules Prown of the Paul Mellon Center for British Art and British Studies at Yale University; George Heard Hamilton of the Sterling and Francine Clark Art Institute in Williamstown; Harry L. Dole, Curator, Milford Historical Society; Mrs. Martin Goldsboro, former registrar of the Lyman Allyn Museum, New London (who has accomplished a great deal of research on the work of New London silversmiths).

Finally we wish to recognize the contribution of Frances Fall Bohan, who has given time and painstaking attention to this manuscript and to those of several previous essays where her contributions have been unrecorded.

Peter Bohan
New Paltz, New York

Philip Hammerslough
West Hartford, Connecticut

Early Connecticut Silver, 1700-1840

The Connecticut Silversmith

ONNECTICUT'S EARLIEST SILVERSMITHS came principally from Massachusetts and New York. The great ports of Boston and New York City were the centers of the craft in the northern colonies during the seventeenth century. Craftsmen there often referred to themselves as "goldsmiths" rather than silversmiths, using the more impressive designation in their newspaper advertisements, since it helped to establish their connection with their prestigious and influential forebears in Europe and in Britain, where the title goldsmith was used by masters of the guild who worked in either metal. Most of the surviving colonial gold objects were made in New York City, Boston, Newport, or Philadelphia. Of Connecticut gold there remain only a few pieces, a necklace clasp, three rings, a miniature frame, and spectacles, all quite late in date and illustrated in this volume.

Many Connecticut silversmiths were formally apprenticed, though not always for the traditional seven years. The accompanying illustration shows the articles of indenture of Daniel Porter, then about seventeen years old. By the terms of this document of 1793 the young man is apprenticed by his guardian Ezekiel Loomis until the age of twenty-one to the clockmaker and silversmith Daniel Burnap of East Windsor near Hartford. Porter would thus have been apprenticed to Burnap for only three years and a half, although he may have had prior training elsewhere. A Daniel Porter, born in Danvers, Massachusetts, c. 1771 – c. 1773 was in Topsfield, Massachusettts, in 1790, was working as a clockmaker and silversmith in Stockbridge, Massachusetts, in 1797, and later in Williamstown. He is the only known New England silversmith of this name other than the apprentice in this indenture. It is not yet known if they are the same person. The indenture requires that

> the said apprentice his said master faithfully shall serve, his secrets keep, his lawful commands gladly obey, he shall do no damage to his said master nor see it to be done of others without giving notice thereof to his

Indenture of apprentice Daniel Porter to East Windsor silversmith Daniel Burnap in 1793. (Collection of Philip Hammerslough)

said master, he shall not waste his said master's goods nor lend them unlawfully to any, he shall not commit fornication nor contract matrimony within the said term — at cards, dice or any unlawful game he shall not play, he shall not absent himself by day or by night from his said master's service without leave nor haunt taverns or play houses but shall in all things behave himself as a faithful apprentice ought to do toward his said master — And the said Ezekiel Loomis [guardian] to find and furnish the said apprentice all the wearing apparel he shall want during his apprenticeship — And the said Daniel Burnap [silversmith] doth hereby covenant and promise to teach or cause the said apprentice to be taught and instructed in the art, trade or calling of clockmaking, silversmithing and watch repairing so far as his business will admit, and will provide meat, drink, washing, lodging, and mending cloths suitable for such an apprentice, and at the expiration of said term dismiss him from his apprenticeship . . .

Outside of the cities some fledgling silversmiths were not formally apprenticed; they merely "learned their trade" from someone already qualified. For example, John Avery of Preston, a farmer and a self-taught silversmith, taught the trade to his four sons. In a few instances a young silversmith was working on his own by the age of nineteen or twenty, but most were in their early or middle twenties by the time they set up in business for themselves.

The lack of close political unity among the northeastern colonies and the absence of a regional goldsmiths' organization precluded any kind of quality control and marking system comparable to the British and European, even if such systems had been acceptable to these craftsmen, which they probably would not have been.

Nevertheless, colonial silversmiths followed the sterling standard for the silver content of their pieces. The derivation of the term sterling has been the subject of much conjecture. It was once thought to be a corruption of the word *Easterling*, used to describe the German goldsmiths who came to England during the reign of Edward I, around the year 1300. These Continental craftsmen had worked with a silver-copper alloy that contained 92.5 per cent pure silver, a degree of fineness still indicated by the word sterling. Another theory was that the word comes from *staer,* or starling, the name of coins of Edward the Confessor with the likenesses of such birds. The prevailing view is that the designation is derived from *steorling*, the name for early Norman pennies that bore a small star (*steorra*).

Early Connecticut pieces carry only the punch mark of the silversmith. A few silversmiths in Connecticut, as elsewhere, added one or two pseudo-hallmarks in the last decade of the eighteenth century and later. but these marks — often in the form of stars, eagles, profile heads, vines, or letters — are most commonly found on pieces made between 1820 and 1850. Some of these may have been local standard or assay marks, as, for example, the Ionic pillar entwined with a grapevine, as a New Haven City mark used by the Merri-

man firms, but others were simply of the silversmith's own invention. The words "Coin" or "Pure Coin" on nineteenth-century examples indicate that the piece was of American coin standard, which was 89.2 per cent silver from 1792 until 1837 and subsequently 90 per cent.

Some of these men were trained as silversmiths and followed that trade for a few years, then gave it up for more predictable businesses, perhaps in other states. In any event they disappear from the records early in their careers. Others appear late, to judge from their birth dates; they probably took up silversmithing to satisfy local demand or as an adjunct to their regular businesses. Whether they were apprenticed or merely learned their trade informally, some never went into business for themselves but remained as journeymen with their old masters or went into partnership as junior members with other craftsmen who were more adventuresome or better situated financially. Occasionally silversmiths were business partners of men in other trades. These partners may appear in the double names marked on certain mid-nineteenth-century spoons and other small items. Purveyors of silver, watches, and jewelry also sometimes incised or punched their names on their wares during the same period. Some silversmiths left Connecticut, often permanently, to work in the South or in the Western Reserve and beyond; we find them appearing in New York, Ohio, Michigan, Wisconsin, North Carolina, Georgia, Alabama, Mississippi, and Florida. Isaac Marquand of Fairfield, Connecticut, began in business there around 1787 at the age of twenty-one, but four years later he went to Edenton, North Carolina, and subsequently to Savannah, Georgia, returning to Fairfield in the interim. He appears to have set up businesses in the two southern cities and also in New Orleans, while he maintained the New York outlet as a jeweler and watchmaker, and later as an importer of Sheffield plate.

It cannot be assumed that a man always worked until his death, especially if he were long-lived or if he had sons to take over his business. A number of silversmiths, such as Pygan Adams, were active in civic affairs that would have consumed much of their available working time; many lost a number of years of work, and some their lives in military service during the Revolution. Joseph W. Hopkins of Waterbury had a silversmith's shop which was robbed three times between 1766 and 1772, and it burnt down in 1780, when he was fifty years old. He also practiced law — was it out of desperation? — finally becoming a Judge of the Probate Court, and dying at the age of seventy-one.

The skills of silversmithing could be readily applied to a number of allied trades. Many Connecticut men were also engravers and jewelers as well as makers, repairers, or sellers of clocks and watches. William Blakslee of Newtown, whose father, Ziba, was an extremely versatile craftsman, in 1817 at age twenty-one took the trouble to go to St. Louis, Missouri, to perfect his silversmithing skills with French artisans there. He also learned engraving and clockmaking before returning after four years to go into business with his father. Occasionally Connecticut silversmiths worked in other metals too,

such as copper, brass, tin, and pewter, in the absence of local craftsmen specializing in this work. The accompanying illustration of two pages from the second account book of the silversmith John Avery, Jr., of Preston (whose self-taught father was mentioned earlier), shows that between January 1791 and June 1802 he made, in addition to nine silver teaspoons and a silver buckle, a number of objects in brass (keyhole plates, a lamp, parts for clocks), two lathes, and a complete clock, as well as repairs to miscellaneous metal household objects, all for Captain Ebenezer Tracy, the chairmaker, of Preston. Other silversmiths, such as the previously mentioned Ziba Blakslee of Newtown, were also brass founders, blacksmiths, bell founders, gunsmiths, makers of surveying instruments, printers, or inventors, in the Connecticut Yankee tinker tradition, which they helped to establish. Clement Beecher of Cheshire, a silversmith, brass founder, farmer, and inventor, was at times an itinerant in the Cheshire-Meriden-Berlin region, carrying his equipment around in a cart, selling his farm produce and fashioning spoons or gold beads on demand.

Some did not use their silversmithing skills in closely related work: they ran farms, general stores, or taverns. A few were even dentists. Many Connecticut silversmiths are known only from their marks on silver spoons. It is known that a number of enterprising men furnished themselves with a modicum of equipment for melting silver and beating it into spoon molds to meet local demand. It is perhaps a question as to whether they are rightly grouped as silversmiths together with others who were properly trained, who worked at silversmithing as their principal trade and who could turn out a well-designed piece of holloware.

The three burglaries of Joseph W. Hopkins' silversmith's shop in Waterbury between 1766 and 1772 represent an unusual case, but such thefts were not uncommon. It is often suggested that in those days, because of the absence of banks (until 1792), coin was turned into silver objects, which might be more easily identified or recovered if stolen. Certainly this was a consideration, and we know that at a time of fluctuating values of money, silver plate was also used in financial transactions, but there are other factors which would seem to militate against the safety hypothesis. Apart from the reduction in liquidity of assets caused by turning coin into utensils, the objects surely would have been more difficult to hide than coin. And in any event, even though they did not have the immediate negotiability of coin, and thieves might even have had to melt them down, silver objects were still frequently stolen. The following newspaper advertisement was inserted in the Boston News-Letter of March 24, 1774, by the Honorable Thaddeus Burr of Fairfield, a state assemblyman:

FIFTY DOLLARS REWARD. Last Night the Dwelling-House of the Subscriber was broke open, and from thence were taken the following articles, viz. one Pair of Silver Chaffing-Dishes; one Pair of Butter Cups; one Silver Can; two large Soup Spoons; one Pepper Box; six large Table Spoons; six Tea ditto & a Strainer, mark'd E.D. Maker's Name

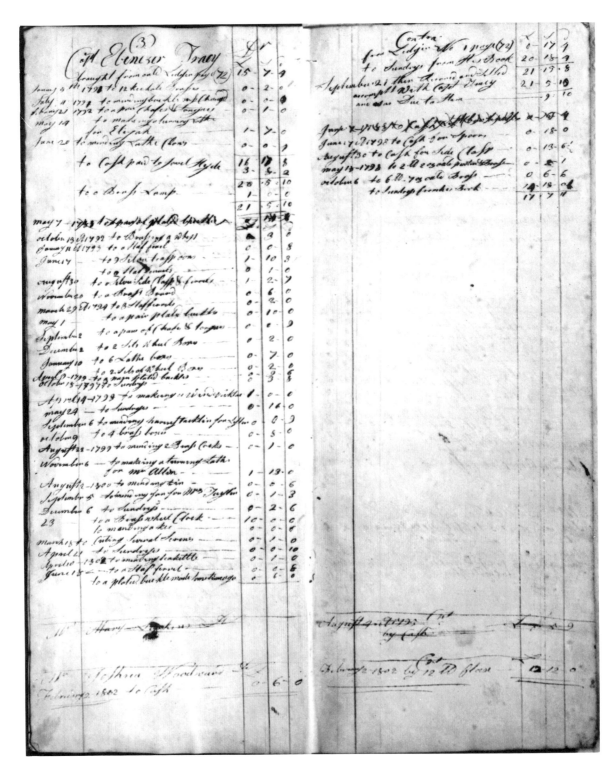

Pages from account book of Preston silversmith John Avery, Jr., for years 1791–1802. (Collection of Philip Hammerslough)

D. Henchman, all except the Spoons which have a Hand for a Crest;
a Silver Tea Pot; one ditto Sugar Dish; a Boat for Tea Spoons; one
Pair Tea Tongs; five Tea Spoons and a Cream Cup; two Porringers
and two Salt-Cellars, all mark'd E.S., one Silver Tankard without a Lid,
mark'd I.S.S. one Silver Can mark'd I.D.E. an old fashioned Pepper Box,
marked A.D.E. six large Table Spoons, mark'd E.S. one Silver Salver,
no mark on it, the Foot resembling the Mouth of a Tunnel; a Silver
Tankard marked A.B. one Silver Porringer without any Mark; three
Table Spoons marked A.B. one old Spoon mark'd I.S.S. four Tea Spoons
no mark; one Pair Tea Tongs; Maker's Name of these not D.
Henchman; I. Hurd, some of them, and some B.W., with other small
articles.

Whoever will take up the Thief or Thieves, so as he or they may be
brought to Justice, and the Plate recovered, shall be paid the above
Reward, and a reasonable Reward for any Part of the Plate, in
proportion to its Value, per me,

Fairfield, Conn. *THADDEUS BURR*

March 15, 1774.

Silver objects were not simply a repository for family wealth, but also a
symbol of social position and taste, as well as a delight to the hand and eye.

Most of Thaddeus Burr's plate, even in the later eighteenth century,
still came from Boston, although he did have a few pieces by Benjamin
Wynkoop, Jr. (BW) of Fairfield. He turned to the English-influenced crafts-
men of Boston, despite the proximity of New York, with its silversmiths of
Dutch and Huguenot descent, or of provincial sources in Connecticut itself.
Men of wealth and political power within the state took their custom to the
big cities, where they would find the more sophisticated, up-to-date styles —
as is still the case. Through the ports of Boston, New York, Newport, and
Philadelphia passed the latest examples of the British and Continental silver-
smiths' craft, for it was especially in these ports that the retail outlets were
established to meet demand and to capture some of the money in circulation
there. Since the American city craftsmen would thus see the latest in foreign
styles and would quickly copy them, there was little or no stylistic lag. But
many Connecticut nonurban silversmiths did not have wealthy patronage or
perhaps immediate access to the latest styles. Perhaps, too, their customers did
not have much interest in these styles and this conservative taste is reflected
in the history of Connecticut silver forms.

Congregational churches were the Connecticut silversmith's best patrons.
This fact is evidenced by the existence of more church hollowware than
domestic, although a few of the earlier pieces were donated rather than being
made expressly for church use. Flagons, tankards, caudle cups, beakers, and
mugs dispensed the communion wine, while the bread was carried on plates
or patens. Silver baptismal basins were occasionally used. We have no Con-
necticut silver made for other denominations except the single chalice (Plate

62) made around 1773 by John Gardner of New London and used in the Protestant Episcopal Church after 1784. The established church was Congregational, while Anglicans, Baptists, and Quakers were in the minority.

Silver spoons were made in large numbers in Connecticut. They were the principal eating utensil for most people until well into the nineteenth century, when silver-mounted forks and knives began to be more generally adopted as individual, as well as serving, implements. A few persons born as late as the 1880's used the spoon alone for eating. Some craftsmen may have made only spoons. More of these survive than examples of any other form made by Connecticut silversmiths. Silver spoons would have been used by families of moderate means, such as town tradesmen and more prosperous farmers, as well as by the wealthy.

There was not then much demand in Connecticut for domestic hollowware. Only the few wealthy urban merchants, who acted as middlemen between Boston importers and Connecticut farmers and tradesmen, had both the taste and the means to acquire the larger silver pieces, such as teapots, chafing dishes, tankards, and porringers, in the latest style. Since they bought most of these items in Boston, relatively few examples appear in this book. These few would most likely have been commissioned by customers, since it is unlikely that a Connecticut silversmith would have invested much time and silver in a larger piece for which the local market was quite limited, unless he made it for his own family. These Connecticut pieces show that their makers were cognizant of the Boston and New York styles, which in turn were to some degree inspired by imported pieces, although again the taste of the customer may have had something to do with the final form. Presumably the Connecticut silversmith would have made sketches of Boston and English forms and ornament for his reference, or perhaps had some of the actual pieces in his shop. In any event he must have worked more by eye and rule of thumb than from carefully prepared designs. Although several thousand silversmiths were working in the colonies, so far only one surviving set of drawings has been discovered. It was perhaps prepared as a pattern book for customers. The drawings are by William Faris (1728–1804), of Annapolis, Maryland, dating from c. 1770 – c. 1790 and include designs for teapots, canns, coffeepots, and some smaller items.

In addition to John Avery, Jr.'s account book, already mentioned, a few others exist, including that of Joseph Carpenter, in the possession of Philip Hammerslough, which is on loan to the Society of Founders of Norwich and on exhibition at the Leffingwell Inn there. Carpenter's shop in Norwich is one of few still extant. Some eighty-eight tools that belonged to John Staniford of Windham are on view at the Heritage Foundation in Old Deerfield, Massachusetts, acquired from the collection of Elmer D. Keith.

Tradition and Innovation in Connecticut Silver

THE ECONOMY OF CONNECTICUT during the Colonial period was more agrarian than mercantile owing principally to its geographical location and its topography. Divided roughly down the middle by the Connecticut River Valley with highlands to the west and to the east, the colony represented a cultural buffer zone between the English-influenced regions of Massachusetts and Rhode Island and the Dutch-influenced Hudson River Valley. The early settlements lay along the tidal rivers and along the coast line; indeed, Connecticut means 'on the long tidal river' in the Algonquin language. During this period Connecticut had no dominant artistic centers such as Boston or New York City, and the development of the arts followed what might be termed a convergent pattern. Boston and New York City were centers of influence for the outlying countryside. Connecticut assimilated these influences into an indigenous manner of working, especially in the Connecticut River Valley. In return for its agricultural goods, Connecticut received various manufactured wares by way of Boston, Newport, and New York City. As a result of this circular commerce there was little early need within the state for highly skilled professional craftsmen such as were found in those cities. An examination of seventeenth-century plate preserved in Connecticut churches bears out this hypothesis, for it is all the work of Boston's silversmiths. During the first quarter of the eighteenth century, however, there arose a local need for silversmiths, partly because of the uncertainty of the value of paper currency. As mentioned earlier, in the absence of banks, silver coin was converted into handsome and useful objects, which if stolen could be more easily identified.

The first silversmiths arriving in the state had been trained in established centers elsewhere. Consequently, their backgrounds represent a number of different outside influences. Job Prince, one of the earliest, was born in Hull, Massachusetts, and came to Milford by 1699, where he died in 1703. The three diminutive, almost identical pepperboxes bearing the mark I·P (Plates 1–3) are attributed to his hand.

The profession of goldsmithing in Boston and New York, as well as in London, profited after 1685 by the influx of a number of Huguenot craftsmen, who had been deprived of their religious liberty by Louis XIV's revocation of the Edict of Nantes. One of them, René Grignon, joined a settlement of French émigrés at Oxford, Massachusetts, in the latter part of the seventeenth century. Indian persecution soon drove them to East Greenwich, Rhode Island, where Grignon lived for a time. But he returned to Massachusetts and worked in Boston and Oxford before settling in Norwich, Connecticut, before 1708. He died there in 1715. Although little of his silver has survived, the porringer illustrated in Plate 4 exhibits in its pierced handle the vocabulary of balanced curvilinear ornament of the French Baroque, which was to appear in the arts of both Britain and the colonies around the turn of the century in the so-called Flemish style. This handle should be compared with that of the contemporary porringer by Samuel Gray (Plate 5), who had moved to New London from Boston before 1707. In contrast to the unity of flowing curves of the French style, Gray's handle pattern is one of discrete, round elements unified into an overall design, exactly equivalent to that of contemporary New England turned chairs.

There is nothing tentative or delicate about these early designs in the colonies: a direct approach to function resulted in a boldness, strength, and often dramatic simplicity of form. This "Puritan aesthetic" of bold, simple design is nowhere exemplified more clearly than in the sets of beakers (Plates 16, 17) made for the Durham and East Windsor churches by John Potwine, a Boston-trained craftsman who moved to the Hartford region around 1737. Their bulk, height, thickness, and boldly everted lips give them a vitality of style that was to be suppressed and eradicated by the more self-consciously stylized design of the later years of the century. Potwine's sword (Plate 19), and especially his teapot with the arms of the Welles family (Plate 18), reveal the freedom and accomplished elegance possible when the demands of material luxury and rank, rather than those of ecclesiastical restraint, dictated both form and ornament.

Other early silversmiths came to Connecticut from New York. The most accomplished of these was Cornelius Kierstede, who was born of Dutch stock in New York in 1675. In the early 1720's, already established as a master craftsman, he came to Connecticut to look into copper mine interests. Around 1724 he settled in New Haven, which was then the richest town in the colony and which lacked a worker in precious metals. Shortly thereafter he made the two-handled beaker and baptismal basin (Plates 6, 7) for the church in Milford. These objects show a simplicity of form and lack of exuberance that contrast markedly with his earlier secular work in New York, which had been generous and vigorous in its proportions, heavy in body, and elaborately decorated with cast work, engraving, and repoussé. The spirit of the applied leafwork of his New York style is preserved, however, in the corresponding applied band of semicircular scalloping running around the base of the beaker. The tankard that Kierstede made around 1735, now at Trinity Church

in New Haven has again more of New England than of New York in its character. In contrast to several superb tankards that he made in New York before 1725, the Trinity Church example has a higher and slenderer body. Its domed lid rises in several stages, there is no applied leafwork around the base molding, and the thumbpiece is of the open corkscrew or ram's-horn type typical of New England. Certainly the most ornamental piece of silver produced in Connecticut is the punch bowl (Plate 8) that Kierstede made for the Yale Class of 1746, who presented it to Thomas Darling, their only tutor. The stylized decoration of tulips, roses, and other floral forms is reminiscent of similar designs in Stuart ornament. Here it is set radially within chased panels in the Dutch manner rather than allowed to meander around the bowl in a manner more closely resembling actual growth, as in comparable forms by John Coney of Boston. The Darling bowl is, therefore, in this instance more like New York examples, except for a less elaborate foot and the absence of the usual cast, term handles.

Similar modification or simplification of New York forms in Connecticut practice can be observed in the tankards by Peter Quintard and Timothy Bontecou, Sr., now in the Mabel Brady Garvan Collection at the Yale University Art Gallery (Plates 12, 14). Although they are of the New York type, the degree of elaboration through applied ornament has been considerably reduced, especially by omitting the usual applied leafwork around the bases and the elaborate cast foliate and figural ornament on the handles and their termini. Both men were of Huguenot origin. Quintard had been trained and had worked in New York, moving to South Norwalk around 1737. Bontecou, although born in New York, had learned his trade in France, and was active in Stratford by 1735, and later in New Haven. His son Timothy was born in France and continued his father's profession in New Haven after the mid-century. The younger Bontecou's French temperament was readily amenable to the newly imported Rococo mode, which he used to produce the sophisticated and elegant curves and countercurves of his porringer handle, cann, and cream jug (Plates 34, 35, 36). Benjamin Wynkoop, Jr., who worked in Fairfield, was, like Timothy Bontecou, Jr., probably trained by his father, also of New York origin. His Stamford and Stratfield church beakers and his teapots, when compared with their equivalents made by his Boston-trained contemporary John Potwine (whose name, coincidentally, is similar in meaning), provide a revealing demonstration of the difference between the approaches of English-influenced Boston and Dutch-influenced New York to the design of the same type of vessel. The same sort of rather broad geometry of form is evident both in Wynkoop's teapots and in his porringer handle.

These early immigrant silversmiths established their practices and trained apprentices during the first half of the eighteenth century. As a result, after the mid-century a new generation of Connecticut-born and Connecticut-trained young craftsmen began to practice. Most of them seemed to gravitate to five particular locations: New Haven, New London, Norwich, Hartford, and Middletown. This second generation was employed principally in the

fashioning of sets of beakers for presentation by one or more members of a church congregation for the communion service. They also made a large number of spoons, as well as a few other objects for domestic use, notably porringers, casters, and cream jugs. In general, their designs do not exhibit as much individuality as those of the previous generation because of the increased exchange of ideas between the various artistic centers and the pervasive influence of Rococo forms and ornament, which had arrived in the colonies in the middle of the reign of Louis XV via London or direct from the *hôtels* of Paris. The older, Baroque dynamic equilibrium of symmetrical curves and the four-square and eight-square (octagonal) shapes of the Queen Anne style gave way to a more organic freedom, a totality of serpentine contours vivified by naturalistic foliate and shell ornament. By taking the mass off the ground plane and supporting it on hoof- and shell-feet (or on a single "limpet" foot), an additional sense of lightness was imparted to the new forms so that they appear to have an intrinsic organic vitality. The creamers of this type by Daniel Deshon of New London, James Tiley of Hartford, Samuel Parmele(e) of Guilford, and John Avery, Sr., of Preston, as well as the chafing dish by Robert Fairchild of Stratford, are hardly distinguishable in their sophistication from the similar products of the longer-established urban centers. This increasing conventionalization of forms is clearly evident in the Rococo keyhole-pattern handles used on all of the porringers. The same standardization is seen in the caster, although the possibilities for individual expression by means of the variation of proportions within this accepted form provide a fascinating study.

If Cornelius Kierstede was the most accomplished craftsman of the first generation in Connecticut, Ebenezer Chittenden is certainly deserving of the title in the second. He understood most clearly the expressive character of the swelling curves of the Rococo and their suggestion of the containment of an inner, expansive vitality. This dynamic force in design is clearly embodied in the soaring proportions of his Derby church flagon (Plate 75) and in the tendril-like movement of the scroll handle of his cream jug (Plate 76). These are unsurpassed masterpieces of design.

Of all the objects illustrated, the two cream jugs made around the time of the Revolution by Samuel Buel of Hartford and Phinehas Bradley of New Haven (Plates 80, 86), best epitomize the rustic individuality usually associated with Connecticut workmanship. Both are representative of a transitional form between the three-legged pear shape of the Rococo and the helmet shape with pedestal foot of the later, classical style. But it is their proportions and decoration which give them an unmistakable Connecticut character. Buel's design is attenuated and slight in proportion to its wide, simple foot, whereas the body of Bradley's design is big and portly in relation to the short, small base. In addition, both pieces are ornamented with a characteristic beading of the rims and feet, a type of decoration found not only on the silver of Connecticut, but also on other objects made within the state, such as pewter by Samuel Danforth; highboys, secretaries, and chests; and even slip-decorated

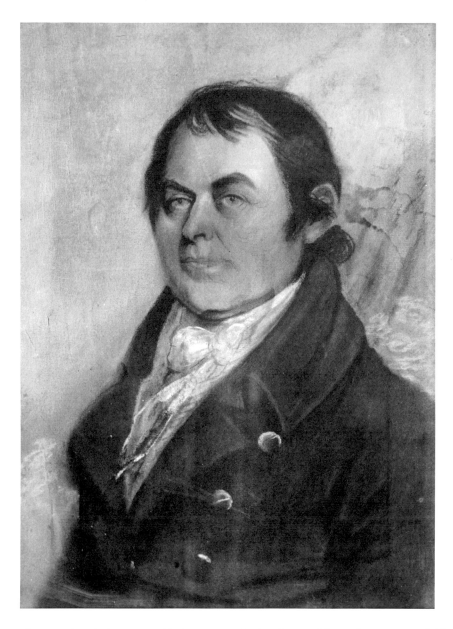

Pastel portrait of Amos Doolittle (1754–1832), silversmith and engraver of New Haven. (Collection of the New Haven Colony Historical Society, Gift of Mrs. Sarah McClary)

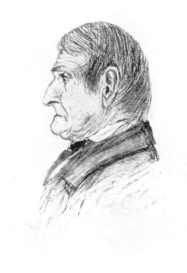

Charles Brewer (1778–1860), silversmith of Middletown, as sketched from life by his nephew, William S. Stearns. (From G. M. Curtis, *Early Silver of Connecticut and Its Makers,* 1913)

red earthenware.

This second generation of native-born Connecticut craftsmen in turn trained a third whose versatility and imagination in inventing mass-production techniques contributed to the legend of Yankee ingenuity. Abel Buel of New Haven, trained by Ebenezer Chittenden, invented a machine for grinding and polishing precious stones and another for planting onions and corn; operated a cotton-cloth factory, no doubt through using Eli Whitney's cotton gin; and coined the first authorized Connecticut coppers. Amos Doolittle of Cheshire was trained by Eliakim Hitchcock, later specialized in engraving, and became one of America's earliest print makers, making reproductions of his friend Ralph Earl's paintings of the battles of Lexington and Concord.

Connecticut continued to receive infusions of fresh blood from without, especially just before and after the Revolution. From England Thomas Hilldrup arrived in Hartford in about 1772, Thomas Harland in Norwich in 1773, and David Aird in Middletown in 1785. These men were principally watchmakers and jewelers, Aird exclusively so. Harland had traveled widely on the Continent before emigrating to America, and his European training is clearly reflected in his deep-bowled porringer with lid (like a French *écuelle,* but with one handle instead of two) shown in Plate 132 and in his

fiddleback tablespoon and fork (Plates 130, 131) of the newly popular English King's Pattern. This pattern normally exhibited the anthemion motif of the Greek Revival, but Harland replaced it with a bust of the recently deceased Washington. In his Norwich workshop Harland trained David Greenleaf, Jr., Nathaniel Shipman, William Cleveland, as well as the clockmakers Daniel Burnap and Eli Terry. It was Terry who revolutionized the clockmaking industry in America around 1806 by adapting waterpower to the mass production of clocks in his Plymouth factory.

In the period after the Revolution, the silversmith's craft was put to an increasingly diverse number of applications, some utilitarian, others purely decorative. Thus, from about 1790 on, more silver-mounted sabers are encountered as well as a silver-mounted New Testament by John Staniford of Windham, spectacles by Edmund Hughes and George Kippen, and a gold frame for a miniature made by Goodwin & Dodd around 1812 to 1821, one of the very few pieces of marked Connecticut gold.

The communion services of several Connecticut churches were periodically added to, and as a result they are now representative of the work of many distinguished craftsmen over a considerable span of time. Perhaps the most interesting service from this point of view is that of the First Church of Christ in Durham, now in the Mabel Brady Garvan Collection at Yale, whose beakers range in date from those by Potwine (1740) through others by Robert Fairchild (c. 1773), Jonathan Otis (c. 1782), Ebenezer Chittenden (1796), Marcus Merriman & Co. (1813), Merriman & Bradley (1817–1826), and Charles Brewer (1821). In order to obtain suitable presentation pieces, the donors naturally turned to silversmiths working in nearby centers of the craft. For members of the Durham church, Middletown and New Haven were the obvious choices. In most instances, later additions to communion services were made to match the earlier pieces, at least in shape. Nevertheless, certain silversmiths had their own canons of proportion to which they adhered when they made certain forms. Ebenezer Chittenden, for example, usually made a beaker about one inch shorter than those made earlier in the century, as is evident from the Durham examples. All of the Northford church beakers are also of this shorter type, since between 1817 and 1826 Merriman & Bradley copied the earlier two made by Chittenden, which had been presented to the church c. 1784 and c. 1792.

Beakers of the chalice type, that is, with a splayed pedestal foot, seem to have been used at first for the services of the Anglican church. This form, and the word "chalice" itself, were not generally used in Congregational churches, perhaps because of the association with the cup used in the Roman Catholic Mass. An early example of the chalice form (Plate 62), at the Berkeley Divinity School in New Haven, was made around 1773 by John Gardner of New London, and used after 1784 in the celebration of the sacrament by Bishop Samuel Seabury, the first Bishop of the Protestant Episcopal Church. The later examples made by Jonathan Otis in the 1780's for the churches at Suffield and Middletown, and in the 1790's by Miles Beach for the church in

Barzillai Benjamin (1774–1844), silversmith of New Haven and Bridgeport. (From an oil painting owned by The Milford Historical Society)

Berlin, and by Abel Buel for the church of North Haven, all show the impact of the Classical Revival on form and ornament. It is not until we come to Miles Gorham's chalices (Plate 127) made in 1804 for the Derby church, however, that we encounter a splendid purity of form illustrative of the best production in the new taste.

Spoons as well as beakers were increasingly made in sets. The replication of such objects manifests a similar association of their makers in the years directly after 1800. It was during these years that partnerships and companies appeared in numbers: Hart & Brewer in Middletown in 1800; Marcus Merriman & Co. in New Haven in 1802; Ward & Bartholomew in Hartford in 1804; and Hart & Wilcox in Norwich in 1805. In the second decade, the work of Goodwin & Dodd in Hartford in 1811, Cleveland & Post in Norwich in 1815, and Merriman & Bradley in New Haven in 1817 is particularly noteworthy.

The purity of form and restraint in ornamental detail engendered by the developed and refined taste of the eighteenth century were rapidly altered in the nineteenth by the influences of machine production and the more archaeologically-motivated Greek Revival. Both influences led to a hardness of line, a rigidity of form which visually took the life out of individual design. The effects can be seen on the one hand in the machine-like precision of the moldings which stiffen the set of three beakers (Plate 170) made by George Kippen, probably around 1815–1825, now in the United Congregational Church, Bridgeport. On the other hand, the tea sets by Marcus Merriman of New Haven and Barzillai Benjamin of Bridgeport (Plates 152, 175) reveal a new interest in ornamental form and formal ornament on the part of a newly prosperous semi-industrial society, which completely upset the mood of restraint existing in design at the turn of the century. The epitome of this French Empire taste in America, which was to lay the foundations for later Victorian exuberance, is surprisingly encountered in Connecticut in Ward & Bartholomew's water pitcher (Plate 144), made for James Madison probably just before he became President in 1809.

The subsequent decline in the number of practicing silversmiths during the nineteenth century because of competition from machines is a familiar story. This phase of the history of the craft in Connecticut is the last of three, which can be summarized as follows:

 a. An *assimilation* phase, from around 1700 to about 1740, during which silversmiths from Massachusetts and Rhode Island, working under English influence, and from New York, working under Dutch and Huguenot influence, simplified or adapted their styles to meet the demands of Connecticut patronage.

 b. An *indigenous* phase, running from roughly 1740 to after the Revolution, during which a new generation of Connecticut-born craftsmen began to practice, sometimes seeking out their own solutions to prob-

lems of design, more often working with an eye on the products of the artistic centers.

c. A third and final phase, contemporary with the beginnings of *quantity production* methods within the state, during which silversmiths worked frequently in association, using their versatility and imagination to turn their skills to an increasingly diverse number of applications.

During this final phase, the development of machine production and the demands of a more prosperous society for less expensive, ostentatious forms began to undermine the established tradition of individual design and handcraftsmanship. This tradition has still not been replaced by a satisfactory machine equivalent.

Illustrations of Hollowware and Selected Flatware

T HE ILLUSTRATIONS are, for the most part, arranged in chronological order by the working dates of the silversmiths, so that the reader may trace in broad terms the stylistic development of silver in Connecticut. Pieces made by the same craftsman are generally shown in succession. Occasionally, as in the case of a long-lived silversmith, early and late works are separated in order that they will be grouped with other works of similar style. Occasionally, too, related pieces by different craftsmen, or a set of matching communion cups made over a period of years by various hands, are shown in one photograph.

The makers of the individual works are usually known with certainty, but a few pieces have been attributed to particular craftsmen because they contain elements of style or decoration that correspond closely with those of pieces of unquestioned authorship. The same criteria may have been used in determining the probable date of a piece when this information is not suggested by an inscribed date, or when it is not known through old records. Such conjectured dates are approximate, and no conjecture is made for the date of a piece that could have been made at any time throughout the silversmith's career.

Although the style of a piece is most helpful in dating it, especially if it was made before 1725 or after 1775, when styles changed more rapidly and characteristically, it is not always a reliable factor in attributing a work to a particular silversmith. Some styles or forms became accepted for specific types of objects, and were made over long periods of time. For example, the keyhole-handle porringer appeared around 1725 in the colonies, but the Connecticut example shown here (Plate 108), by John Proctor Trott (1769–1852), of New London, could not have been made much before 1790 and may even have been made in the early nineteenth century. On the basis of style alone, most pieces can be dated only within a span of fifteen or twenty years. Inscrip-

tions are helpful in establishing when a piece was made, but the dates given in them can be misleading. They may have been added years after the piece was made or, as in the case of some church silver, an early date may have been inscribed for memorial purposes on a piece made years after the occasion commemorated in the inscription.

Some background information about individual pieces (except details of their exhibition, a subject judged to be of restricted interest) is given in the captions whenever possible. The amount of significant information in the records of museums, churches, and private owners is less than might be expected. For much of the church silver illustrated herein, the authors have reproduced biographical and genealogical information about the donors that was originally published in E. Alfred Jones's *The Old Silver of American Churches,* which was privately printed in 1913 for the National Society of Colonial Dames of America. This is a truly monumental work, but it is, unfortunately, almost unobtainable now as only 506 copies were printed. But often we do not know for whom a piece was made, or when, or where. The geographical location at which an object was found, or evidence which suggests that a piece has been in its present location for many years, is some indication of the possibility that the piece could have originated in that town or state. This is especially true of early silver made by village craftsmen if the piece was brought to light before the collecting of American silver began in earnest after 1900. Geographical evidence of this sort, however, is seldom definitive, for we know that silver was frequently made by urban craftsmen to fill out-of-town and out-of-state orders. When information on provenance is available—when we know, for example, whose initials are inscribed on a piece, or who its owners were before it came into the possession of a collector or museum—these facts help to establish the authenticity of a piece and its mark, and make them touchstones against which other pieces and marks may be tested.

Hollowware and Selected Flatware

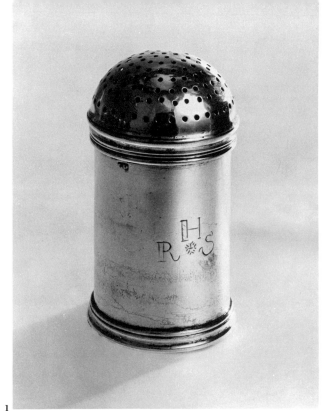 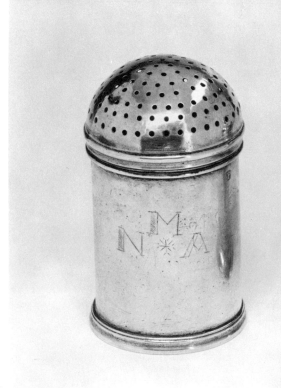

1 2

PLATE 1 Pepperbox, 1701–1703

JOB PRINCE, working in Milford from 1701 on.

Cylindrical body with molded rim and foot; hemispherical removable top
with peripheral rows of circular perforations, molded rim.

Inscription: R * S (shaded block capitals) on body.

Mark: I · P (capitals within rectangle) twice on body near rim.

Height: 3¼ inches.

Job Prince is the earliest recorded silversmith in Connecticut. In addition
to the three pepperboxes illustrated in this book, a fourth inscribed F * B is in
the collections of The Heritage Foundation, Old Deerfield, Massachusetts.

Yale University Art Gallery, the Mabel Brady Garvan Collection.

PLATE 2 Pepperbox, 1701–1703

JOB PRINCE, working in Milford from 1701 on.

Cylindrical body with molded rim and foot; hemispherical removable top
with peripheral rows of circular perforations, molded rim.

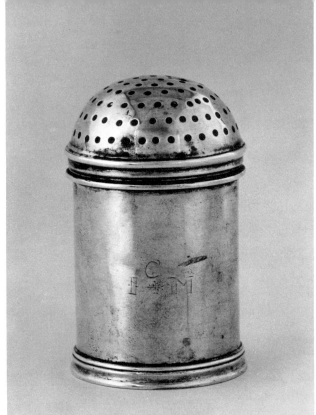

3

Inscription: N * A^M (shaded block capitals) on side of body.

Mark: I · P (capitals within rectangle) twice on body near rim.

Height: 3¼ inches.

Anonymous owner.

Pepperbox, 1701–1703

PLATE 3

JOB PRINCE, working in Milford from 1701 on.

Cylindrical body with molded rim and foot; hemispherical removable top with peripheral rows of circular perforations, molded rim.

Inscription: I * M^C (shaded block capitals) and Bermuda (script) on opposite sides of the body.

Mark: I · P (capitals within rectangle) twice on body near rim.

Height: 3 5/16 inches.

Collection of the late Mark Bortman.

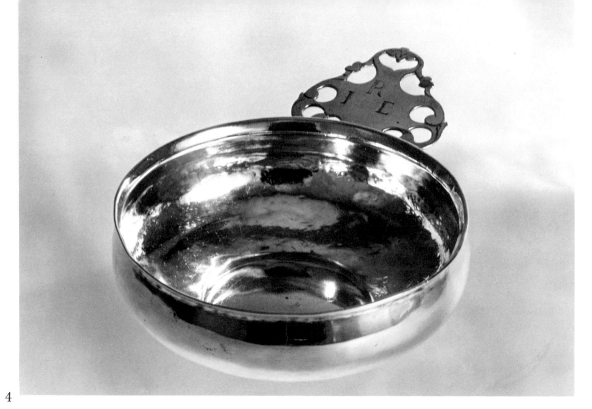

4

5

Porringer, c. 1692

PLATE 4

RENÉ GRIGNON, working in Norwich c. 1708–1715; earlier in Rhode Island and Massachusetts.

Circular bowl with convex sides, everted rim, and domed bottom; flat, cast pierced handle of curvilinear design.

Inscription: I ^R E (shaded capitals) on upper face of handle.

Mark: R G (capitals crowned over heart in shaped punch) twice on bottom.

Diameter: 4⅜ inches.

The inscription is for James and Elizabeth Rayner, who were married in Boston in 1692. This piece is included in order to illustrate Grignon's style, since none of the very few pieces attributed to him is definitely of Connecticut origin. He left his tools to his apprentice, Daniel Deshon of New London.

Yale University Art Gallery, the Mabel Brady Garvan Collection.

Porringer, c. 1707–1713

PLATE 5

SAMUEL GRAY, working in New London c. 1707 to 1713.

Circular, convex bowl with flat handle pierced in geometric pattern of circles and quatrefoils.

Inscription: D * S ^I (shaded capitals) on upper face of handle.

Mark: S G (capitals within heart) on rim of bowl to left of handle.

Diameter: 4½ inches.

Samuel Gray was the older brother of the silversmith John Gray, also of New London.

Yale University Art Gallery, the Mabel Brady Garvan Collection.

PLATE 6 Two-handled Beaker, c. 1729

CORNELIUS KIERSTEDE, working in New Haven c. 1724 – c. 1750.

Tapering body with slightly flared rim and molded base decorated with applied banded and semicircular-scalloped ornament; a pair of thin, flat strap scroll handles.

Inscription: The : gift : of : M^{rs} Abigail : Beech/ To : the : Church : in : Millford/ : July : y^e : 6 : Anno : Domini : 1729 (script).

Mark: C K (capitals within rectangle) three times near upper part of handles.

Height: 5 7/16 inches.

The donor was the wife of Samuel Beech (1660–1728) of Milford. In 1734 she married the Rev. Samuel Andrews of Milford, one of the original trustees of Yale College and its second rector. This is the earliest dated piece of church plate made in Connecticut.

The Church of Christ, Congregational, Milford.

PLATE 7 Baptismal Basin, c. 1731

CORNELIUS KIERSTEDE, working in New Haven c. 1724 – c. 1750.

Simple bowl with slightly domed bottom; narrow flanged rim with molded edge.

Inscription: halfe : By : The : Gift : of * M^{rs} : Alice * Buckingham : to : The : Church : of : Milford * october : y^e 26 : A°1731 (script) on rim.

Mark: C K (capitals within rectangle) at center of basin and five times on upper side of rim.

Diameter: 9⅞ inches.

Mrs. Alice Buckingham (1664–1741/2) was the daughter of the pastor of this church, the Rev. Roger Newton, and her mother was the eldest daughter of the Rev. Thomas Hooker. She married Daniel Buckingham on January 1, 1689. He was a ruling elder of the church until his death in 1712.

The Church of Christ, Congregational, Milford.

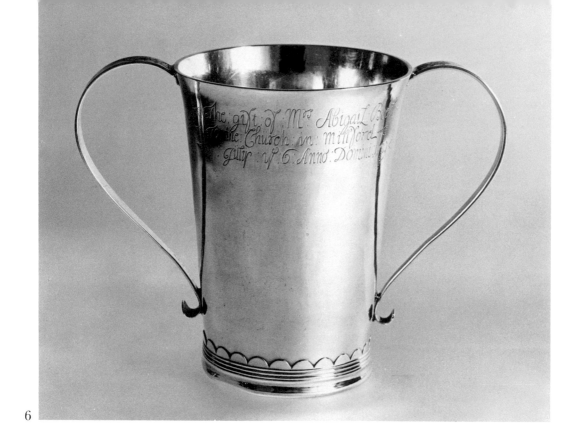

6

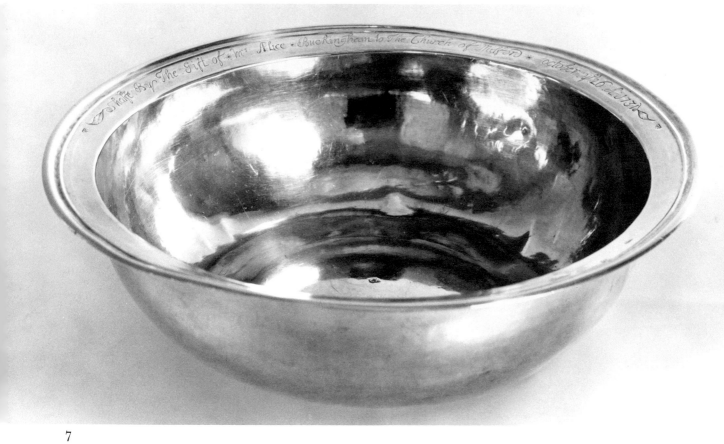

7

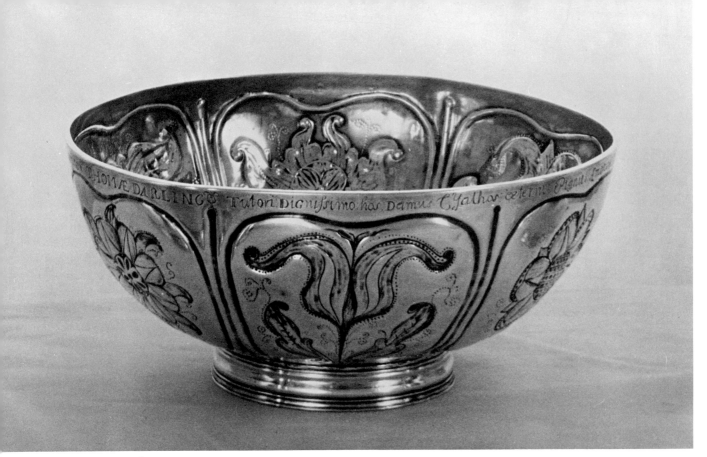

8

PLATE 8 Punch Bowl, c. 1745

CORNELIUS KIERSTEDE, working in New Haven c. 1724 – c. 1750.

Hemispherical bowl set on molded annular foot; decorated with six panels of flat-chased stylized flowers arranged vertically around periphery.

Inscription: * Domino * THOMÆ : DARLING Tütori : Dignissimo : hos : Damus Cyathos : oeterni : Pigniis : Amoris : * Classis : Süa 1745 (script and block) around the rim; A Gift to Thomas Darling by his Parents Samuel & Clarinda Darling 1842, Thomas Darling to his son Thomas 1843 (script) on rim and panels.

Mark: C K (capitals within rectangle) twice on rim.

Height: 3¼ inches; *diameter:* 7½ inches.

Thomas Darling (1720–1789), Yale College 1740, was a tutor in the college 1743–1745, during which time he was sole instructor of the Class of 1746, the donors of the bowl, the most ornamental piece of plate made in Connecticut.

Yale University Art Gallery, bequest of Miss Helen S. Darling, in 1913, in memory of Thomas Darling, Yale College 1836.

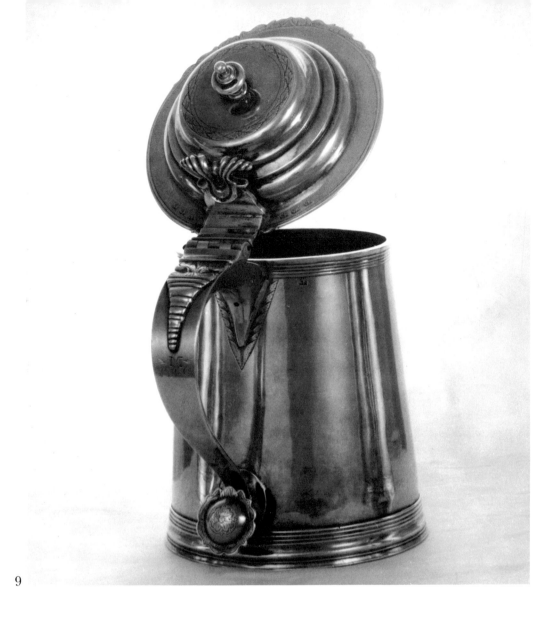

9

Tankard, c. 1730 – c. 1740

PLATE 9

CORNELIUS KIERSTEDE, working in New Haven c. 1724 – c. 1750.

Tapered body with molded base and rim; domed cover with shaped front edge, flat top, and cast, bell-shaped finial; S-scroll handle with cast, applied ornamental drop and boss-shaped rosette terminus; cast, scrolled thumbpiece.

Inscription: A * C (block letters) on handle; A later inscription: This Cup/ was bequeath/ with a Legacy of £200/ to Trinity Church New Haven/ by M^{rs} Mary Hillhouse,/ who died June 22.1822./ aged 87. years. (script) on front of tankard.

Mark: C K (capitals within rectangle) on each side of handle on body below rim, six times on flange of cover, three to each side of thumbpiece.

Hollowware and Selected Flatware 31

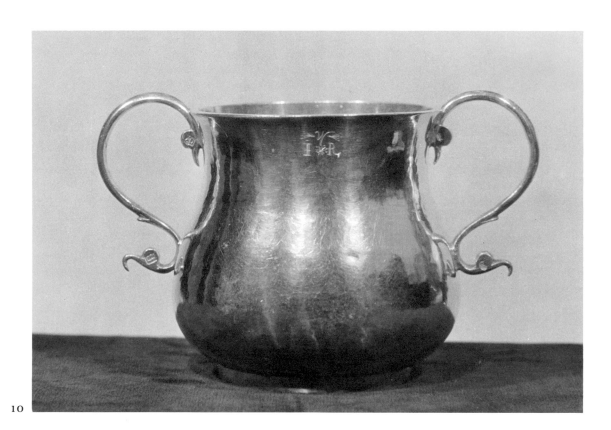

10

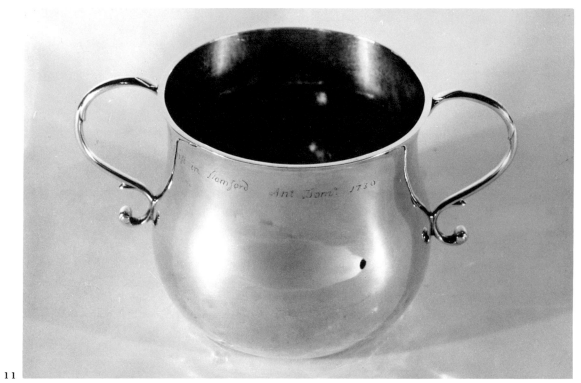

11

Height: 7½ inches.

Mrs. Hillhouse (1735–1822) was the wife of James Abraham Hillhouse, Yale College 1749. In her original will of 1801 she gave this tankard to Richard Cutler and his heirs, but in a codicil of 1821, after Richard Cutler's death, she bequeathed it to the Episcopal Church in New Haven. Trinity Church was not organized in New Haven until 1765.

Trinity Church-on-the-Green, New Haven.

Caudle Cup, c. 1730 – c. 1740

PLATE 10

CORNELIUS KIERSTEDE, working in New Haven c. 1724 – c. 1750.

Gourd-shaped body with a pair of cast, S-scroll handles; simple annular base.

Inscription: I * R (block and script) on side of body below lip.

Mark: C K (capitals within rectangle) twice on each handle, three times on bottom.

Height: 4⅛ inches.

This piece was once part of the service of the Congregational Church of North Haven. A note in the church records states that it was given by Ruth Atwater, who married Deacon Samuel Ives in 1706.

Present owner unknown; formerly (1947) in the collection of Mrs. William B. Church.

Caudle Cup, c. 1730

PLATE 11

PETER QUINTARD, working from 1737 on in South Norwalk.

Gourd-shaped body with a pair of thin, cast, S-scroll handles; flat base.

Inscription: The Gift of Mʳ Jonathan Gold to the Church of Christ in Stamford Anᵒ Domᵒ 1730 (script) in continuous line around body below lip.

Mark: P Q (capitals within rectangle) on bottom.

Height: 3 9/16 inches.

Jonathan Gold, in his will of October, 1730, left £8 to the church, which was doubtless used to purchase this cup. The piece was made during Quintard's early period in New York City, before 1735.

The First Congregational Church, Stamford.

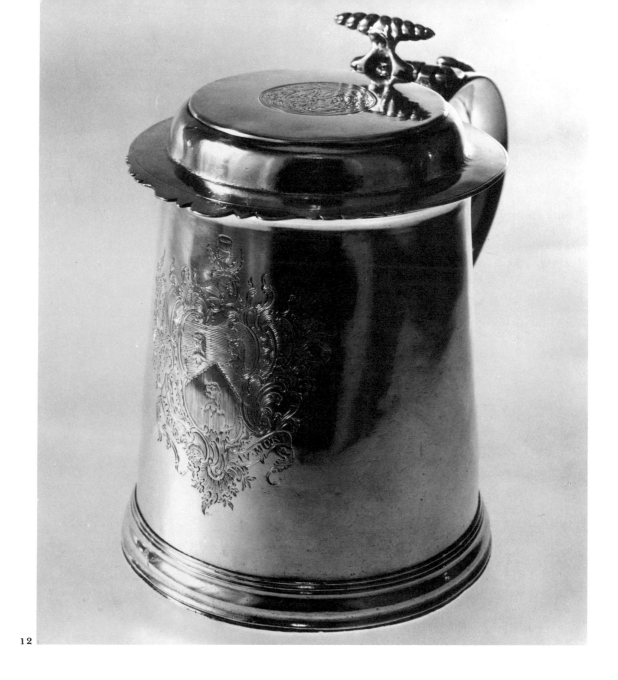

12

PLATE 12 Tankard, c. 1740 – c. 1760

PETER QUINTARD, working from 1737 on in South Norwalk.

Tapered body with molded base and everted, molded lip; domed, flat-topped lid with shaped front edge; S-scroll handle with rattail molding and plain, oval terminus; cast, corkscrew thumbpiece.

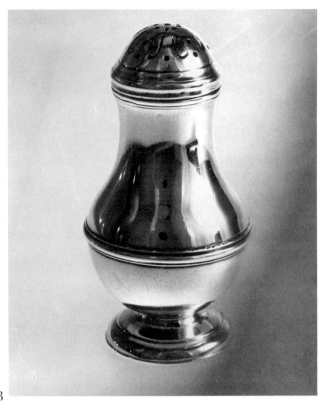

13

Inscription: Arms of Dunscombe family in Rococo mantling on front of body; JD (shaded reversed cipher) within medallion on lid; I D (block capitals) on handle.

Mark: P Q (capitals within rectangle) on body to either side of handle.

Height: 6 inches.

Yale University Art Gallery, the Mabel Brady Garvan Collection.

Caster, c. 1740 – c. 1760

PLATE 13

PETER QUINTARD, working from 1737 on in South Norwalk.

Pyriform body on low, splayed foot; molded mid-band and lip; domed top with pattern of curvilinear and circular perforations and molded edge.

Mark: PQ (capital and lower case within square) on bottom.

Height: 4 inches.

Yale University Art Gallery, the Mabel Brady Garvan Collection.

PLATE 14 Tankard

TIMOTHY BONTECOU, working in Stratford 1735; in New Haven after 1735
to 1775.

Tapered body with simple molded base and lip; flat cover in two stages with
shaped front edge; scroll handle with plain shield-shaped terminus; cast, cork-
screw thumbpiece.

Inscription: Contemporary coat of arms, unidentified, on front of body; lid
 bears reversed cipher of T C G and carpenter's gauge within circular
 medallion.

Mark: T B (capitals within conjoined circles) on bottom, to left of handle on
 body, and three times on cover.

Height: 5¼ inches.

Probably made during Bontecou's Connecticut period, because of the com-
bination of New York and Connecticut detail, possibly for a member of his
wife's family, as his wife's mother's name was Prudence (Churchill) Goodrich.

Yale University Art Gallery, the Mabel Brady Garvan Collection.

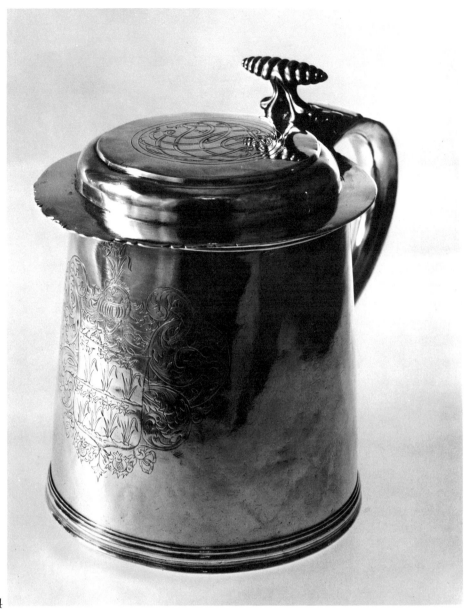

14

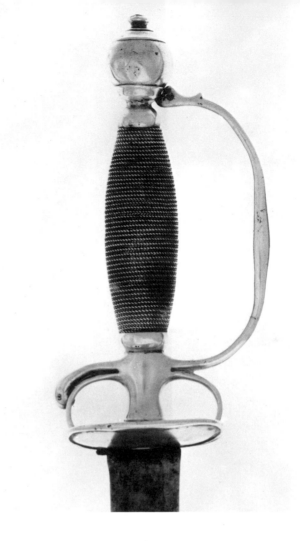

15

PLATE 15 Court Sword

TIMOTHY BONTECOU, working in Stratford 1735; in New Haven after 1735 to 1775.

Triangular blade; ball pommel with octagonal section next to the grip; conventional knuckle bow, pas d'âne, ricasso, and quillon; grip wound alternately with braided and plain wire.

Mark: T B (capitals within conjoined circles) on edge of one of counterguards.

Length: 37½ inches overall; blade 31 inches.

Court swords, known also as small swords, were dress swords of richer detail, especially in the hilts, than the heavier combat swords.

Collection of Dr. John K. Lattimer.

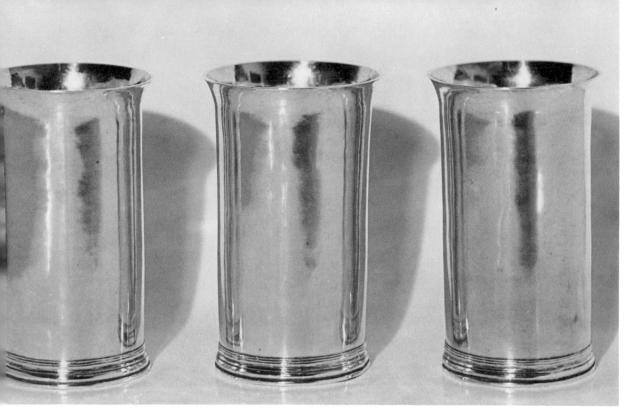

16

Set of Three Beakers, c. 1740

PLATE 16

JOHN POTWINE, working in Hartford 1737–1752 and c. 1761; also as a merchant there and in Coventry.

Tall, slightly tapered bodies with everted lips and molded bases.

Inscription: The Gift of Mr/ Wm Thomas to the/ Church of Christ/ in Durham 1740 (script) on base of each.

Mark: I:Potwine (bold script within shaped rectangle) on bottom of each.

Height: 5 13/16 inches.

William Thomas of Durham died in 1740. In his will he bequeathed all his "Goods, Chattels and Estate" to the church to be converted "into plate convenient for the use of said Church." These are the earliest dated pieces made by Potwine in Connecticut after his move to Hartford from Boston in 1737.

Yale University Art Gallery, the Mabel Brady Garvan Collection.

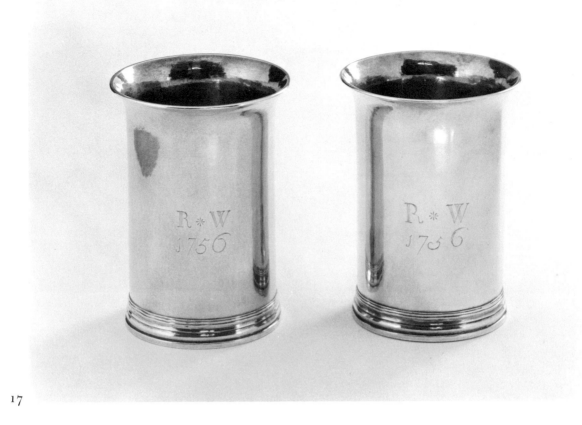

17

PLATE 17 Pair of Beakers, c. 1756

JOHN POTWINE, working in Hartford 1737–1752 and c. 1761; also as a merchant there and in Coventry.

Cylindrical bodies with widely flaring mouths and molded bases.

Inscription: R * W (shaded block capitals) on side of body of each.
 1756

Mark: I:Potwine (bold script within shaped rectangle) on bottom of each.

Height: 4¾ inches.

This pair of beakers was presented by Governor Roger Wolcott (1679–1767) to the East Windsor church in 1756. In 1741 he was appointed deputy-governor and judge of the supreme court. In 1745, at the age of sixty-seven years, he led the Connecticut troops as a major-general against Cape Breton, and was second-in-command under Sir William Pepperell at the capture of Louisburg. He was elected governor of the Connecticut colony in 1750.

The First Congregational Church, East Windsor.

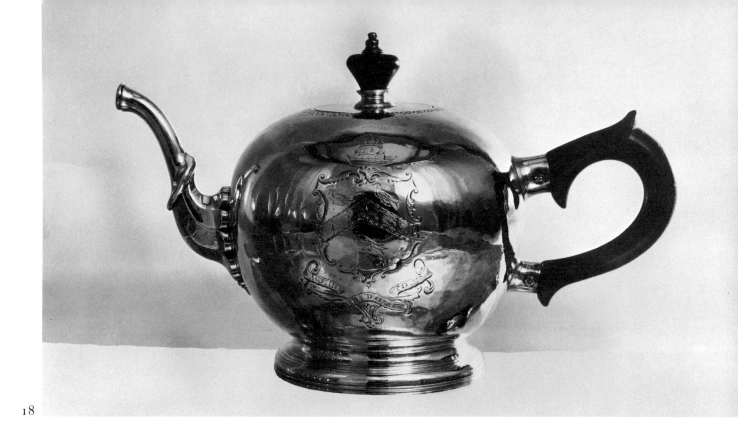

Teapot, c. 1740 – c. 1760

PLATE 18

JOHN POTWINE, working in Hartford 1737–1752 and c. 1761; also as a merchant there and in Coventry.

Globular body on low, splayed molded foot; gooseneck spout, upper section of which is circular in cross section, the lower section, below a collar, being decagonal in section; wooden C-scroll handle; flat detachable lid with turned wooden knop finial.

Inscription: Arms of the Welles family (contemporary) on one side; A W (Gothic capitals) surmounted by Welles crest, a later inscription, on opposite side.

Mark: I:Potwine (bold script within shaped rectangle) on bottom.

Height: 5½ inches.

Formerly belonging to the Hon. Sumner Welles.

Yale University Art Gallery, the John Marshall Phillips Collection.

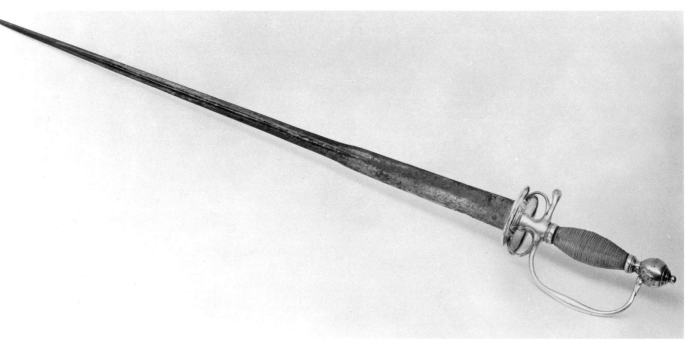

19

PLATE 19 Small Sword, c. 1740 – c. 1770

JOHN POTWINE, working in Hartford 1737–1752 and c. 1761; also as a merchant there and in Coventry.

Colichemarde blade damascened in gold; ball pommel with tip; conventional knuckle bow, pas d'âne, ricasso, and quillon; wire-wound grip.

Mark: I · P (capitals within square) on underside of counterguard.

Length: 33 inches.

There is a tradition that this sword belonged to Governor Roger Wolcott of Connecticut, who was Potwine's neighbor in East Windsor.

Collection of Dr. H. W. Erving.

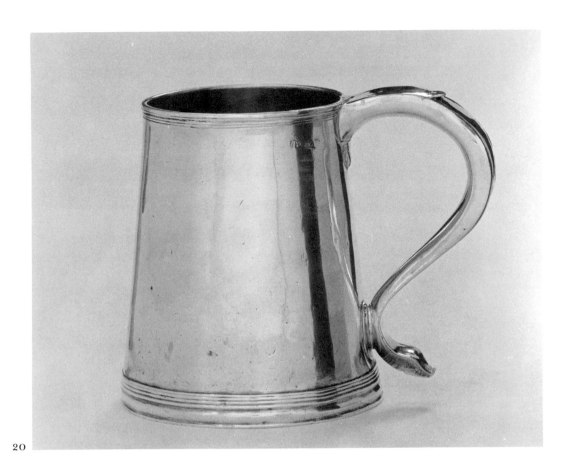

20

Mug

PLATE 20

JOHN POTWINE, working in Hartford 1737–1752 and c. 1761; also as a merchant there and in Coventry.

Tapered body with banded moldings at base and rim; S-scroll handle with small crest and curvilinear shaped terminus.

Inscription: H P (block capitals) on handle.

Mark: Potwine (script within shaped cartouche) to left of handle.

Height: 4⅜ inches.

The inscription is for Hannah Potwine.

Collection of Philip Hammerslough.

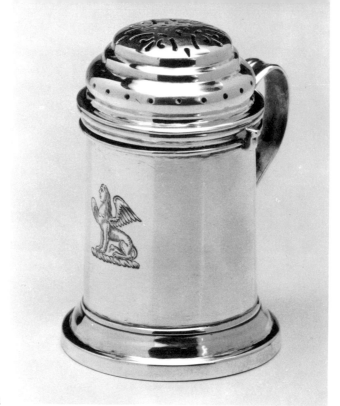

21

PLATE 21 Pepperbox, c. 1725 – c. 1760

JOHN BENJAMIN, working in Stratford c. 1725 on.

Cylindrical box with splayed molded foot and everted rim; removable multi-domed cover with curvilinear and circular perforations; reeded, S-scroll strap handle; bayonet cover fasteners.

Inscription: Engraved sphinx sejant crest on front of body. M S (block capitals) on bottom.

Mark: I · B (block capitals within oval) on upper body to right of handle.

Height: 3 inches.

Both the crest and the initials are unidentified. Benjamin's wife's maiden name was Mary Smith.

Collection of Philip Hammerslough.

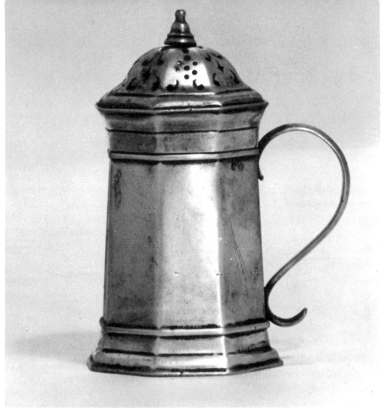

22

Pepperbox, c. 1750

PLATE 22

CHARLES WHITING, working in Norwich after c. 1750, and partner of John Potwine in Potwine & Whiting in Hartford in 1761.

Slightly tapered body of octagonal plan form, with molded base and lip; removable domed top with bell-shaped finial pierced in ornamental pattern; S-scroll strap handle.

Inscription: I * L (block letters) on bottom; 1744/ 1764/ 1877/ 1909 (all inscriptions later) on front of body.

Mark: c w (capitals within shaped shield) on bottom.

Height: 3¾ inches.

Owned by Jerusha (Talcott) Lathrop, 1717–1805, of Norwich, wife of Dr. Daniel Lathrop, Yale College 1733, founder of the first drugstore in Connecticut. They were the foster parents of Lydia Sigourney, "The Sweet Singer of Hartford."

Yale University Art Gallery, the Mabel Brady Garvan Collection.

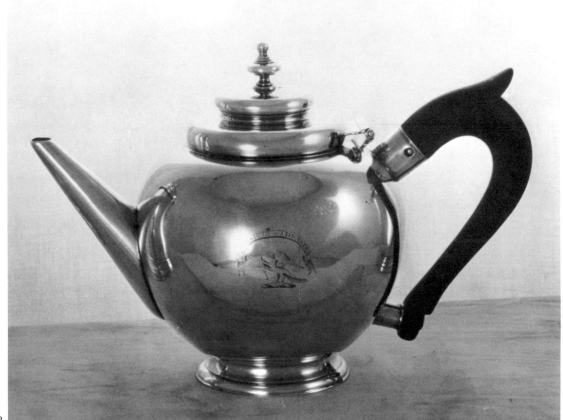

23

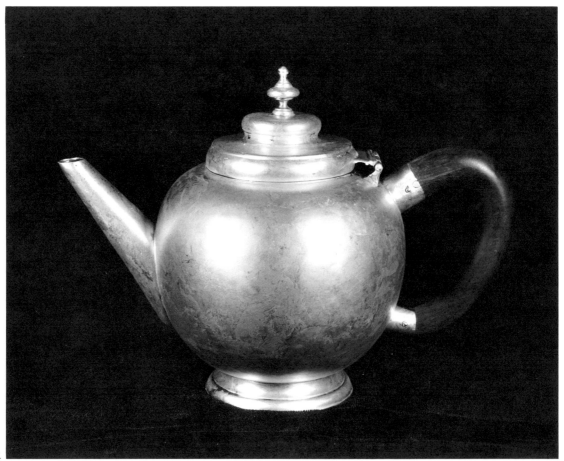

24

Teapot, c. 1725 – c. 1750

PLATE 23

BENJAMIN WYNKOOP, JR., working in Fairfield possibly as early as 1730 until 1766.

Globular body set on low, splayed foot; truncated conical spout; wooden C-scroll handle set in silver sockets; hinged, double-tiered, flat-topped lid with cast, button finial.

Inscription: w ^B * s (block letters) on bottom; arms of the Johnson family engraved on side of body.

Mark: B W (capitals within flat oval) four times on the bottom.

Height: 6¼ inches.

The initials are those of William and Sarah Beach of Stratford, who were married in 1725. William Beach died in 1751, and his widow married the Rev. Samuel Johnson, D.D. (1696–1772), Yale College 1714, first president of King's College, now Columbia University. His son by a former marriage, William Samuel Johnson, Yale College 1744, married in 1749, Ann Beach, daughter of Willam and Sarah. He too became president of King's College in 1787. His daughter, Elizabeth, married in 1785, D. C. Verplanck, great-great-grandparents of Edward Fenno Verplanck.

Present owner unknown. In the collection of Edward Fenno Verplanck in 1935.

Teapot, c. 1725 – c. 1750

PLATE 24

BENJAMIN WYNKOOP, JR., working in Fairfield possibly as early as 1730 until 1766.

Globular body set on low, splayed foot; truncated conical spout; wooden C-scroll handle set in silver sockets; hinged, double-tiered, flat-topped lid with cast, button finial.

Mark: B W (capitals within flat oval) twice on bottom.

Height: 6¼ inches.

The Sterling and Francine Clark Art Institute, Williamstown.

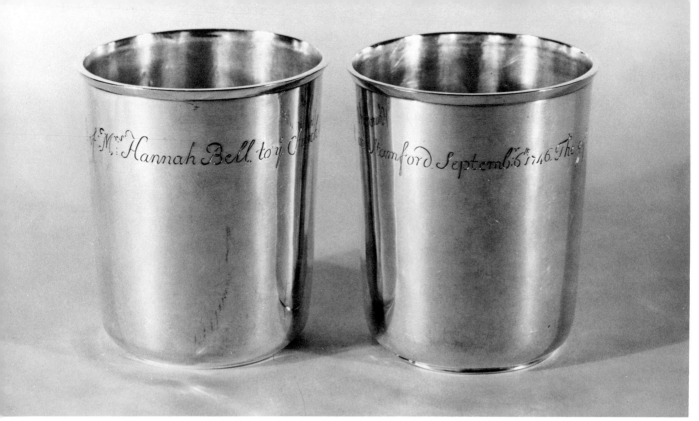

25

PLATE 25 Pair of Beakers, c. 1746

BENJAMIN WYNKOOP, JR., working in Fairfield possibly as early as 1730 until 1766.

Simple, squat slightly tapered bodies with rounded bottoms, everted rims and molded bases.

Inscription: The gift of Mⁱˢ Hannah Bell. to yᵉ Church of Christ in Stamford Septembʳ 6ᵗʰ 1746. (script) in continuous line around body of each.

Mark: B Ŵ (capitals within flat oval) four times on bottom of each.

Height: 4 inches.

Hannah Bell was born about 1718. She was designated "Mrs." because of her prominent social position, a custom not uncommon at that time. In an entry for September of 1746 in the *Land evidence* for Stamford, because of her regard for "rituall Holyness & piety," she gave £50 to the church for cups and the interest from another £50 to be used for the benefit of poor communicants.

The First Congregational Church, Stamford.

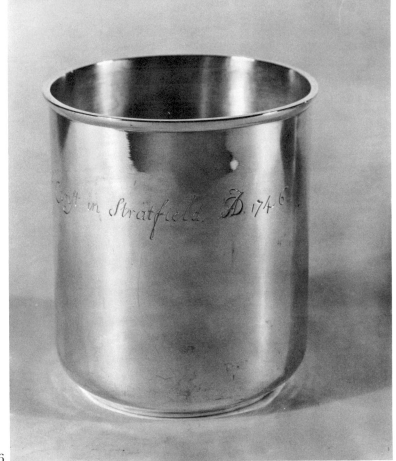

26

Beaker, c. 1746

PLATE 26

BENJAMIN WYNKOOP, JR., working in Fairfield possibly as early as 1730 until 1766.

Simple, squat cylindrical body with rounded bottom, everted rim, and molded base.

Inscription: The Gift of Mʳ John Edwards To the Church of Christ in Stratfield AD 1746 (script) in continuous line around body.

Mark: B W (capitals within flat oval) four times on bottom.

Height: 3⅞ inches.

Captain John Edwards died at the age of eighty-eight years. His will is dated 1735, and was proved in 1744. In it he left £30 in "Bills of Public Credit Currency. . . . for a Silver Vessel for ye use of ye Lords Table in said Church . . ."

The United Congregational Church, Bridgeport.

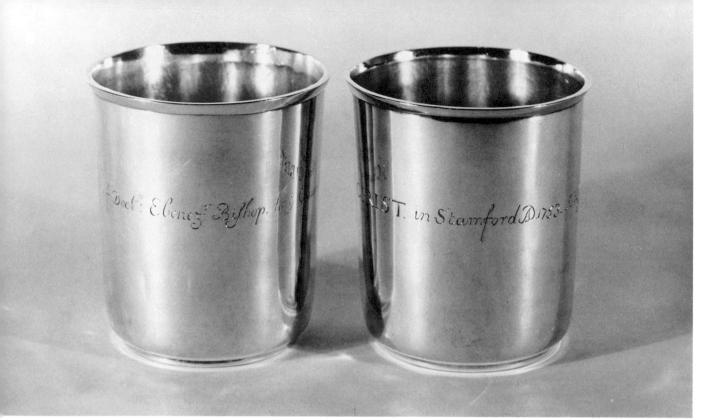

27

PLATE 27 **Pair of Beakers, c. 1753**

BENJAMIN WYNKOOP, JR., working in Fairfield possibly as early as 1730 until 1766.

Simple, squat cylindrical bodies with rounded bottoms, everted rims, and molded bases.

Inscription: The Gift of Doctr Ebenezr Bishop. to $\overset{e}{y}$ Church of CHRIST, in Stamford AD 1753 (script and block letters) in continuous line around body of each.

Mark: B W (capitals within flat oval) four times on bottom of each.

Height: 3 13/16 inches.

Dr. Ebenezer Bishop (1705/6–1743) was a physician. In his will of 1743 he left £80 to the church and also the remainder of the £50 he left his "Hon'd Mother" if she did not need the whole thereof. These two beakers and two others made c. 1761 by Elias Pelletreau of Southampton, Long Island, New York, were presumably paid for out of his legacy.

The First Congregational Church, Stamford.

Paten, c. 1730–1766

PLATE 28

BENJAMIN WYNKOOP, JR., working in Fairfield possibly as early as 1730 until 1766.

Circular tray with molded rim, set on pedestal support with splayed, molded foot.

Inscription: Trinity Church/ In Memory of Rev. Philo Shelton/ Easter/ 1826 (script) on upper surface around center punch.

Mark: B W (capitals within oval) on upper surface near rim.

Height: 2½ inches; *diameter:* 7¼ inches.

Since the inscription *Trinity Church* is in an earlier style than the remainder, and since Wynkoop died in 1766, it seems likely that this paten was part of the original communion service presented in 1762 by St. George Talbot, and presumed to have been looted by the British at the destruction of the church in 1779. It was probably found by the donor, the widow of the Rev. Philo Shelton (1754–1825). He was a 1775 graduate of Yale College, and married Lucy Nichols of Stratfield in 1781. He was the first clergyman to be ordained

Hollowware and Selected Flatware 51

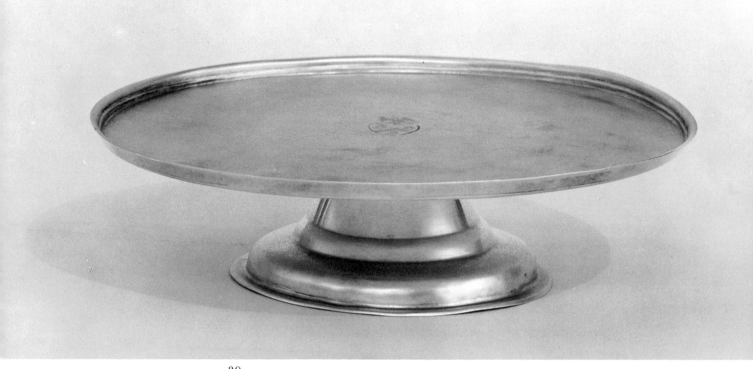

29

episcopally in the United States of America, receiving deacon's orders, along with three others, at the first ordination held by Bishop Seabury on August 3, 1785, at Middletown, Connecticut.

Trinity Church, Southport.

PLATE 29 Paten, c. 1730–1766

BENJAMIN WYNKOOP, JR., working in Fairfield possibly as early as 1730 until 1766.

Circular tray with molded rim, set on pedestal support with stepped, flanged foot.

Inscription: Engraved arms of Rev. Samuel Johnson (1696–1772) of Stratford, Connecticut, at center of upper surface.

Mark: B W (capitals within rectangle, rounded at left), three times on underside of flange of foot.

Height: 2⅜ inches; *diameter* 8⅜ inches.

Collection of Mr. and Mrs. James H. Halpin.

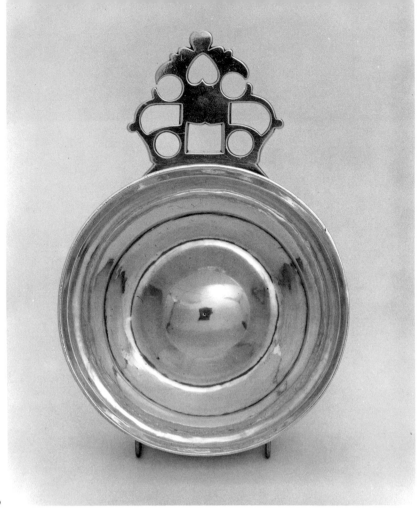

30

Porringer

PLATE 30

BENJAMIN WYNKOOP, JR., working in Fairfield possibly as early as 1730 until 1766.

Circular bowl with convex sides and slightly domed bottom, molded rim; flat, cast handle of curvilinear outline perforated in pattern of heart, circles, and rectangles.

Inscription: T $\overset{\text{F}}{}$ H (block capitals) on bottom.

Mark: B W (capitals within oval) on bottom and underside of handle.

Diameter: 5 inches.

The inscription is for Thomas Fitch (1699–1774), Colonial Governor of Connecticut, and his wife Hannah.

Collection of Philip Hammerslough.

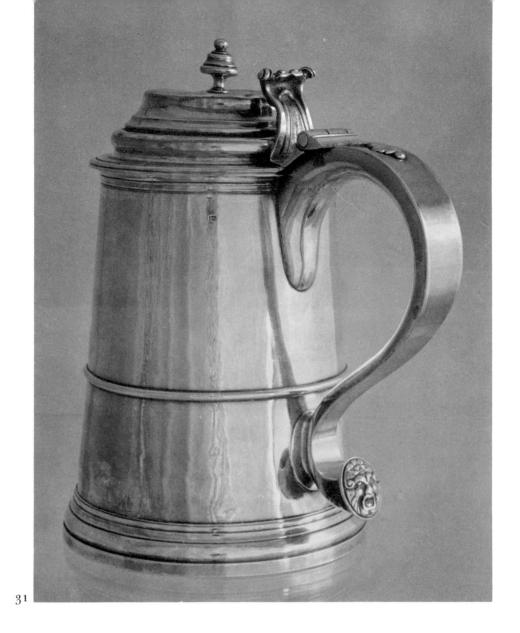

31

PLATE 31 Tankard, c. 1735–1776

PYGAN ADAMS, working in New London from before 1735.

Round, tapered body with molded base and mid-band and molded, everted lip; flat-topped, domed lid with cast, bell-shaped finial; S-scroll handle with oval terminus bearing grotesque mask; cast, scrolled thumbpiece.

Mark: P A (capitals within rectangle) on body below rim to left of handle.

Height: 8 inches.

Anonymous owner.

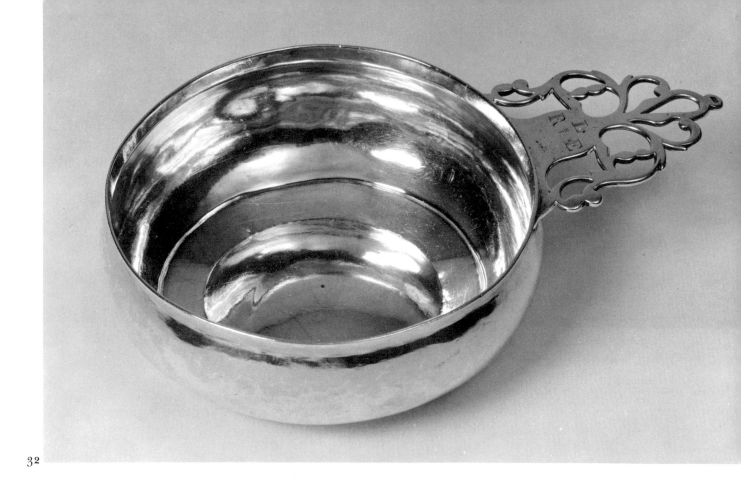

32

Porringer, c. 1735–1776

PLATE 32

PYGAN ADAMS, working in New London from before 1735.

Circular bowl with convex sides and slightly domed center; flat, cast handle in keyhole pattern.

Inscription: R ᴸ E (shaded block letters) on upper surface of handle.

Mark: P A (capitals within rectangle) on underside of handle.

Diameter: 5 inches.

The Henry Francis du Pont Winterthur Museum.

PLATE 33

Small Sword, c. 1755

TIMOTHY BONTECOU, JR., working in New Haven 1749–1789.

Colichemarde-type blade, upper 6 inches etched; ball pommel with tip, conventional knuckle bow, pas d'âne, ricasso, and quillon; wire-wound grip. Scabbard has silver throat with frog stud and silver tip.

Inscription: David Day 1755, on reverse of counterguard.

Mark: T · B (capitals within heart-shaped punch) on reverse of knuckle bow and quillon.

Length: 34 inches overall; blade 28 inches.

Collection of Hermann Warner Williams, Jr.

PLATE 34

Porringer, 1749–1789

TIMOTHY BONTECOU, JR., working in New Haven 1749–1789.

Circular bowl with convex sides and slightly domed center; flat, cast handle in keyhole pattern.

Inscription: M * B (shaded block capitals) on upper surface of handle.

Mark: T · B (capitals within rectangle) three times on lower surface of handle.

Diameter: 5 inches.

Collection of Maxwell Brainard.

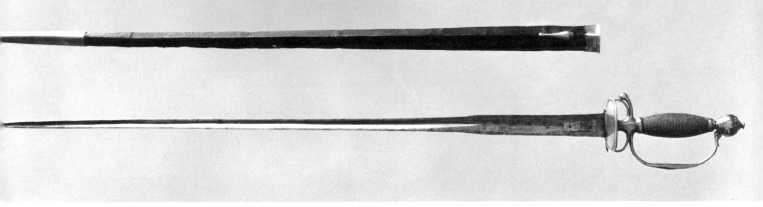

33

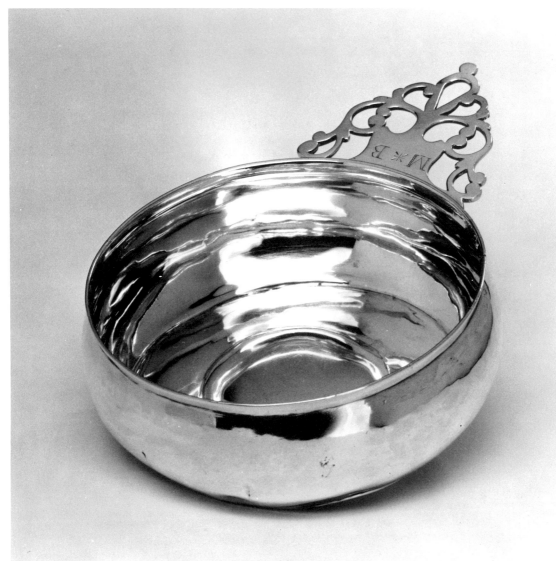

34

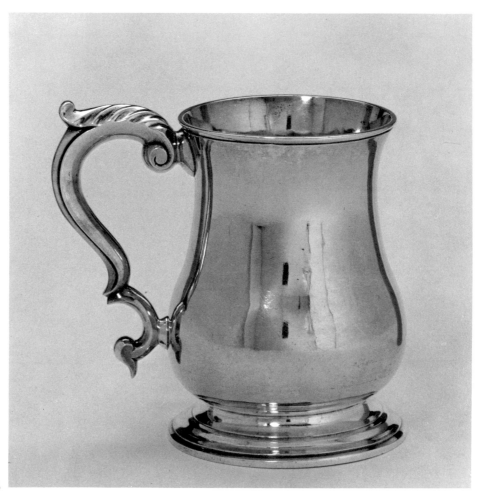

35

PLATE 35 Cann, 1749–1789

TIMOTHY BONTECOU, JR., working in New Haven 1749–1789.

Pyriform body with flaring mouth and molded rim; molded splayed foot; cast, S-C scroll handle with acanthus leaf crest.

Inscription: D $\overset{\text{E}}{+}$ L (block capitals) on bottom.

Mark: T · B (capitals within rectangle) on bottom.

Height: 4¾ inches.

Collection of Philip Hammerslough.

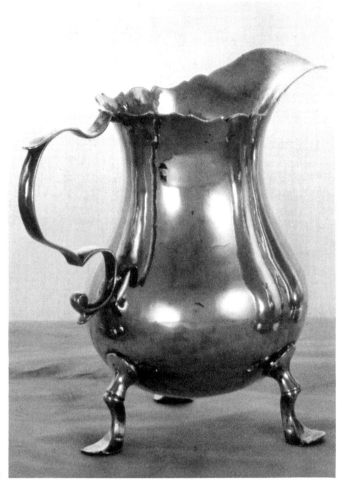

36

Cream Jug, 1749–1789

PLATE 36

TIMOTHY BONTECOU, JR., working in New Haven 1749–1789.

Pyriform body with flaring spout and scalloped rim, supported on three bracketed legs with trefoil feet; cast, S-C scroll handle.

Mark: T B (capitals within rectangle) on bottom.

Height: 4 5/16 inches.

Present owner unknown.

PLATE 37

Ladle, c. 1785

Timothy Bontecou, Jr., working in New Haven 1749–1789.

Hemispherical bowl attached to handle with double-pointed oval drop; handle has down-turned pointed end and bright-cut decoration.

Inscription: H H (script) within bright-cut oval on upper surface of handle.

Mark: T B (capitals within rectangle) on handle reverse.

Length: 14½ inches.

Collection of Philip Hammerslough.

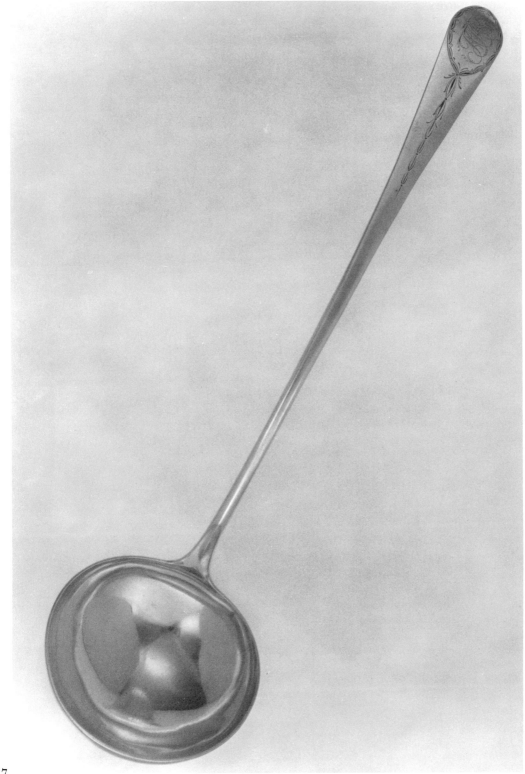

37

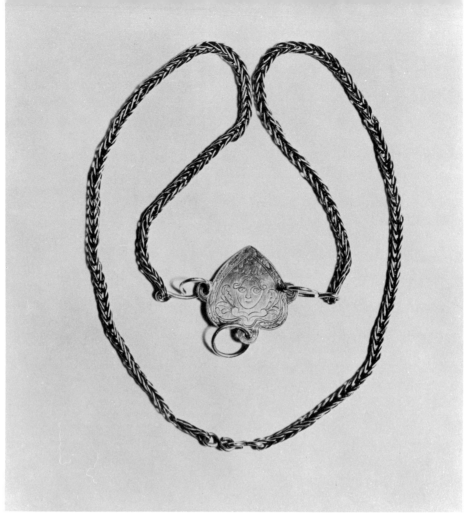

38

PLATE 38 Pendant and Chain, c. 1756

SAMUEL PARMELE(E), working in Guilford, possibly as early as 1756.

Heart-shaped pendant with lugs at center and sides; center lug bears simple ring, side lugs bear S-shaped loops to which multi-linked chain is attached; chain clasp consists of a pair of S-shaped hooks.

Inscription: (obverse) cherub head and foliate mantling within foliate border; (reverse) Anïi Cushing (script)/ 1756/ P + B (capitals).

Mark: S.P (capitals within shaped rectangle) on reverse at bottom point.

Width: pendant alone 1¼ inches; *length* with chain 12⅝ inches.

Yale University Art Gallery, gift of Miss Emily Chauncey.

Baptismal Basin, c. 1768

PLATE 39

SAMUEL PARMELE(E), working in Guilford, possibly as early as 1756.

Hemispherical body with flat base and rim with molded edge.

Inscription: The gift of Mr^s Deborah Spinning to the first Church in Guil-
ford. 1768. (script) in continuous line around rim.

Mark: S · Parmele (script within shaped rectangle) on upper side of bottom
at center of basin.

Diameter: 9½ inches.

Deborah Chittenden (1693–1766) married John Spinning in 1721. This
basin seems to have been made or inscribed two years after her death.

The First Congregational Church, Guilford.

40

PLATE 40

Beaker, c. 1773

SAMUEL PARMELE(E), working in Guilford, possibly as early as 1756.

Slightly tapered body with flaring lip and molded base.

Inscription: Mrs Ruth Naughty Donor. 1773 (script) in continuous line around body.

Mark: S Parmele (vertical script within shaped rectangle) on bottom.

Height: 4¼ inches.

Mrs. Naughty was the widow of David Naughty, a shopkeeper, who came to Guilford from Boston in 1721, and who died in 1739. She died in 1773. Her will of 1771 provided £4 for a "Silver Cup for the Use of the Lord's Table which Cup shall have my name Engraven on the same."

The First Congregational Church, Guilford.

PLATE 41

Gold Posy Ring, c. 1760 – c. 1800

SAMUEL PARMELE(E), working in Guilford, possibly as early as 1756.

Plain gold band.

Inscription: My heart for the is most free (script) on inside of band.

41

42

43

Mark: s.p (capitals within shaped reserve) on inside of band.

Diameter: ¾ inches.

Posy rings are so named because of the "poesy" or poetic inscription on the inside of the band. They were probably betrothal rings.

Collection of Mr. and Mrs. Edgar H. Sittig.

Gold Posy Ring, c. 1760 – c. 1800 PLATE 42

SAMUEL PARMELE(E), working in Guilford, possibly as early as 1756.

Plain gold band.

Inscription: United hearts death only parts (script) on inside of band.

Mark: s.p (capitals within shaped reserve) on inside of band.

Diameter: ¾ inches.

Posy rings are so named because of the "poesy" or poetic inscription on the inside of the band. They were probably betrothal rings.

Collection of Mr. and Mrs. Samuel Schwartz.

Snuffbox, c. 1760 – c. 1800 PLATE 43

SAMUEL PARMELE(E), working in Guilford, possibly as early as 1756.

44

Cylindrical body with molded base and rim; bottom and lid made of tortoise shell; lid turned in concentric moldings.

Inscription: I T A to E T G (script capitals) on side of body.

Mark: s.P (capitals within shaped reserve) on bottom.

Diameter: 3¼ inches.

Collection of Philip Hammerslough.

PLATE 44 Saltcellar, c. 1760 – c. 1785

Samuel Parmele(e), working in Guilford, possibly as early as 1756.

Circular bowl with convex sides and scallop-beaded, molded rim, supported on three cabriole legs with hoof feet and ridged body attachments.

Inscription: E H D (conjoined script capitals) on side of bowl.

Mark: s P (capitals within shaped reserve) on bottom.

Diameter: 2½ inches.

Collection of Philip Hammerslough.

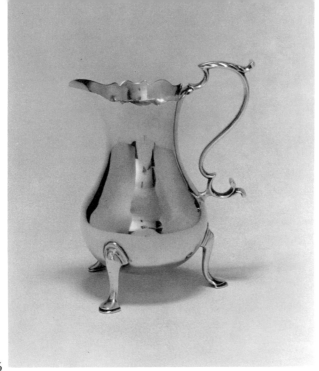

45

Cream Jug, c. 1760 – c. 1785

PLATE 45

SAMUEL PARMELE(E), working in Guilford, possibly as early as 1756.

Pyriform body with flaring spout and scalloped rim, supported on three cabri-ole legs with hoof feet; S-C scroll handle with crest and bifurcated terminus.

Inscription: B B F (block capitals) on bottom.

Mark: S P (capitals within shaped reserve) on bottom.

Height: 3⅞ inches.

Inscription is for Bezaleel and Fanny Bristol of Guilford.

Collection of Philip Hammerslough.

Cream Jug, c. 1755 – c. 1765

PLATE 46

DANIEL DESHON, working in New London possibly after c. 1718.

Pyriform body with wide flaring spout and scalloped rim, supported by three bracketed legs with hoof feet and trifoliate body junctures; cast, S-C scroll handle.

Inscription: W S A (block letters) on base.

Mark: D · D (script within double circles) on bottom.

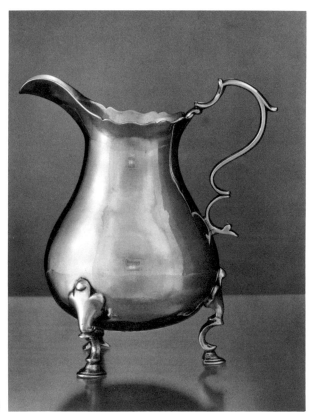

46

Height: 4 5/16 inches.

Deshon was apprenticed to René Grignon of Norwich, and possibly subsequently to John Gray of Boston and New London.

Yale University Art Gallery, the Mabel Brady Garvan Collection.

PLATE 47 Tankard, c. 1762

Unmarked, but probably Connecticut maker.

Round, tapered body with molded base and rim; double-domed lid with cast, flame finial; cast, scrolled thumbpiece; S-scroll handle, molded drop below hinge, plain oval terminus.

Inscription: Given by yᵉ/ Æᵈ Elʳ George Clark/ to yᵉ 2ⁿᵈ Chʰ of Chrᵗ in/ Milford 1762 (script) within circular foliate medallion on front of body.

Height: 9½ inches.

The donor's will of August of 1762 gives to the church a silver tankard to the value of £12, the expense of which was to be provided by his son Job.

The Church of Christ, Congregational, Milford.

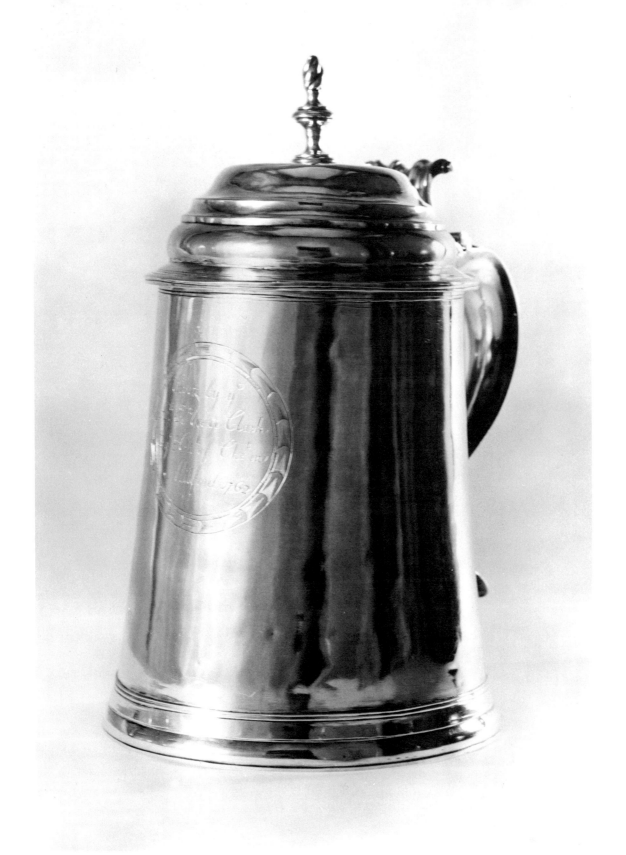

47

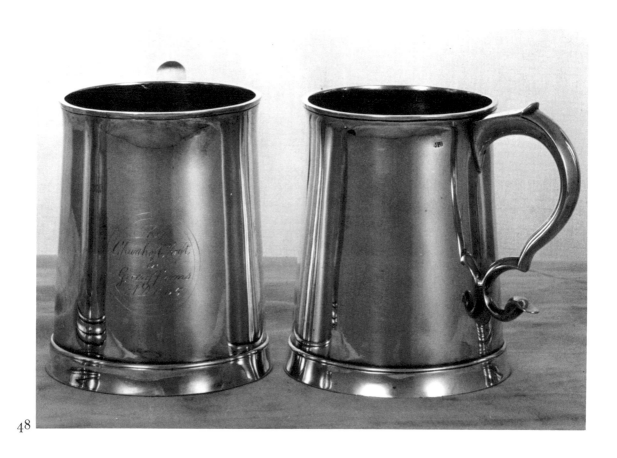

48

PLATE 48 Pair of Mugs, c. 1765

MUNSON JARVIS, working in Stamford from 1765 to 1783.

Round, tapered bodies with wide, plain base moldings and slightly everted, molded rims; cast, S-C scroll handles with crests.

Inscription: The/ Church of Christ/ in/ Greensfarms/ A D 1765 (script) within circular panel on each. One bears in addition: A gift to the Church of Christ at Greensfarms by M^rs Abigail Couch A.D. 1765 * (script) in continuous line on bottom.

Mark: M · J (capitals within rectangle) to left of handle on each.

Height: 4⅛ inches.

The donor was the daughter of Joshua Jennings of Fairfield, one of the signatories to the first covenant of this church in 1715. She married Simon Couch (d. 1770) in 1721; she died in 1765.

The Congregational Ecclesiastical Society of Greens Farms.

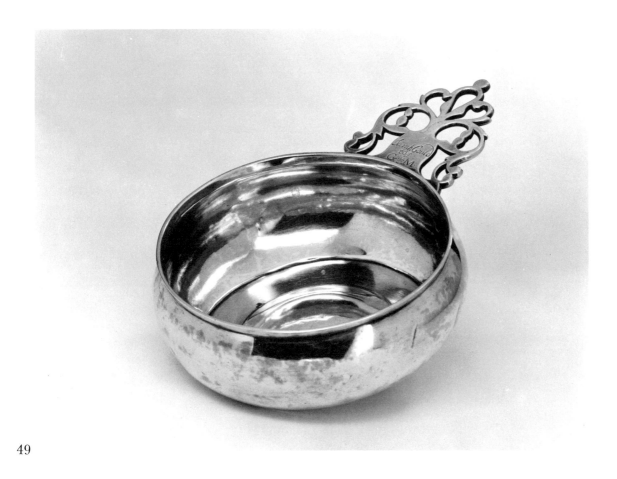

49

Porringer, c. 1766

PLATE 49

JOSEPH COPP, working in New London c. 1757 – c. 1776.

Circular bowl with convex sides and slightly domed center; flat, cast handle in keyhole pattern.

Inscription: Sarah Gould/ to/ G * M (script and shaded block capitals) on upper surface of handle; 1766 on lower surface of handle.

Mark: J · COPP (capitals within rectangle).

Diameter: 5 inches.

Anonymous owner.

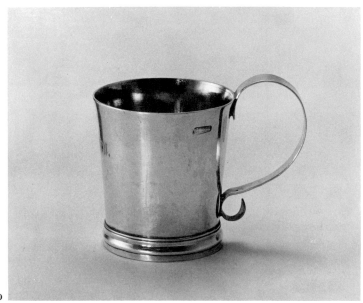

50

PLATE 50 Cup, 1759 – c. 1776

JOSEPH COPP, working in New London c. 1757 – c. 1776.

Round, slightly tapered body with flaring lip and molded base; S-scroll strap handle.

Inscription: N + L (block capitals) on bottom; Belden (Gothic letters) on front.

Mark: J · COPP (italic capitals within rounded rectangle) on upper body to left of handle.

Height: 2½ inches.

Owned by Captain Nathaniel Coit, shipmaster in Irish and West Indian trade, who married his third wife, Love (Richards) Rogers, in 1759. Coit's daughter by his first marriage, Sarah, married Samuel Belden.

Collection of Philip Hammerslough.

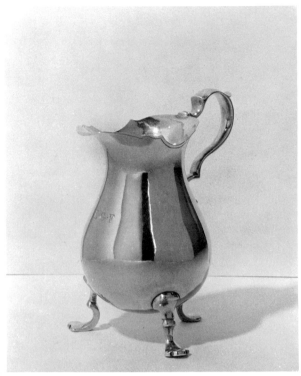

51

Cream Jug, c. 1760 – c. 1780

PLATE 51

JOHN AVERY, working in Preston from 1760.

Pyriform body with flaring spout and curvilinear rim, supported by three bracket legs with trifid feet; S-C scroll handle with crest.

Inscription: E · G · F (shaded block capitals) on front of body; M M G (block capitals) on bottom.

Mark: I A (capitals within rectangle) three times on bottom.

Height: 3⅝ inches.

Collection of Philip Hammerslough.

PLATE 52

Snuffbox, c. 1765 – c. 1785

JAMES TILEY, working in Hartford from before 1765 to 1785.

Circular body and top with parallel moldings on sides; horn cover grooved with concentric rings and slightly domed at center.

Inscription: H C (block letters) on bottom, probably for Harriet Chenevard.

Mark: I · TILEY (capitals within rectangle) on bottom.

Diameter: 2 inches.

The present owner is a direct descendant of Harriet Chenevard.

Collection of Joseph Wadsworth.

PLATE 53

Cream Jug, c. 1765

JAMES TILEY, working in Hartford from before 1765 to 1785.

Pyriform body with shaped rim and pouring spout, set on three hoofed bracket legs with scallop shells at body juncture; cast, S-C scroll handle.

Inscription: W $\overset{T}{\cdot}$ S (block capitals) on bottom.

Mark: I · Tiley (capitals and lower case within rectangle) on bottom.

Height: 4 inches.

Made around 1765 for William and Sarah Tiley of Hartford, great-great-great-grandparents of the present owner.

Collection of Joseph Wadsworth.

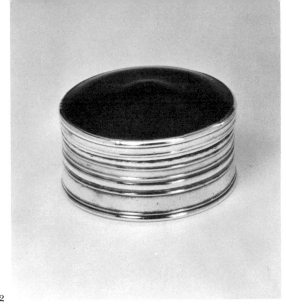

52

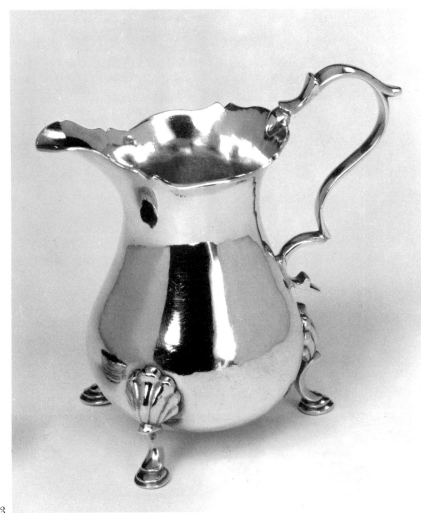

53

PLATE 54 Tankard, c. 1764

ROBERT FAIRCHILD, working in Durham before 1747; in Stratford 1747 to c. 1767; in New Haven 1767–1789.

Round, tapered body with molded base and rim; double-domed lid with elongated, turned bell finial; cast, scrolled thumbpiece; S-scroll handle with molded drop below hinge and plain oval terminus.

Inscription: This/ the Gift of/ Thomas Hill Esq^r/ To the Church of Christ in/ Greensfarms/ A.D. 1764 (script) within circular panel on front.

Mark: R. FAIRCHILD (capitals within rectangle) on bottom.

Height: 10 inches.

Captain Thomas Hill was born in Fairfield. He and Lothrop Lewis took the deputy's oath in 1756 and represented Fairfield in the state general assembly for several years. He gave a tankard by William Homes, Sr., of Boston to the Fairfield church in 1757 and another by Robert Fairchild to the Greenfield church (now Greenfield Hill, Fairfield) in 1764, that is, in the same year and by the same maker as that illustrated here. He died in 1770.

The Congregational Ecclesiastical Society of Greens Farms.

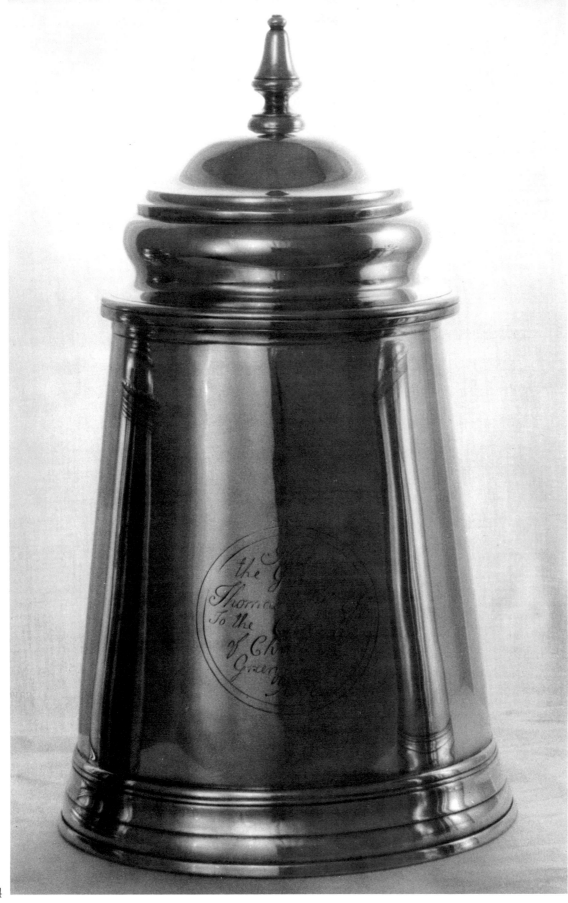

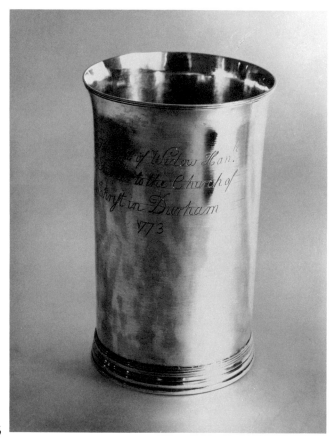

55

PLATE 55 Beaker, c. 1773

ROBERT FAIRCHILD, working in Durham before 1747; in Stratford 1747 to c. 1767; in New Haven 1767–1789.

Tall, slightly tapered body with molded base and everted, molded lip.

Inscription: The Gift of Widow Han[h]/ Fowler to the/ Church of/ Christ in Durham/ 1773 (script).

Mark: R · FAIRCHILD (capitals within rectangle) on bottom.

Height: 5⅝ inches.

Hannah Baldwin (1696–1776) married Josiah Fowler in 1723. He died in 1767 at Durham. Her brothers Ezra and Noah Baldwin, both deacons, gave silver to this church and to the Plymouth Congregational Church at Milford, respectively.

Yale University Art Gallery, the Mabel Brady Garvan Collection.

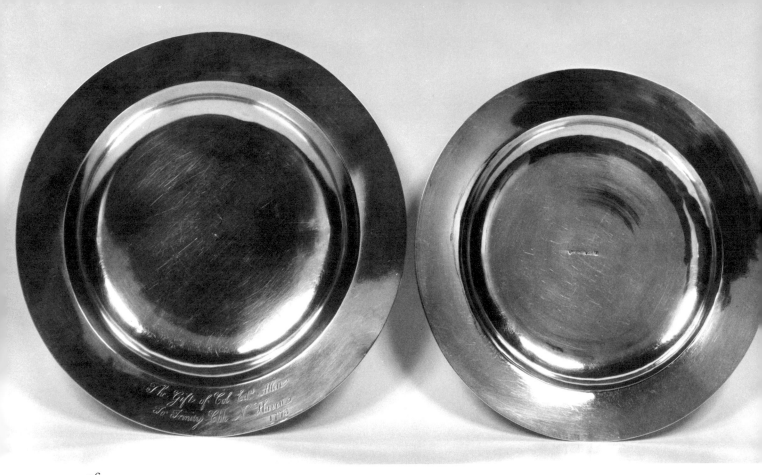

Plates, c. 1773

PLATE 56

ROBERT FAIRCHILD, working in Durham before 1747; in Stratford 1747 to c. 1767; in New Haven 1767–1789.

Shallow bowls, wide flat rims.

Inscription: The Gift of Col. Ed^d Allen/ To Trinity Chh N Haven/ 1773 (script) on rim of plate at left.

Mark: R. FAIRCHILD (capitals within rectangle) at center of bowl of plate at right. The plate at left is not marked; it is attributed to Robert Fairchild on the basis of the similar plate bearing his mark.

Diameters: left, 9 inches; right, 8½ inches.

Edward Allen was a deputy from Milford to the state general assembly in 1767 and 1774, and a colonel of the second Connecticut regiment. He married Rebecca Prince of Milford before 1743, in which year they gave land to the "Church of England" in Milford.

Trinity Church-on-the-Green, New Haven.

Hollowware and Selected Flatware 79

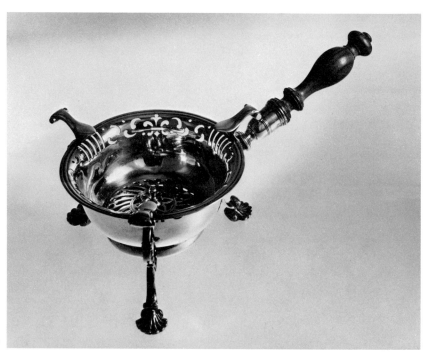

57

PLATE 57 Chafing Dish, c. 1750 – c. 1770

ROBERT FAIRCHILD, working in Durham before 1747; in Stratford 1747 to c. 1767; in New Haven 1767–1789.

Circular, bowl-shaped body standing on three cast scrolled legs terminating in shell-shaped feet; upper part of body pierced in design of bars, curvilinear, and fleurs-de-lis motifs; rim surmounted by three cast, scrolled knobs; inset plate pierced in geometric design; turned wooden handle of baluster type.

Inscriptions: W · S · J TO W · H · B (capitals) on bottom.

Mark: R×F (capitals within shaped cartouche) twice, to either side of center, on bottom.

Height: 4 13/16 inches to end of handle.

This piece is thought to have been made for the Rev. Dr. Samuel Johnson (1696–1772), Yale College 1714, clergyman, philosopher and first president of King's College (now Columbia University).

Yale University Art Gallery, anonymous gift for the John Marshall Phillips Collection.

58

Serving Spoon, c. 1750 – c. 1760

PLATE 58

ROBERT FAIRCHILD, working in Durham before 1747; in Stratford 1747 to c. 1767; in New Haven 1767–1789.

Oval, almost elliptical, bowl attached to handle with elongated rounded drop; narrow handle stem widening to rounded, upturned end.

Inscription: C I (block capitals) on reverse of handle near upturned end.

Mark: R×F (capitals within shaped cartouche), four times on reverse of handle stem.

Length: 15½ inches.

The inscribed initials are those of Charity Johnson, wife of the Rev. Dr. Samuel Johnson (1696–1772), Yale College 1714, clergyman, philosopher, and first president of King's College (now Columbia University).

Collection of Mr. and Mrs. James H. Halpin.

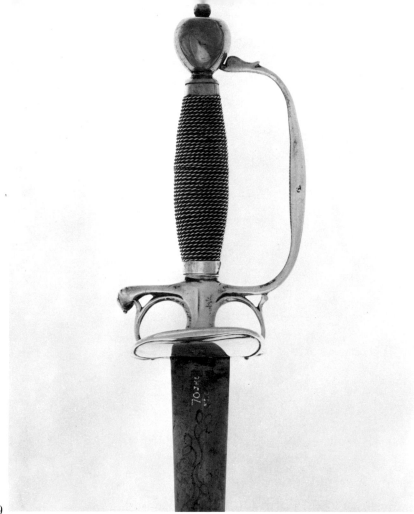

59

PLATE 59 Court Sword

ROBERT FAIRCHILD, working in Durham before 1747; in Stratford 1747 to c. 1767; in New Haven 1767–1789.

Ball pommel, symmetrical knuckle bow, shell counterguards, colichemarde blade with gold inlay.

Mark: R F (capitals within irregular reserve) once on bow, once on counter-guard.

Length: 35½ inches overall; blade 28¾ inches.

Collection of Dr. John K. Lattimer.

60

Spout Cup, c. 1766 – c. 1776

PLATE 60

ROBERT DOUGLAS, working in New London c. 1766 on.

Round, tapered body with molded base and flaring to rim; tapered cylindrical spout with molded mouth; reeded, S-scroll strap handle set 90 degrees to spout position on body.

Inscription: P.L./–: to :–/D.W.L. (script) on side of body opposite handle.

Mark: R D (capitals within rectangle) on bottom.

Height: 3¼ inches.

Collection of Philip Hammerslough.

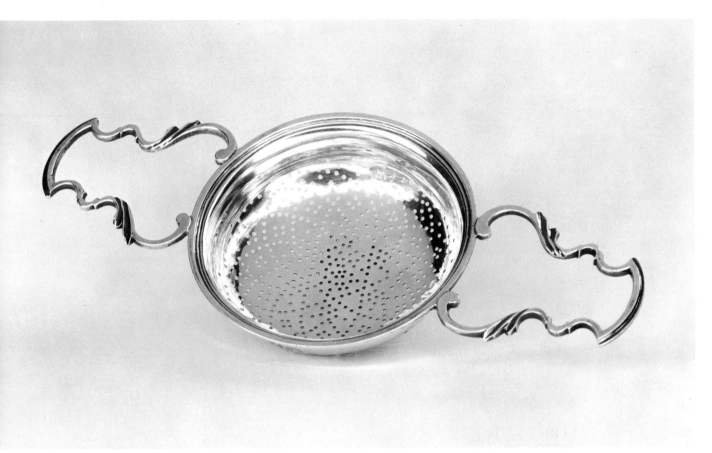

61

PLATE 61

Punch Strainer, c. 1770

HEZEKIAH SILLIMAN, working in New Haven 1764–1770.

Circular, perforated bowl with molded edge; pair of curvilinear, lyre-shaped open handles, each fastened at two points to rim.

Inscription: Crest in form of bird engraved on outside of bowl.

Mark: H S (block capitals within rectangle) in three places on bowl and on the underside of one handle.

Length: 10¼ inches.

Collection of Philip Hammerslough.

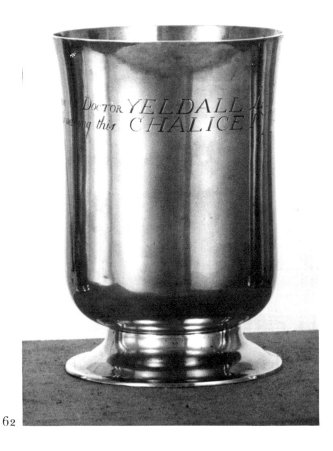

62

Chalice, c. 1773

PLATE 62

JOHN GARDNER, working from c. 1760 on in New London.

Vertical sides, flaring lip, and rounded bottom, set on splayed pedestal base.

Inscription: Given by DOCTOR YELDALL, 4 oz. pw.
7 / Towards making this CHAL-
ICE 1773. (script and italic capitals).

Mark: J:GARDNER (capitals within rectangle) near rim on opposite side from inscription.

Height: 5⅛ inches.

Dr. Anthony Yeldall, a Loyalist of Philadelphia, advertised his medicines in a New London newspaper in 1775. This chalice was used in the celebration of the sacrament by Bishop Samuel Seabury, Yale College 1748, the first bishop of the Protestant Episcopal Church. It was formerly at St. James's Church, New London, at some time before 1903.

The Berkeley Divinity School, New Haven.

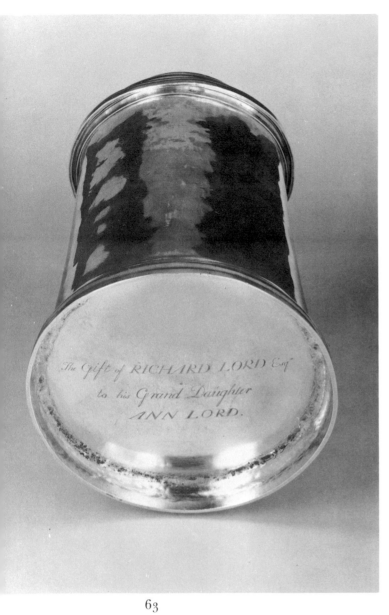

The Gift of RICHARD LORD Esq.
to his Grand Daughter
ANN LORD.

63

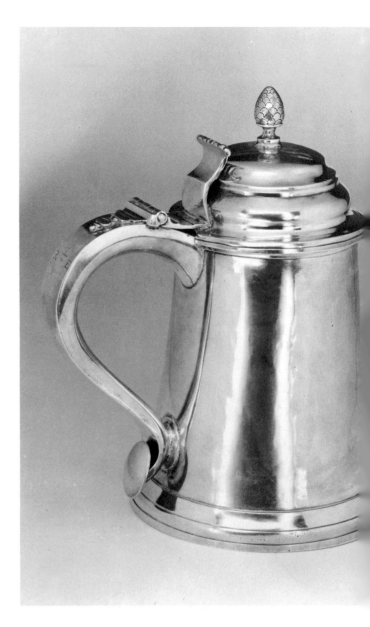

Tankard, c. 1760 – c. 1774 PLATE 63

JOHN GARDNER, working from c. 1760 on in New London.

Round, concave-tapered body with molded base and rim; double-domed lid with pine cone finial and cast, fluted thumbpiece; S-scroll handle with cast, applied drop below hinge and plain oval terminus.

Inscription: R *L* E on handle; The Gift of RICHARD LORD Esq^r/ to his Grand Daughter/ ANN LORD (script and capitals) across the bottom.

Mark: J:GARDNER (capitals within rectangle) near rim to left of handle.

Height: 8¾ inches.

The inscription is for Judge Richard Lord and his wife, Elizabeth, who were married in Lyme in 1720. He died in 1778. His granddaughter, Ann, was born in 1754 and married Captain Stephen Johnson in 1774.

Collection of Philip Hammerslough.

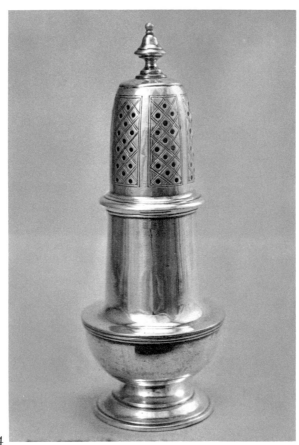

64

PLATE 64 Caster, c. 1760 – c. 1775

JOHN GARDNER, working from c. 1760 on in New London.

Vasiform body on low, splayed foot; removable top perforated and engraved with diaper pattern set within panels; cast, bell-shaped finial.

Inscription: L C (block capitals) on underside of foot.

Mark: I G (capitals within rectangle) on neck.

Height: 5½ inches.

The Art Institute of Chicago, gift of the Antiquarian Society.

65

Three Porringers, c. 1760 – c. 1775

PLATE 65

JOHN GARDNER, working from c. 1760 on in New London.

Circular bowls with convex sides and slightly domed centers; flat, cast handles in keyhole pattern.

Inscription: J * E (shaded block capitals) on upper surface of handles.

Mark: J:GARDNER (capitals within rectangle) on underside of handles.

Diameter: 5 inches.

This is the only set of three porringers known to have been made in Connecticut.

The Lyman Allyn Museum, New London (two), and Collection of Philip Hammerslough.

66

67

Gold Necklace Clasp, c. 1760 – c. 1775

PLATE 66

JOHN GARDNER, working from c. 1760 on in New London.

Rectangular gold body with oblique corners and glass face, under which is displayed reverse cipher c w or w c in gold thread against black cloth ground, surrounded by loop work gold thread border, all set against rose-tinted silver background. Rectangular wedge fastening and four loops to each side.

Inscription: E * H (block capitals) on reverse near long edge.

Mark: I G (capitals within rectangle) on reverse.

Length: 1 1/16 inches.

The Connecticut Historical Society.

Punch Strainer, c. 1761 – c. 1787

PLATE 67

EBENEZER AUSTIN, working in Hartford c. 1761 – c. 1787.

Shallow, circular bowl perforated with regular pattern of circular and cruciform holes; molded edge; pair of lyre-shaped, flat, open handles, each fastened at two points to strainer rim.

Inscription: J C (interlaced script) on underside of bowl.

Mark: E · A (capitals within rectangle) twice on underside of bowl; Austin (italics within oval) on underside of each handle.

Length: 11½ inches.

The inscribed initials are those of Captain John Chenevard, a prominent pre-Revolutionary merchant of Hartford. The present owner is a direct descendant of Captain Chenevard.

Collection of Joseph Wadsworth.

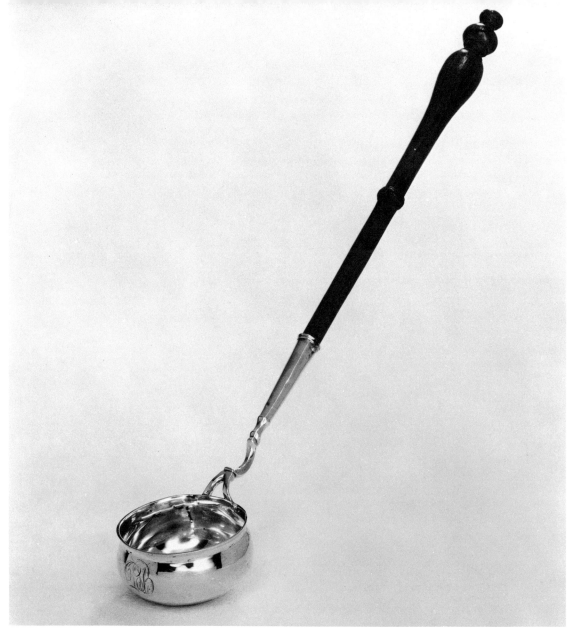

68

PLATE 68 Punch Ladle, c. 1761 – c. 1787

EBENEZER AUSTIN, working in Hartford c. 1761 – c. 1787.

Circular bowl with everted lip; turned wooden handle set in silver socket, attached to bowl through bifurcated bracket.

Inscription: D B (elaborated script) on front of bowl.

Mark: Austin (italics within oval) on bottom of bowl.

Length: 14½ inches.

Collection of Philip Hammerslough.

69

Funeral Spoon, c. 1779

SAMUEL AVERY, working in Preston from c. 1779 on.

Egg-shaped bowl attached to handle with molded drop, below which is Rococo shell ornament in relief; handle of narrow semicircular cross section widening to down-turned handle with rounded end.

Inscription: In Mem.ry of/ P * A who/ Died June/ 29th 1779/ L : A (script with initials in block letters) on handle obverse.

Mark: S A (capitals within rectangle) on stem reverse.

Length: 77/8 inches.

Yale University Art Gallery, the Mabel Brady Garvan Collection.

Hollowware and Selected Flatware 93

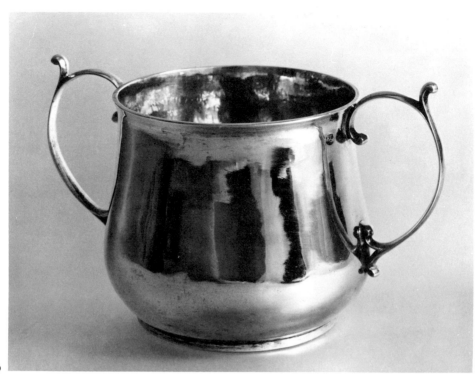

70

PLATE 70 Caudle Cup

EBENEZER CHITTENDEN, working in Madison (formerly East Guilford) before
c. 1770; in New Haven c. 1770–1812.

Gourd-shaped body on molded base; everted lip; pair of thin, cast, C-scroll
handles, bifurcated at lower end.

Mark: E C (capitals within oval) near handle at lip.

Height: 3⅝ inches.

The United Congregational Church, New Haven.

PLATE 71 Two-handled Cups, after 1797

EBENEZER CHITTENDEN, working in Madison (formerly East Guilford) before
c. 1770; in New Haven c. 1770–1812.

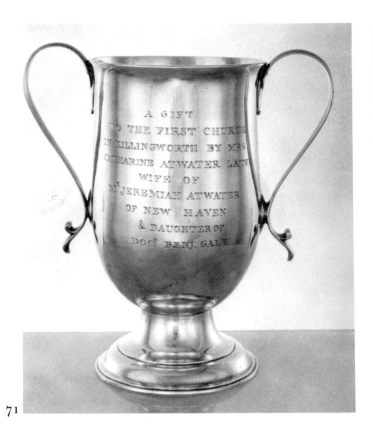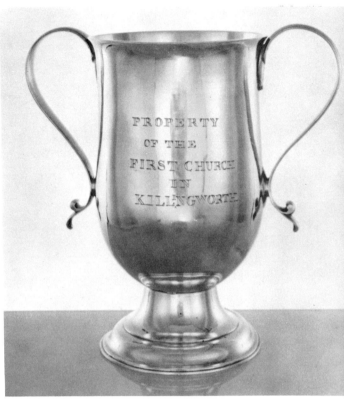

71

Bell-shaped bodies, short stems, splayed molded feet, pairs of cast, S-scroll handles with bifurcated termini.

Inscription: (left) A GIFT/ TO THE FIRST CHURCH/ IN KILLINGWORTH BY MRS/ CATHARINE ATWATER LATE/ WIFE OF/ M^r JEREMIAH ATWATER/ OF NEW HAVEN/ & DAUGHTER OF/ DOC^t BENJ: GALE (capitals)
(right) PROPERTY/ OF THE/ FIRST CHURCH/ IN/ KILLⁱNGWORTH (capitals).

Mark: E C (capitals within oval) on bottom of each.

Height: 5¾ inches.

Catherine Gale (1742–1797) of Killingworth became the second wife of Jeremiah Atwater (1734–1811) in 1780. He was elected steward of Yale College in 1778.

See also the matching cup by Merriman & Bradley in Plate 117.

The First Church of Christ, Congregational, Clinton.

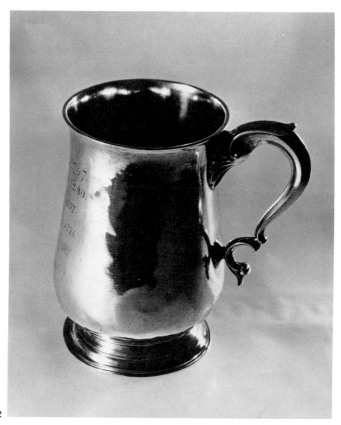

72

PLATE 72 Cann, c. 1767

EBENEZER CHITTENDEN, working in Madison (formerly East Guilford) before
c. 1770; in New Haven c. 1770–1812.

Pyriform body with everted rim on splayed, molded foot; cast, S–C scroll
handle attached to body at upper juncture with shell-shaped molding.

Inscription: Stephen Hotchkiss 1767/ Steven Hotchkiss 1800/ (block letters);
 Lucy Hotchkiss 1857/ Frank E. Hotchkiss 1876/ Ellen M. Hotchkiss
 Goodyear 1911 (script) on front of body.

Mark: E C (capitals within oval) on body to left of handle.

Height: 5 5/16 inches.

The New Haven Colony Historical Society.

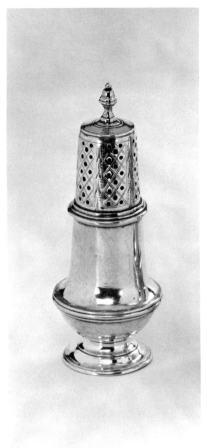

73

Caster

PLATE 73

EBENEZER CHITTENDEN, working in Madison (formerly East Guilford) before c. 1770; in New Haven c. 1770–1812.

Vasiform body set on low, splayed foot; removable domed cover with flattened top and cast, bell-shaped finial; cover pierced and engraved with diaper pattern and vertical bands of leafwork.

Mark: E C (capitals within rectangle) on bottom.

Height: 5¼ inches.

Anonymous owner.

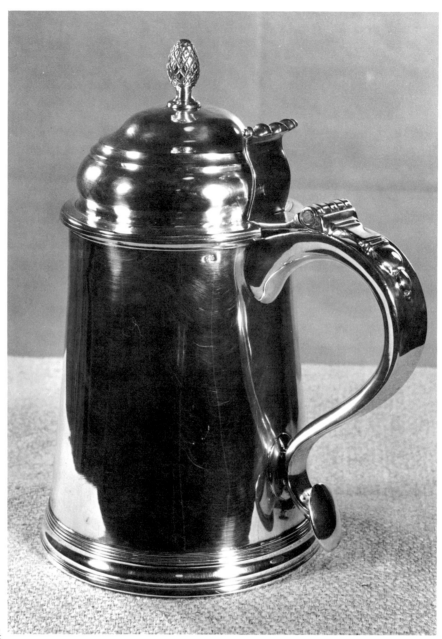

74

Tankard

PLATE 74

EBENEZER CHITTENDEN, working in Madison (formerly East Guilford) before
c. 1770; in New Haven c. 1770–1812.

Tapered body with molded base and molded, everted rim; domed cover with
pineapple finial; S-scroll handle with cast, applied drop and oval terminus;
cast, scrolled thumbpiece.

Inscription: c + m (block capitals) within engraved oval medallion on front
of body.

Mark: E C (capitals within shaped rectangle) to left of handle on body near
rim.

Height: 8¾ inches.

Los Angeles County Museum of Art, the Marble Collection.

PLATE 75 Flagon, c. 1798 – c. 1799

EBENEZER CHITTENDEN, working in Madison (formerly East Guilford) before c. 1770; in New Haven c. 1770–1812.

Elongated pyriform body on spreading, domed pedestal foot; domed, molded lid surmounted by urn-shaped finial; S-scroll handle with plain oval terminus; molded triple drop below hinge; cast, scrolled thumbpiece.

Inscription: A/ GIFT/ to the first/ CHURCH OF CHRIST/ in/ DERBY/ by/ N:^L FRENCH/ 1781 (capitals and lower case) set within an engraved foliate ellipse.

Mark: E · Chittenden (italics within rectangle) on body to left of handle.

Height: 15½ inches.

Nathaniel French (1717–1781) of Derby included in his will of 1781 the sum of £40 to purchase a silver flagon for the church, but the latter's records indicate that in 1797 the bequest had still not been received or applied to this purpose, and it was not until April 1800 that the flagon is recorded as having been procured from Ebenezer Chittenden, at that time "upwards of 70 years of age."

The First Congregational Church, Derby.

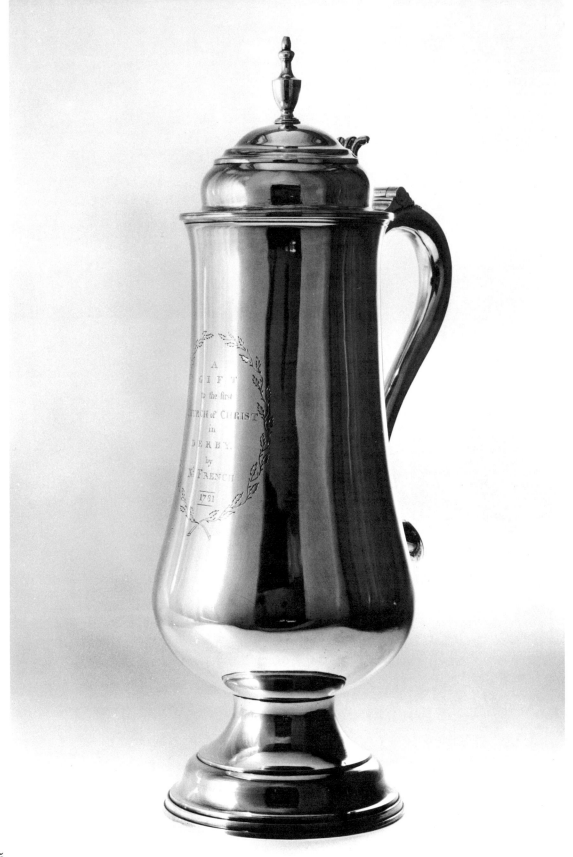

75

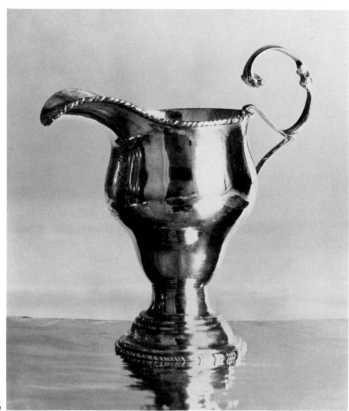

76

PLATE 76 Cream Jug, c. 1775

EBENEZER CHITTENDEN, working in Madison (formerly East Guilford) before c. 1770; in New Haven c. 1770–1812.

Inverted pyriform body on spreading, domed pedestal foot; wide, curved spout; cast, C-scroll handle with bifurcated attachment to body at rim and at point of maximum curvature; edges of rim and base ornamented with "rope-twist" molding.

Inscription: EW (script) within foliate wreath on front of body.

Mark: E C (capitals within oval) on center of bottom.

Height: 5¼ inches.

The New Haven Colony Historical Society.

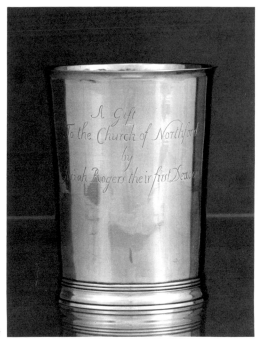

77

Beaker, c. 1784

PLATE 77

EBENEZER CHITTENDEN, working in Madison (formerly East Guilford) before
c. 1770; in New Haven c. 1770–1812.

Tapered round body with molded base and everted rim.

Inscription: A Gift/ to the Church of Northford/ by/ Josiah Rogers their
first Deacon. (script).

Mark: E C (capitals within oval) on bottom.

Height: 4 9/16 inches.

Josiah Rogers (1707/8–1783), in his will, proved in November of 1783, be-
queathed £3 to be paid to the church within a year after his decease "to be
improved at the discretion of said Church, ..."

Yale University Art Gallery, the Mabel Brady Garvan Collection.

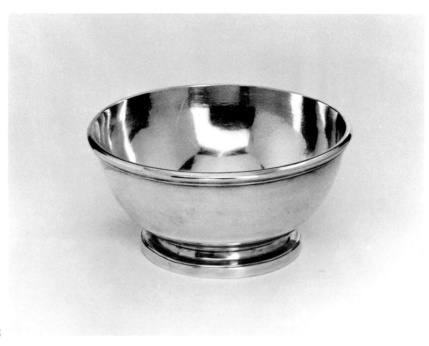

78

PLATE 78 Bowl

SAMUEL BUEL, working in Middletown 1777; in Hartford 1780.

Hemispherical body set on low molded foot with molded rim.

Mark: s · B (capitals within rectangle) on bottom.

Diameter: 6¼ inches.

See also the uninscribed beaker marked s · B presumably Samuel Buel, which is mentioned in the remarks on the three beakers by Ebenezer Chittenden for the Meriden church (Plate 113).

Anonymous owner.

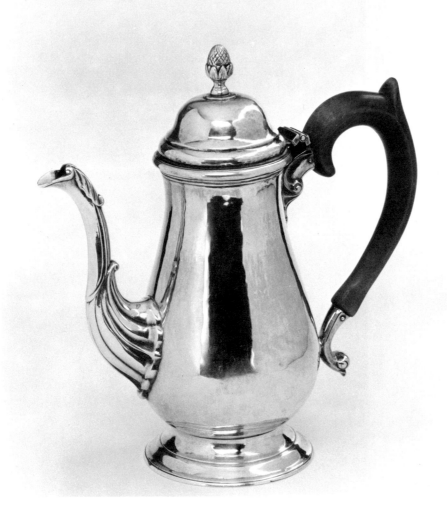

79

Coffeepot, c. 1780

PLATE 79

SAMUEL BUEL, working in Middletown 1777; in Hartford 1780.

Elongated pyriform body set on low, splayed foot; domed lid with pineapple finial; gooseneck spout with lower half ribbed and scrolled, mouth embellished with scrolled leaf ornament at rear; wooden C-scroll handle, upper point of attachment elaborated with shell ornament.

Mark: s · B (capitals within rectangle) on bottom.

Height: 8⅛ inches.

To the best of the writers' knowledge, this is the only coffeepot attributed to a Connecticut maker.

Anonymous owner.

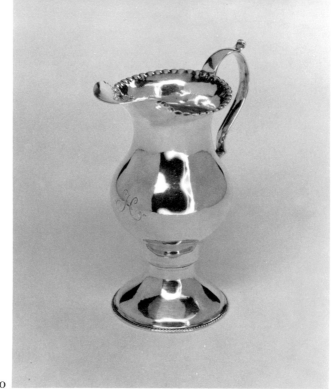

80

Cream Jug

SAMUEL BUEL, working in Middletown 1777; in Hartford 1780.

Pyriform body set on broad, splayed foot; wide, curving spout; S–C scroll handle; lip and foot ornamented with beaded edge.

Inscription: H (script) on front of body; $\begin{smallmatrix} E & C \\ W & R \end{smallmatrix}$ (block letters) on handle.

Mark: S · B (capitals within rectangle) on bottom.

Height: 4⅞ inches.

Collection of Philip Hammerslough.

Pepperbox and Pair of Saltcellars

SILAS MERRIMAN, working in New Haven 1766–1805.

Pepperbox has cylindrical, seamed body with molded base and lip; removable cover with molded edge and domed top pierced in geometric pattern; S-scroll

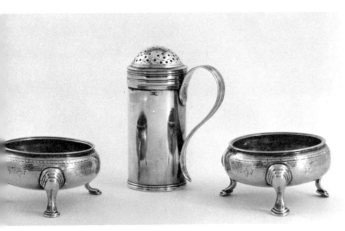

81 82

strap handle with molded face. Saltcellars have circular bowls with convex sides on three molded hoof feet; bands of engravings on sides with female heads at centers of two sides and seated rabbit at third.

Mark: s · m (capitals within rectangle) to left of handle and on band of cover of the pepperbox and on bottoms of saltcellars.

Measurements: pepperbox, 2⅞ inches high; saltcellars, 2⅜ inches in diameter.

Recently reascribed by Mrs. Yves Henry Buhler from original attribution to Samuel Minott of Boston.

The Museum of Fine Arts, Boston. Pepperbox from The Philip Leffingwell Spalding Collection; saltcellars the bequest of Charles Hitchcock Tyler.

Covered Pot

PLATE 82

Attributed to Silas Merriman, working in New Haven 1766–1805.

Round body tapering from mid-region both to the molded base and to the molded rim; small triangular spout with strainer; domed cover with ball finial on scalloped collar; S-scroll strap handle.

Mark: sm (capitals within rectangle) on bottom.

Height: 3⅜ inches, to rim.

Israel Sack, Inc.

Hollowware and Selected Flatware 107

83

PLATE 83 Tankard, possibly c. 1776 – c. 1782

MYER MYERS, working in Norwalk and Stratford, c. 1776 – c. 1782.

Round, tapered body with molded base and molded, everted lip; domed cover in two stages with flat top bearing engraved initials and shaped front edge; S-scroll handle decorated with applied, cast drop and having shield-shaped terminus; cast, scrolled thumbpiece.

Inscription: D S (foliate script) within medallion on top of cover; J S (block letters), one on each side of drop on handle.

Mark: Myers (script within shaped cartouche) twice on bottom and once on underside of cover.

Height: 6 9/16 inches.

Made for Daniel Shelton of Connecticut, possibly during Myers' period of Connecticut residence during the Revolution.

Collection of the late Mark Bortman.

84

Porringer, c. 1777 – before 1811

PLATE 84

JOSEPH CLARK, working in Danbury from c. 1777 to before 1811.

Circular bowl with convex sides, domed bottom, and everted lip; keyhole-pattern, curvilinear, pierced, flat cast handle.

Inscription: $\begin{smallmatrix} A & * & G \\ A & * & S \end{smallmatrix}$ (capitals) on upper surface of handle.

Mark: J:CLARK (capitals within rectangle) on lower surface of handle.

Diameter: 5 inches.

The inscribed initials are unidentified. The silversmith's wife's maiden name was Anna Steadman.

Collection of Philip Hammerslough.

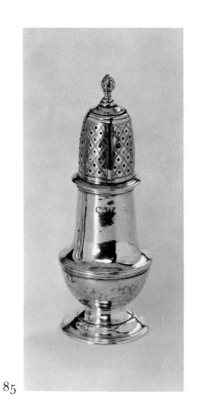

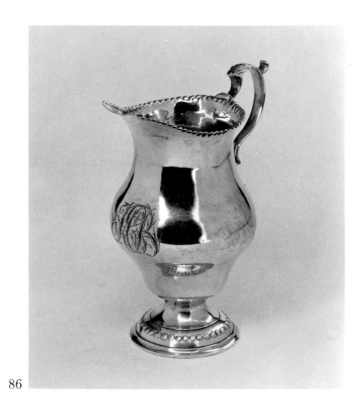

85 86

PLATE 85 Caster, c. 1766 – c. 1797

PHINEHAS BRADLEY, working in New Haven c. 1766–1797.

Vasiform body set on low, splayed foot; removable domed cover with pine cone finial; cover perforated and engraved with diaper pattern set within panels.

Inscription: c w (block capitals) on body near lip.

Mark: P B (capitals within rectangle) on neck.

Height: 5 inches.

Anonymous owner.

PLATE 86 Cream Jug, c. 1775

PHINEHAS BRADLEY, working in New Haven c. 1766–1797.

Pyriform body set on splayed circular foot; wide, curving spout; S-C scroll handle with cresting; beaded ornament on lip and foot.

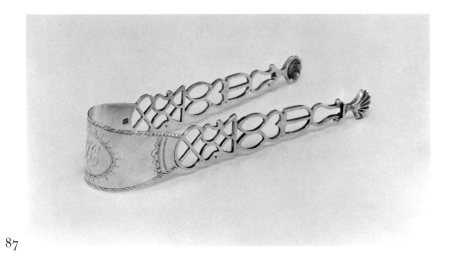

87

Inscription: T C B (elaborate foliate script) on front of body.

Mark: P B (block letters within rectangle) on bottom and on body to left of handle.

Height: 4⅞ inches.

Anonymous owner.

Sugar Tongs, c. 1785

PLATE 87

PHINEHAS BRADLEY, working in New Haven c. 1766–1797.

Wide, smooth bow ornamented with bright-cut medallion and feather-edging; openwork arms of geometric pattern, shell tips.

Inscription: ML (script) within bright-cut medallion on bow.

Mark: P B (capitals within serrated square) twice inside bow.

Length: 5½ inches.

Deacon Ezra Baldwin (1706–1782), in his will of 1765, proved in April of 1782, gave to the church "one Silver Cupp equal to the other given by William Thomas." In 1773 his sister Hannah Fowler gave another beaker by the silversmith Robert Fairchild of New Haven, and his brother Noah gave silver to the Second Congregational Church at Milford.

Collection of Philip Hammerslough.

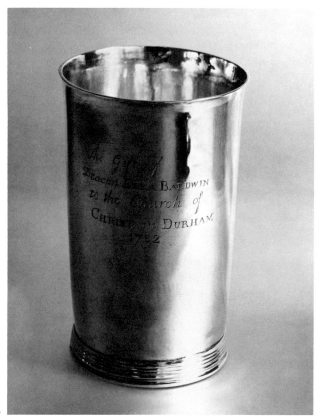

88

PLATE 88 Beaker, c. 1782

JONATHAN OTIS, working in Middletown 1778–1791.

Tall, slightly tapered body with molded base and everted lip.

Inscription: The Gift of/ Deacon EZRA BALDWIN/ to the Church of/ CHRIST in DURHAM/ 1782 (script and block letters).

Mark: OTIS (capitals within rectangle) and Otis (italics within rectangle) on bottom.

Height: 5⅝ inches.

William King (1695–1774) was a farmer, weaver, and lieutenant in a company of militia. He left £10 in his will of 1772 "to supply the Communion Table with such things as the Revd. Mr. Gay shall think proper," but these beakers were not purchased until eight years after his death.

Yale University Art Gallery, the Mabel Brady Garvan Collection.

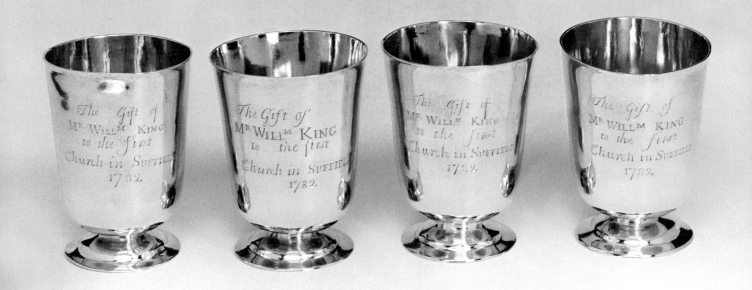

89

Set of Four Beakers, c. 1782

PLATE 89

JONATHAN OTIS, working in Middletown 1778–1791.

Tapered bodies with rounded bottoms, set on low, splayed pedestal feet.

Inscription: The Gift of/ M^R WILL^M KING/ to the first/ Church in Suffield/ 1782 (script and block capitals) on one side of body of each.

Mark: Otis (script within oval) on bottom of each.

Height: 3⅞ inches.

The First Congregational Church, Suffield.

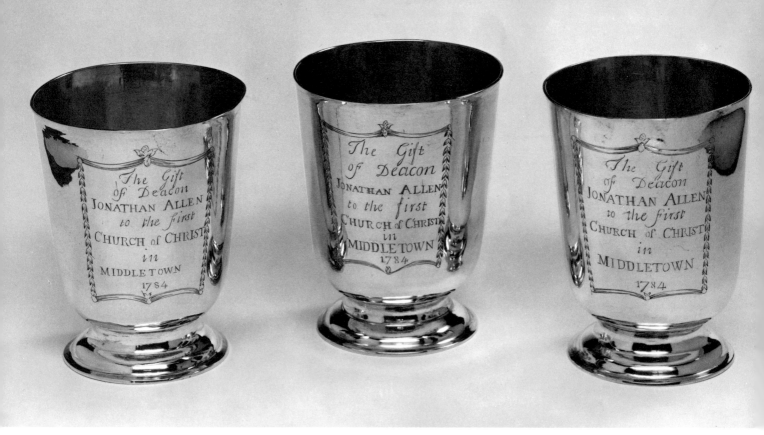

90

PLATE 90 Set of Three Beakers, c. 1784

JONATHAN OTIS, working in Middletown 1778–1791.

Tapered bodies with rounded bottoms, set on low, splayed pedestal feet.

Inscription: The Gift/ of Deacon/ JONATHAN ALLEN/ to the first/ CHURCH of CHRIST/ in/ MIDDLETOWN/ 1784 (script and block capitals) set within an engraved frame of drapery swags and bell-flowers on each.

Marks: OTIS (capitals within rectangle) on bottom of one; Otis (italics within rectangle) on bottoms of two.

Height: 4¾ inches.

Jonathan Allen (1703–1783) was a deacon of this church for the forty years from 1743 until his death. In his will he left £10 for "a Suitable Cup or Vessel for the Communion Table." A codicil provided for an additional 40 shillings for the same purpose.

The First Church of Christ, Middletown.

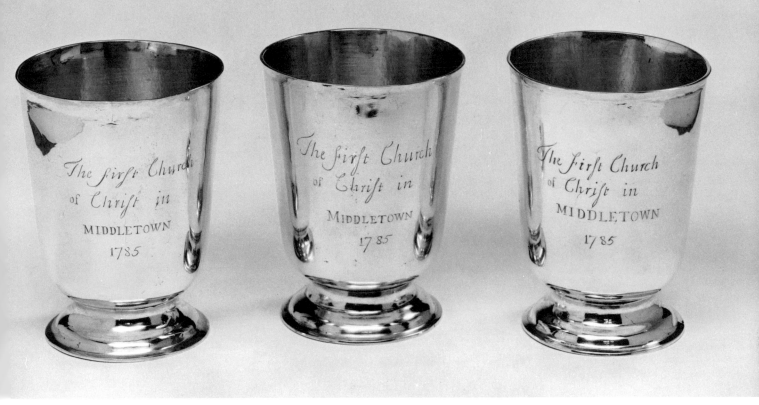

91

Set of Three Beakers, c. 1785

PLATE 91

JONATHAN OTIS, working in Middletown 1778–1791.

Tapered bodies with rounded bottoms, set on low, splayed pedestal feet.

Inscription: The first Church/ of Christ in/ MIDDLETOWN/ 1785 (script and block capitals) on one side of body on each.

Mark: Otis (script within oval) on bottom of each.

Height: 47/8 inches.

The First Church of Christ, Middletown.

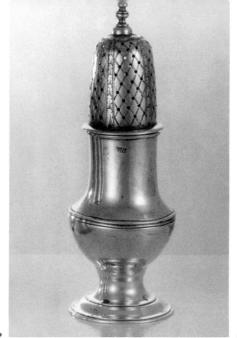
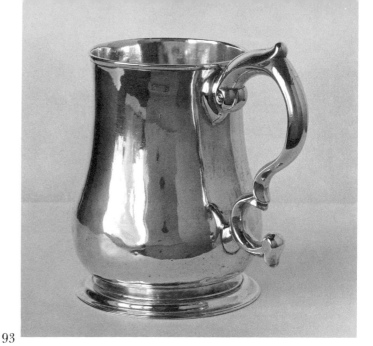

92 93

PLATE 92 Caster, probably c. 1778 – c. 1791

JONATHAN OTIS, working in Middletown 1778–1791.

Vasiform body on low, splayed foot; removable top perforated and engraved with diaper pattern and vertical bands of leafwork; turned, baluster-type finial.

Inscription: M ∴ O (block capitals) on foot.

Mark: Otis (italics within rectangle) on body below lip.

Height: 5⅝ inches.

This caster formed a portion of Mary Otis Bull's wedding silver.

Yale University Art Gallery, the Mabel Brady Garvan Collection.

PLATE 93 Cann

JONATHAN OTIS, working in Middletown 1778–1791.

Pyriform body set on low, splayed, molded foot; molded rim; cast, S–C scroll handle with shaped terminus.

Mark: OTIS (script capitals within rectangle) below rim to left of handle.

Height: 4⅝ inches.

The Metropolitan Museum of Art, bequest of A. T. Clearwater, 1933.

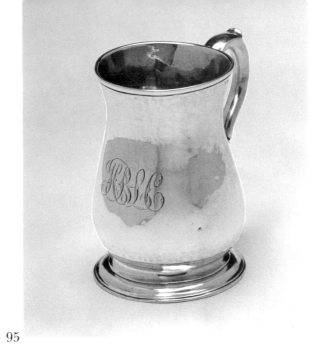

94 95

Pepperbox, c. 1785 – c. 1799

PLATE 94

WILBERT TERRY, possibly working in Enfield from 1785 to before 1799.

Cylindrical body with molded base and rim; removable, pierced, shallow-domed cover; S-scroll handle with full scrolls at body junctures.

Inscription: J∴ M∴ E (shaded block capitals) on front of body.

Mark: W TERRY (capitals within rectangle) on bottom.

Height: 3 inches.

Collection of Philip Hammerslough.

Cann, c. 1785

PLATE 95

MOSES WING, working in Windsor Locks from probably c. 1781 until 1805.

Pyriform body set on splayed, molded foot; molded rim; S-C scroll handle.

Inscription: HBLC (script) on front of body.

Mark: WING (capitals) on rim to left of handle.

Height: 3¾ inches.

The inscribed initials are unidentified. The maiden names of both the silver-smith's wives have the initials HB, however.

Collection of Philip Hammerslough.

96

PLATE 96 Pair of Shoe Buckles, c. 1774 – c. 1798

WILLIAM CLARK, working in New Milford c. 1774 – c. 1798.

Rectangular frames curved to fit foot, exhibiting foliate and geometric engraving; brass backs with steel tongues and U-shaped prongs.

Mark: w. CLARK (capitals within rectangle) on backs of frames.

Length: 2⅞ inches.

Collection of Philip Hammerslough.

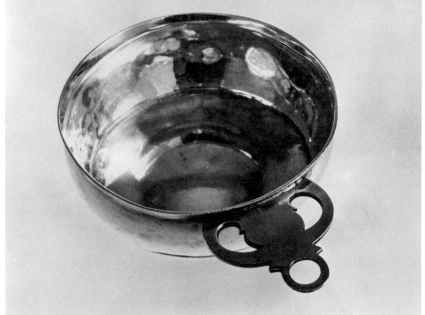

97

Porringer, c. 1787 – c. 1802

PLATE 97

Marcus Merriman, working alone in New Haven 1787–1802; later with partners to at least 1826.

Simple circular bowl with everted rim; small, flat handle pierced with a single circular and a pair of curvilinear apertures.

Mark: M · M (capitals within ribbon) on underside of handle.

Diameter: 4⅜ inches.

The handle of this porringer is typical of the mid-18th-century New York style, which would lead one to think that the piece could be by Myer Myers. The mark does not match any known one of Myers', however, and is closer perhaps to those of Merriman, although here again there is no identical mark on another piece. If the porringer is by Merriman, he was obviously inspired by the earlier New York handle style.

Yale University Art Gallery, the Mabel Brady Garvan Collection.

120 EARLY CONNECTICUT SILVER, 1700–1840

Silver-mounted New Testament, c. 1789

PLATE 98

JOHN STANIFORD, working in Windham before 1789, and in partnership there with Alfred Elderkin as Elderkin & Staniford from 1790–1792.

Open side of book has four silver corners and clasp.

Inscription and Mark: J + s (capitals) on front of clasp, possibly the silversmith's initials, but perhaps also his wife's, since her name was Jerusha Stoughton. The J was originally engraved backward but its foot has been crossed out in the correction. The top of the first page of the Gospel according to Matthew bears the following inscription in ink:

John Staniford Price 13(?/?) 1789/ Wt of corners & Clasps 9/— Making/ Whole £1 ·· 11 ·· 4

Yale University Art Gallery, the Mabel Brady Garvan Collection.

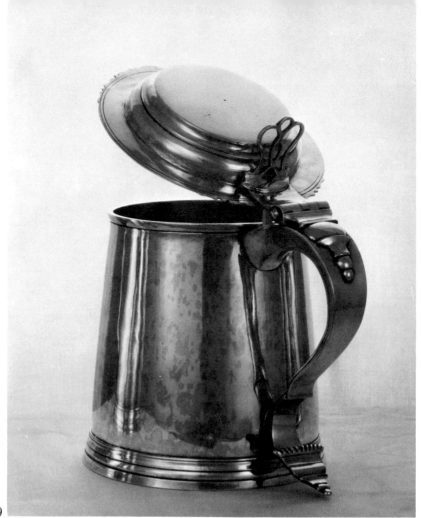

99

PLATE 99 Tankard, c. 1790

GURDON TRACY, working in Norwich in 1787; in New London in 1791.

Tapered body with molded base and molded, everted rim; flat-topped molded lid with shaped front and back edge; S-scroll handle with cast, applied drop and serrated, triangular, molded terminus; flat, openwork thumbpiece of interlaced pattern.

Inscription: THE GIFT OF Mʳ JOSEPH MARVIN TO/ JANE LORD, HIS GRAND DAUGHTER 1790. (block letters).

Mark: G · TRACY (capitals within serrated rectangle) four times on bottom.

Height: 6¾ inches.

Present owner unknown; in 1935, in the collection of Edwin N. Dodge.

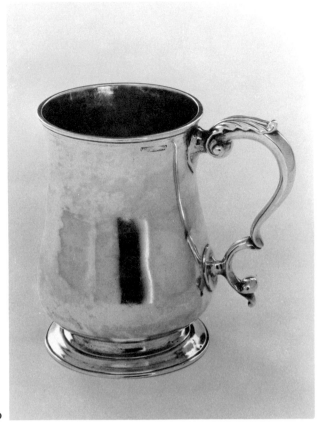

100

Cann, after 1791

PLATE 100

ANTIPAS WOODWARD, working in Middletown from 1791; in his later years he was in Bristol.

Pyriform body with molded rim on splayed, molded foot; S-C scroll handle with acanthus leaf crest and shaped terminus.

Mark: Woodward (capitals and lower case within rectangle) near rim to left of handle.

Height: 5¼ inches.

Collection of Philip Hammerslough.

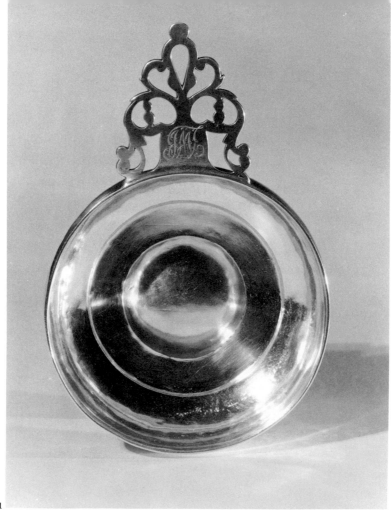

101

PLATE 101 Porringer, after 1791

ANTIPAS WOODWARD, working in Middletown from 1791; in his later years he was in Bristol.

Circular bowl with everted rim and center of bottom domed; keyhole-pattern, curvilinear, pierced, flat cast handle.

Inscription: IMT (script) on upper surface of handle.

Mark: WOODWARD (capitals within rectangle) on lower surface of handle.

Diameter: 5¾ inches.

A similar porringer by Woodward, inscribed MEB, is in the collection of The Heritage Foundation in Old Deerfield, Massachusetts.

Collection of Philip Hammerslough.

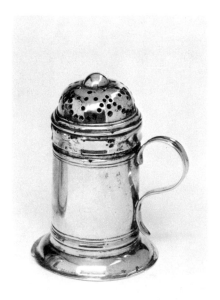

102

Pepperbox

PLATE 102

MILES BEACH, working in Litchfield before 1771 to 1785; in Hartford after 1785.

Cylindrical body with molded rim and base, set on wide, splayed foot; removable domed top perforated in pattern of circular holes, small hemispherical finial; S-scroll, flat strap handle.

Mark: M B (capitals within rectangle) twice on bottom.

Height: 3 inches.

Anonymous owner.

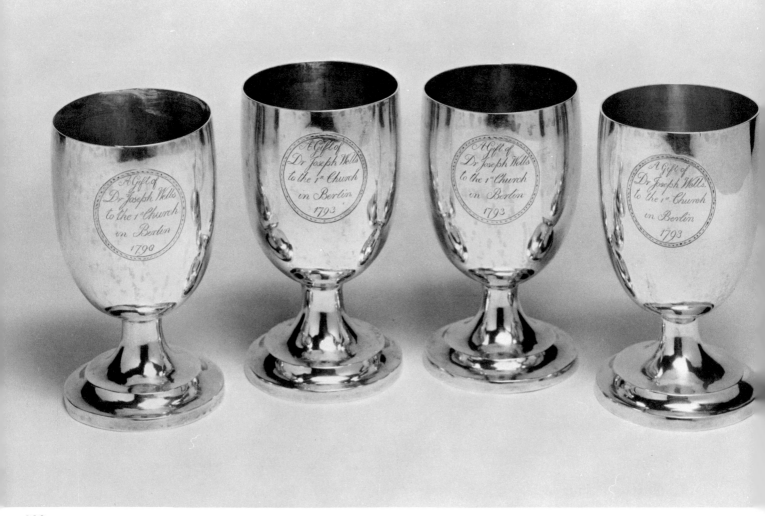

103

PLATE 103 Set of Four Chalices, probably after 1797

MILES BEACH, working in Litchfield before 1771 to 1785; in Hartford after 1785.

Oviform bodies set on splayed, molded pedestal feet.

Inscription: (all four) A Gift of/ Dr Joseph Wells/ to the 1st Church/ in Berlin/ 1793, (script) set within bright-cut circular medallion.

Mark: BEACH (capitals within serrated rectangle) on bottom of two. Remaining two identical but unmarked.

Height: 5 4/5 inches.

In his will, proved in December 1793, Dr. Wells gave £15 to be paid to the church within one year after his decease for a silver tankard for the communion table. It would appear that the executors and legatees agreed that four

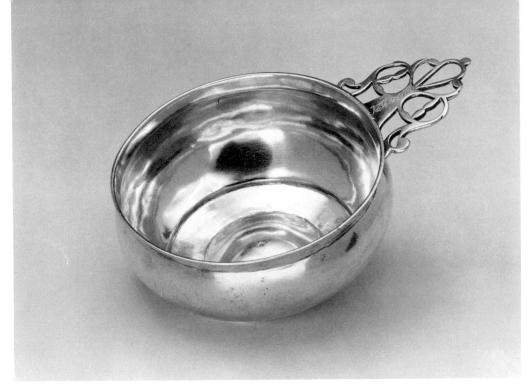

104

chalices were needed more than a single tankard, unless the tankard was originally purchased and subsequently melted down at some time before 1828 (when the silversmith died) to make the four chalices, retaining the wording of the original inscription. This latter possibility is strengthened by the fact that if the chalices had been made before 1797 they should have carried the mark B&W, since Miles Beach was in partnership with James Ward from 1790 until 1797. A similar uninscribed chalice marked WARD/HARTFORD, for James Ward, belongs to Trinity Church, Newtown.

The Kensington Congregational Church.

Porringer, c. 1769 – c. 1804

PLATE 104

JOSEPH CARPENTER, working in Norwich from 1769.

Circular bowl with everted rim; center of bottom domed; keyhole-pattern, curvilinear, pierced, flat cast handle.

Inscription: AEW to LSW (script) along center of upper surface of handle (possibly not contemporary engraving).

Mark: I · C (capitals within square) on underside of handle.

Diameter: 4½ inches.

Collection of Philip Hammerslough.

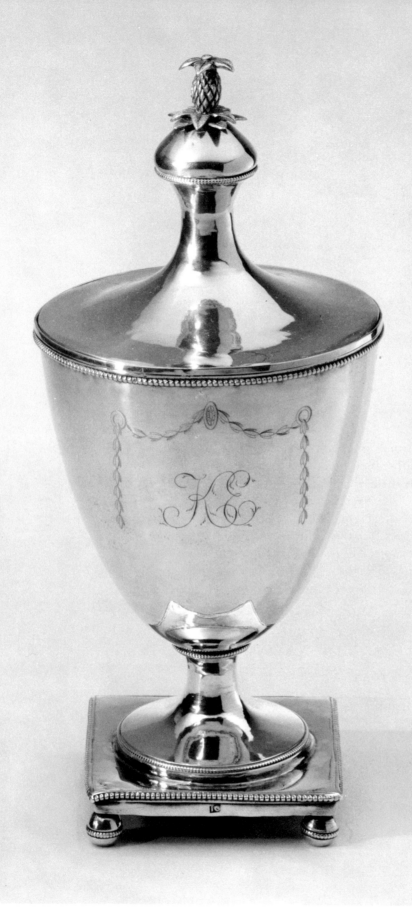

105

106

Covered Sugar Bowl, c. 1790

PLATE 105

JOSEPH CARPENTER and his son, Charles Carpenter, working together in Norwich in 1790.

Urn-shaped body with trumpet stem standing on square base with four ball feet; beaded moldings at principal edges and junctures; canopy lid rising to domed terminus with pineapple finial.

Inscription: KE (script) framed by engraved pendant husks on front of body.

Mark: IC (capitals within rectangle) four times on rim of foot and twice on bezel of lid; CC (capitals within rectangle) on bezel of lid.

Height: 9½ inches.

The inscription is for Katherine Ensworth of Norwich.

Collection of Philip Hammerslough.

Stock Buckle, c. 1775 – c. 1785

PLATE 106

Attributed to JOSEPH CARPENTER, working in Norwich from 1769.

Rounded rectangular frame with bright cutting; four prongs and curvilinear chape with four studs.

Inscription: M · ש · B (capitals) on reverse of frame.

Mark: I C (capitals within rectangle) on reverse of frame.

Length: 1 15/16 inches.

Yale University Art Gallery, the Mabel Brady Garvan Collection.

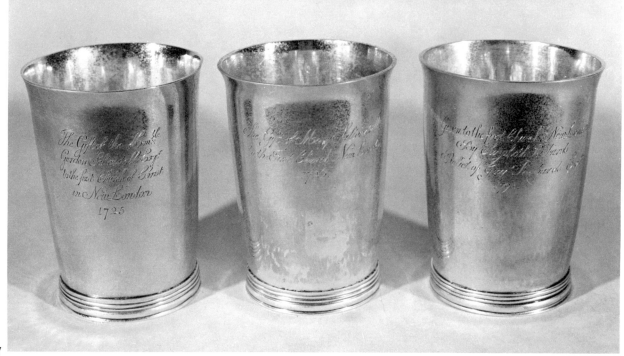

107

PLATE 107 Three Beakers, c. 1795

JOHN PROCTOR TROTT, working in New London alone and with various partners c. 1792 – c. 1820.

Straight, tapered bodies with everted lips and molded bases.

Inscriptions (all script): (left) The Gift of the Hon::ᵇˡᵉ/ Gurdon Saltonstall Esqʳ./ to the first Church of Christ/ in New London/ 1725 (center) The Gift of Mary Saltonstall/ to the First Church New London/ 1726. (right) Given to the first Church, New London/ By Elizabeth Richards/ Relict of Guy Richards Esqʳ/ 1793.

Mark: JPT (script capitals within oval) on bottom of each.

Height: 4¾ inches.

Elizabeth Harris (1727–1793) married Guy Richards (1722–1782) in January of 1746/7. She gave the beaker illustrated at the right, and left a legacy of $40 to the church, which voted in November of 1794 to convert "Tankards belonging to the church into cups, as more convenient for the service of the table." Among the tankards melted down was one given by Governor Gurdon Saltonstall through a bequest of £20 upon his death in 1724, and another through a gift of his third wife Mary, who died in 1729 in Boston. The beaker on the left is one of an identical pair, which, with that illustrated at center, were made c. 1795 by Trott, probably from the two earlier tankards.

Gurdon Saltonstall (1666–1724), Harvard College 1684, was appointed

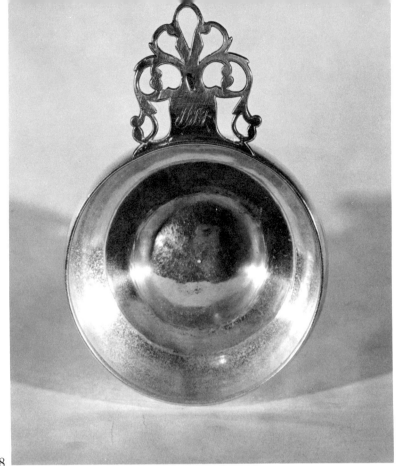

108

pastor of this church in 1688, but resigned on January 1, 1708, upon his election as governor of the Connecticut colony.

The First Church of Christ, New London.

Porringer, after 1792

PLATE 108

JOHN PROCTOR TROTT, working in New London alone and with various partners c. 1792 – c. 1820.

Circular bowl with domed base and convex sides; keyhole-pattern cast handle.

Inscription: L P E (script capitals) on upper surface of handle.

Mark: JPT (script capitals within oval) on upper surface of handle.

Diameter: 5⅛ inches.

The Lyman Allyn Museum, New London.

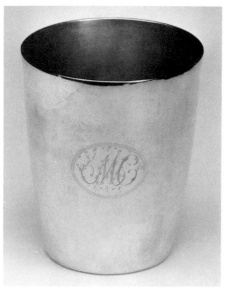 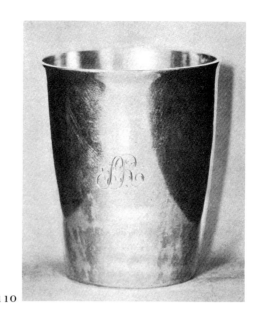

109 110

PLATE 109 **Beaker, after 1792**

JOHN PROCTOR TROTT, working in New London alone and with various partners c. 1792 – c. 1820.

Round, tapered body, slightly everted lip, flat bottom.

Inscription: M C (script) within oval medallion on side of body.

Mark: JPT (capitals within rectangle) on bottom.

Height: 3½ inches.

Collection of Philip Hammerslough.

PLATE 110 **Beaker, after 1792**

JOHN PROCTOR TROTT, working in New London alone and with various partners c. 1792 – c. 1820.

Round, tapered body with slightly flaring lip and flat bottom.

Inscription: SR (script) on side of body.

Mark: J.P.T. (capitals within rectangle) on bottom.

Height: 3 11/16 inches.

Present owner unknown; formerly (1913) in the possession of Mrs. Carl J. Viets, New London. Photograph from George Munson Curtis, Early Silver of Connecticut and Its Makers, 1913.

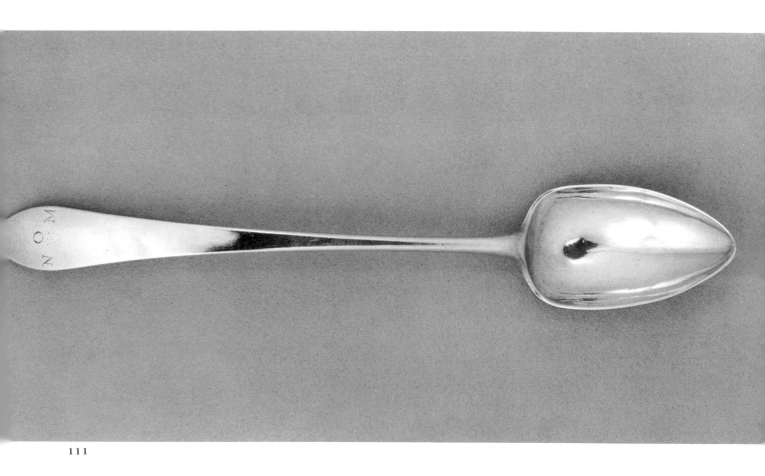

Serving Spoon, after 1792

PLATE 111

JOHN PROCTOR TROTT, working in New London alone and with various partners c. 1792 – c. 1820.

Oval bowl, narrow handle stem flattening to pointed, downturned end.

Inscription: N ⋅ :⋅ M (capitals) on handle obverse at end.

Mark: JPT (capitals within rectangle) on stem reverse.

Length: 13 inches.

The inscription is for Nathaniel and Mary Otis of Montville.

Collection of Philip Hammerslough.

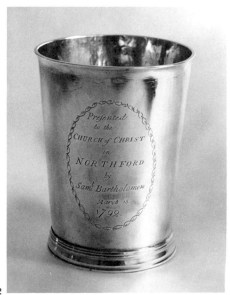

112

PLATE 112 Beaker, c. 1792

EBENEZER CHITTENDEN, working in Madison (formerly East Guilford) before
c. 1770; in New Haven c. 1770–1812.

Tapered body with molded base and everted lip.

Inscription: **Presented**/ to the/ CHURCH of CHRIST/ in/ NORTHFORD/ by/ Saml
Bartholomew/ March 15./ 1792. (script and capitals) set within an
engraved, oval foliate border.

Mark: E C (capitals within oval) on bottom and on body near lip.

Height: 4 3/16 inches.

The donor was born in 1706 and died in 1795.

Yale University Art Gallery, the Mabel Brady Garvan Collection.

PLATE 113 Three Beakers, c. 1767 and c. 1795

EBENEZER CHITTENDEN, working in Madison (formerly East Guilford) before
c. 1770; in New Haven c. 1770–1812.

Straight, tapered bodies, molded bases; left and right have molded rims,
center has everted lip.

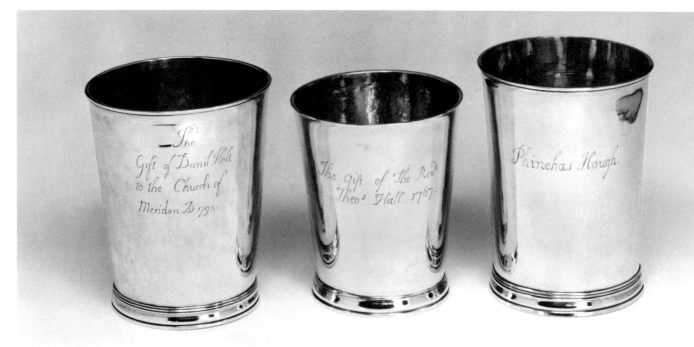

113

Inscriptions (all script): (left) The/ Gift of Danil Holt/ to the Church of/ Meriden AD 1795. (center) The Gift of The Rev^d/ Theo^s Hall 1767. (right) Phinehas Hough.

Mark: E C (capitals within oval) on bottom of each.

Height: left 4⅜ inches; center 3⅞ inches; right 4½ inches.

Daniel Holt (1730–1807) was a captain of militia and a man of some prominence in the community. The Rev. Theophilus Hall, Yale College 1727, was ordained pastor of this church in 1729, which office be held until his death in 1767. He provided for the gift of this cup in his will. Phinehas Hough (1714–1797) willed $11 for a silver cup with his name inscribed upon it to be given to the church. An uninscribed beaker, similar to that on the left, marked s · B, presumably Samuel Buel of Middletown c. 1777 and Hartford c. 1780, is also in the church's collection. A pair of beakers by Chittenden, similar to that at left, are owned by Trinity Church-on-the-Green, New Haven. They are uninscribed; only one bears the maker's mark, E C (capitals within oval), twice on the bottom.

The Center Congregational Church, Meriden.

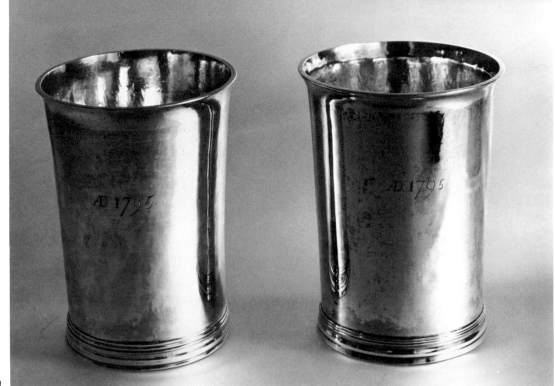

114

EBENEZER CHITTENDEN, working in Madison (formerly East Guilford) before c. 1770; in New Haven c. 1770–1812.

Tall, slightly tapered bodies with molded bases and everted lips.

Inscription: ᴀᴅ 1795 (block letters) on each.

Mark: E C (capitals within oval) twice on bottom of each.

Height: 4¾ inches.

The Congregational Church, East Haven.

EBENEZER CHITTENDEN, working in Madison (formerly East Guilford) before c. 1770; in New Haven c. 1770–1812.

Slightly tapered body with molded base and everted lip.

Inscription: Given by Mʳ Ebenezer Robertson/ To/ the Church In Durham./ 1796 (script).

Mark: E C (capitals within oval) on bottom.

Height: 4¾ inches.

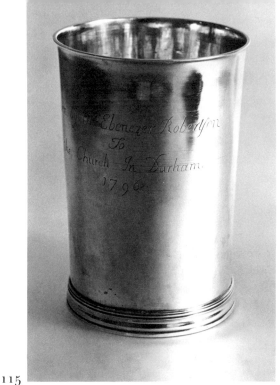

115

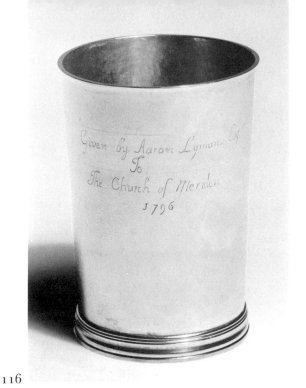

116

The donor's surname was actually Robinson, which is misspelled in the engraving. He was born in Guilford in 1701. His will of 1780 bequeathed a sum of money sufficient "to procure a silver cup for the use of the Lord's Table,..."

Yale University Art Gallery, the Mabel Brady Garvan Collection.

Beaker, c. 1796

PLATE 116

EBENEZER CHITTENDEN, working in Madison (formerly East Guilford) before c. 1770; in New Haven c. 1770–1812.

Cylindrical body with everted rim and molded base.

Inscription: Given by Aaron Lyman Esqr/ To/ The Church of Meriden/ 1796 (script).

Mark: E C (capitals within rectangle) on bottom.

Height: 4¾ inches.

The piece has £3.17.9 scratched on the bottom, presumably its original cost. Aaron Lyman, born 1707 in Northampton, Massachusetts, was a prominent man in Meriden and held several public offices. He died in 1801.

Collection of Philip Hammerslough.

PLATE 117 Set of Two-handled Cups

Four made c. 1797 by ABEL BUEL, learned his trade from Ebenezer Chittenden in Madison (formerly East Guilford); working in 1762 in Killingworth; in New Haven 1770–1774, 1777–1789, 1796–1799; also in Pensacola, Florida 1774–1776; Hartford c. 1799 – c. 1803; Stockbridge, Mass. c. 1810.

The matching fifth (at upper left) made c. 1817–1826 by Merriman & Bradley (Marcus Merriman and Zebul Bradley), working in New Haven 1817–1826, joined after 1823 by Charles O'Neil.

Inverted bell-shaped bodies on splayed, trumpet feet; pairs of cast, S-scroll handles with bifurcated termini.

Inscription: PLATE/ of the Congregational Church/ of NORTH-HAVEN/ 1797 (shaded capitals and script) on each. Note misspellings of "Congregational."

Mark: BUEL (capitals within serrated rectangle) on base of one and on both handles of four; M & B (capitals within serrated rectangle) on one handle of fifth.

Height: 4¾ inches.

Upper left (Merriman & Bradley) and pair in middle row at lower right (Buel): Collection of Philip Hammerslough. Upper right (Buel): Yale University Art Gallery. Lower left (Buel): Collection of Robert Graham.

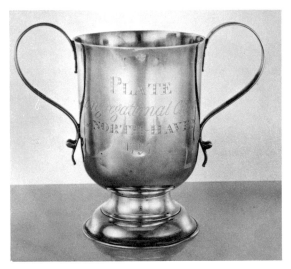
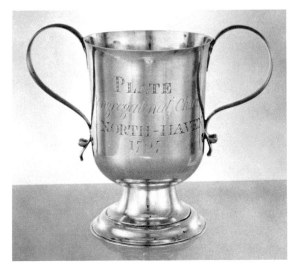
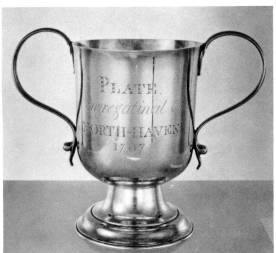
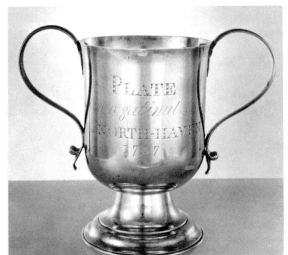

117

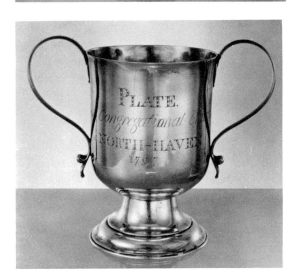

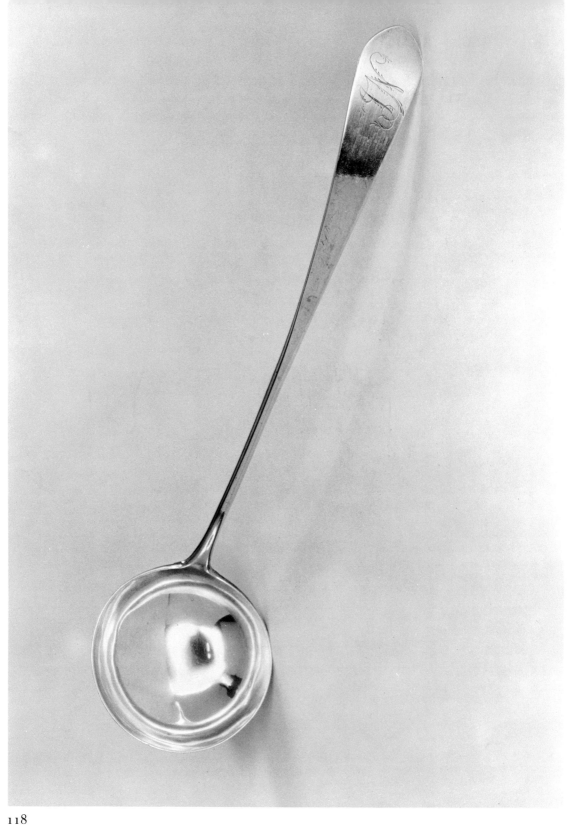

118

119

Ladle, c. 1796 – c. 1800

PLATE 118

JACOB SARGEANT, working in Mansfield in 1784; in Springfield, Mass. 1790–1795; in Hartford from 1795 to c. 1838.

Spherical bowl, slender handle with rounded, down-turned end.

Inscription: I N (script capitals) on handle obverse.

Mark: J SARGEANT and HARTFORD (capitals within rectangles) on handle reverse.

Length: 14½ inches.

Collection of Philip Hammerslough.

Nutmeg Grater, c. 1794 – c. 1805

PLATE 119

SAMUEL MERRIMAN, working in New Haven 1794 to after 1803.

Ovoid body in three sections; steel grater in base.

Mark: SM (capitals within rectangle) on inside of cover.

Diameter: 1 1/16 inches.

The New Haven Colony Historical Society.

120

PLATE 120 Marrow Spoon, c. 1800

CHARLES BREWER, in business in Middletown with Judah Hart 1800–1803; with Alexander Mann 1803–1805; firm of C. Brewer & Co. c. 1810.

Elongated scoop bowl with down-curved handle, rounded end.

Inscription: M A (shaded script) on handle obverse, and a later inscription, 1760, on handle reverse.

Mark: CBrewer (script in shaped reserve) on stem reverse.

Length: 6¾ inches.

The inscribed date of 1760 obviously predates Brewer and at present is inexplainable.

See also his set of beakers made for the Durham church c. 1821 (Plate 172).

Yale University Art Gallery, the Mabel Brady Garvan Collection.

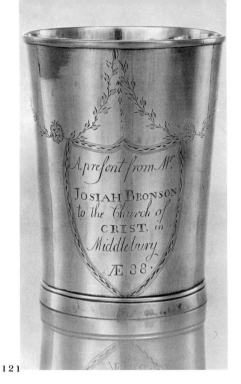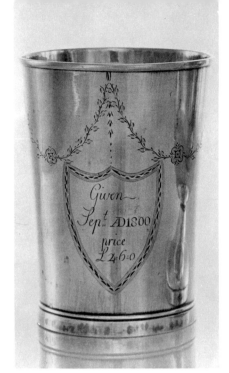

121

Beaker, c. 1800

PLATE 121

Samuel Shethar, working in Litchfield c. 1782–1805, from 1796 to 1805 with Isaac Thom(p)son as Shethar & Thom(p)son; in New Haven 1806–1808 with Richard Gorham as Shethar & Gorham.

Tapered cylindrical body with seam; molded base and rim.

Inscription: A present from Mr./ JOSIAH BRONSON/ to the Church of/ CRIST, in/ Middlebury/ Æ 88 · (script and block capitals) in bright-engraved shield with garlands on one side; and, Given/ Sept/ Æ 1800/ price/ £4 = 6 = o (4 superimposed by 2) (script and block capitals) on opposite side.

Mark: S · · Shethar (large script) scratched on bottom.

Height: 4 5/16 inches.

Josiah Bronson (1713–1804) was the younger brother of Isaac Bronson (1707–1799) who gave the other, unmarked, cup to the church (see next plate).

The scratched signature instead of a punch mark is a rare practice among early American silversmiths.

The Congregational Church, Middlebury.

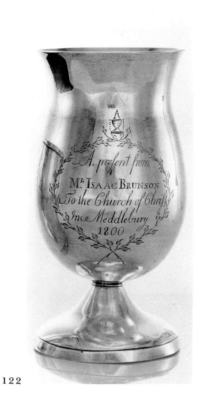

122

PLATE 122 Cup, c. 1800

SAMUEL SHETHAR, working in Litchfield c. 1782–1805, from 1796 to 1805 with Isaac Thom(p)son as Shethar & Thom(p)son; in New Haven 1806–1808, with Richard Gorham as Shethar & Gorham.

Long, inverted bell-shaped body on broad trumpet foot.

Inscription: A, present from/ Mʳ. ISAAC BRUNSON/ To the Church of Christ/ In Mèddlebury/ 1800 (script and block) within crossed-foliate medallion surmounted by urn.

Height: 5¾ inches.

Although this cup is not marked, it is ascribed to Shethar on the basis of the beaker by him, also given to the Middlebury church in 1800 (see previous plate). The donors of these two pieces were the brothers Bronson; their name was misspelled here. Although these pieces are mentioned in early books on the subject (E. Alfred Jones, *The Old Silver of American Churches,* 1913; George Munson Curtis, *Early Silver of Connecticut and Its Makers,* 1913), the identification of Shethar as the silversmith from his name scratched on the

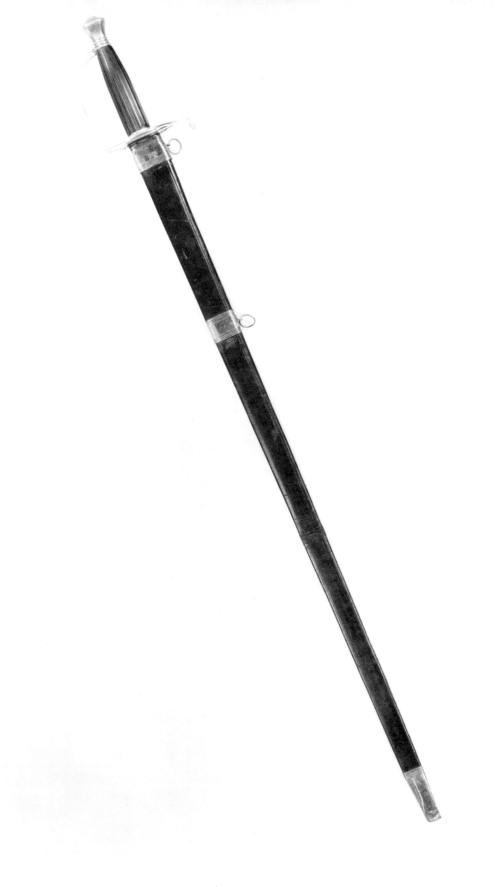

123

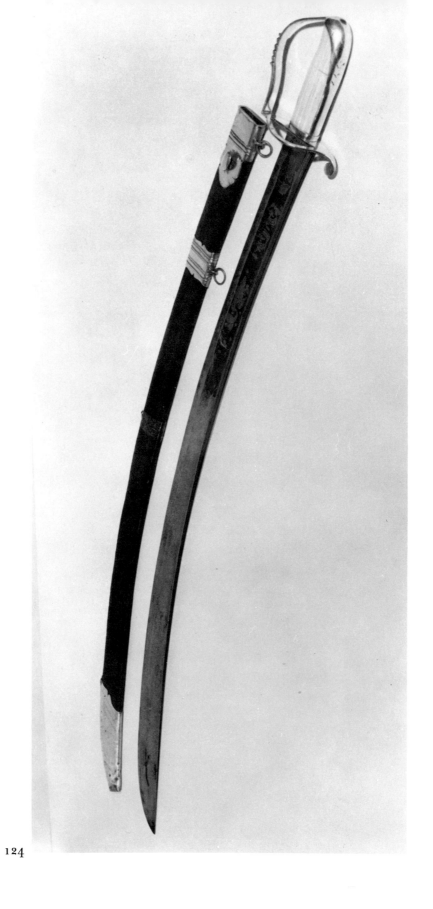

124

146 EARLY CONNECTICUT SILVER, 1700–1840

beaker was made only recently in connection with the 1967 exhibition of New Haven Silver at the New Haven Colony Historical Society.

The Congregational Church, Middlebury.

Sword

PLATE 123

JUDAH HART, working with Charles Brewer as his partner in Middletown from 1800 and with Jonathan Bliss from 1803; in Norwich 1805–1807 in partnership with Alvan Wilcox; working in Norwich alone in 1807 and with his brother Eliphaz as Hart & Hart c. 1810–1816; subsequently in business in other states.

Pillow pommel, longitudinally ribbed ebony grip, simple knuckle bow and counterguard; plain blade; scabbard has three embossed mounts, two carrying rings.

Mark: J HART (capitals within rectangle) on underside of counterguard.

Length: 36¾ inches overall; blade 31¼ inches.

Collection of Philip Hammerslough.

Mounted Officer's Sword, c. 1807 – c. 1810

PLATE 124

JUDAH HART, working with Charles Brewer as his partner in Middletown from 1800 and with Jonathan Bliss from 1803; in Norwich 1805–1807 in partnership with Alvan Wilcox; working in Norwich alone in 1807 and with his brother Eliphaz as Hart & Hart c. 1810–1816; subsequently in business in other states.
Silver cap pommel and back strap partially enclosing longitudinally ribbed ivory grip; curvilinear knuckle bow with beading; curved blade etched, blued and gilded for one-third of its length.

Mark: J HART NORWICH CONNECTICUT (capitals within ribbon) on blade.

Length: 37½ inches overall; blade 32⅜ inches.

Collection of Philip Hammerslough.

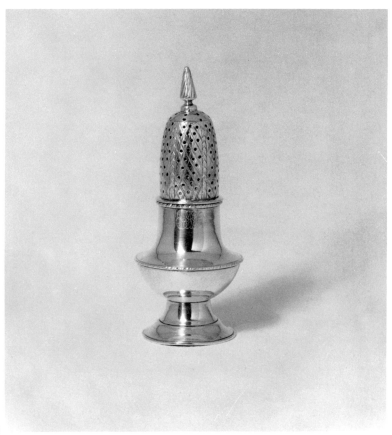

125

PLATE 125 Caster, 1800–1803

HART & BREWER (Judah Hart and Charles Brewer in partnership), working in Middletown 1800–1803.

Vasiform body on trumpet foot; high domed cover with conical finial, spirally grooved; cover engraved with panels of diaper pattern and leafwork and pierced with circular holes; gadrooned edges to rim and midsection of body.

Inscription: ESS (script) on neck.

Mark: H & B (capitals within square) on bottom.

Height: 5⅜ inches.

Inscription is possibly for the Stowe family of Middlefield.

Collection of Philip Hammerslough.

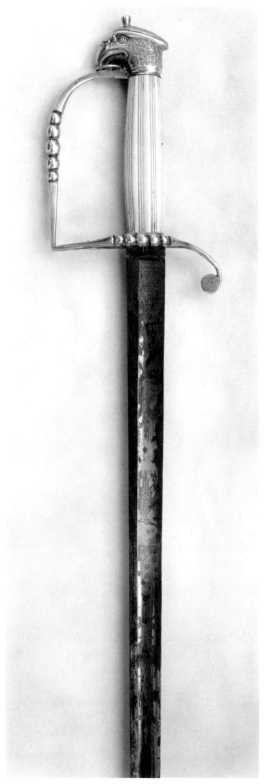

126

127

Mounted Officer's Saber, 1805–1807

HART & WILCOX (Judah Hart and Alvan Wilcox in partnership), working in Norwich 1805–1807.

Eagle's-head pommel; knuckle bow and counterguard with beaded ornament; longitudinally ribbed ivory grip; straight blade etched and blued.

Mark: HART & WILCOX and NORWICH (each capitals within rectangle); former mark with hand in shaped reserve below. All on underside of counter-guard.

Length: 35¾ inches; handle about 5 inches.

The Metropolitan Museum of Art, bequest of A. T. Clearwater, 1933.

Pair of Chalices (from set of six), c. 1804

PLATE 127

MILES GORHAM, working in New Haven 1790–1840.

Oviform body on simple trumpet foot; edge of foot ornamented with beaded molding.

Inscription: Derby Church/ 1804 (shaded block letters) on each.

Mark: M G (capitals within serrated rectangle) stamped on each in vertical position near rim on side opposite inscription.

Height: 5⅝ inches.

It would seem that the six chalices were obtained through the disposal of earlier church silver, since a church record of July 22, 1804, indicates that it was voted "To sell one Flagon & the cups formerly used by the Chh . . . a committee to dispose of them to the best advantage for the Chh— ."

The First Congregational Church, Derby.

Ladle, c. 1805

PLATE 128

MILES GORHAM, working in New Haven 1790–1840.

Hemispherical bowl attached to handle of rectangular cross section through molded double drop; handle of elongated fiddleback design with coffin-end.

Inscription: L B (floriated script) on handle obverse, toward end.

Mark: M ♦ GORHAM (capitals within serrated rectangle) on stem reverse.

Length: 12¼ inches.

Yale University Art Gallery, the Mabel Brady Garvan Collection.

Sugar Tongs

PLATE 129

Left, made c. 1800 by MILES GORHAM, working in New Haven 1790–1840. Right, made 1787–1802 by MARCUS MERRIMAN, working alone in New Haven 1787–1802; later with partners to at least 1826.

The Gorham tongs are bow-shaped with bright-cut decorated tapering stems, oval grips. The Merriman tongs are bow-shaped with solid arms, bright-engraved, and oviform grips.

128

129

Inscriptions: Gorham tongs have s H (script) in bright-cut circle on outside of bow, plus added dates and record of ownership in shields on outside of arms. Merriman tongs have EH (script) in bright-engraved oval on outside of bow.

Marks: M · GORHAM (capitals within serrated rectangle) on inside of each arm; MM (capitals within serrated rectangle) on inside of each arm.

Lengths: Gorham tongs, 6 inches; Merriman tongs, 6⅝ inches.

The inscription on the Gorham tongs is for Susanna Hotchkiss, who married Justus Hotchkiss in 1800; that on the Merriman tongs is unidentified; however, Merriman's son Marcus, Jr., married as his second wife the daughter of

Gorham tongs from the collection of Mr. and Mrs. Henry H. Townshend, Jr.; Merriman tongs from the collection of Philip Hammerslough.

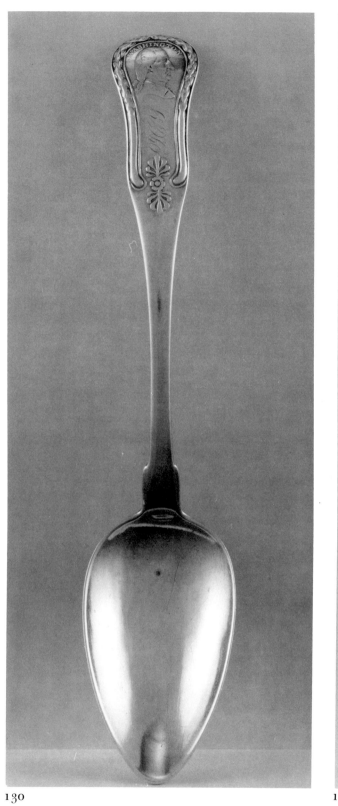

130

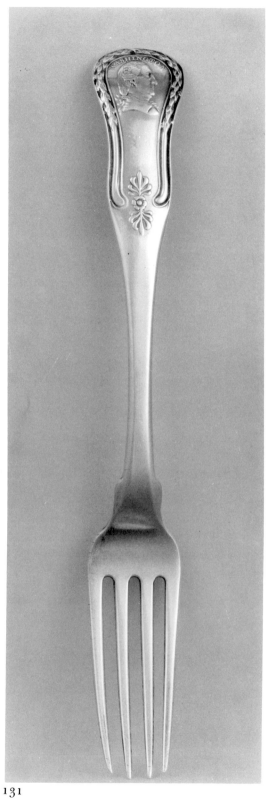

131

Tablespoon, c. 1805–1807

PLATE 130

THOMAS HARLAND, working in Norwich 1773–1807.

Oviform bowl and fiddleback handle in modified King's pattern, with Washington bust in right profile surmounted by name WASHINGTON (capitals).

Inscription: D C Y (script) on handle obverse below Washington profile.

Mark: HARLAND (capitals within rectangle) on stem reverse.

Length: 8⅞ inches.

The Henry Francis du Pont Winterthur Museum.

Fork, c. 1805–1807

PLATE 131

THOMAS HARLAND, working in Norwich 1773–1807.

Four tines; fiddleback handle of modified King's pattern, with Washington bust in right profile surmounted by name WASHINGTON (capitals).

Mark: HARLAND (capitals within rectangle) on stem reverse.

Length: 8⅜ inches.

The Henry Francis du Pont Winterthur Museum.

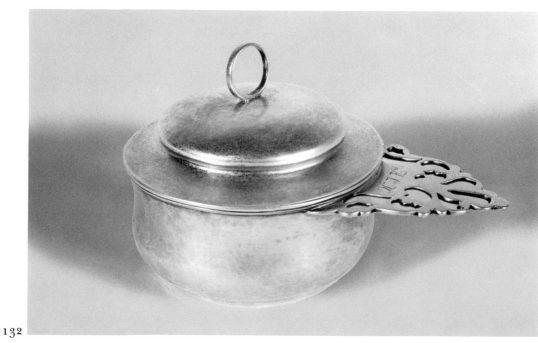

132

PLATE 132 Covered Porringer, 1773–1807

THOMAS HARLAND, working in Norwich 1773–1807.

Deep circular bowl with everted lip and slightly domed bottom; flat, cast handle in keyhole pattern. Domed lid in two stages with ring handle.

Inscription: A L H (script) on upper surface of handle.

Mark: HARLAND (capitals within rectangle) between eagle and profile head on base.

Diameter: 4¾ inches.

The inscribed initials are for Anna Leffingwell Hyde of Norwich.

Collection of Mr. & Mrs. Philip Johnson.

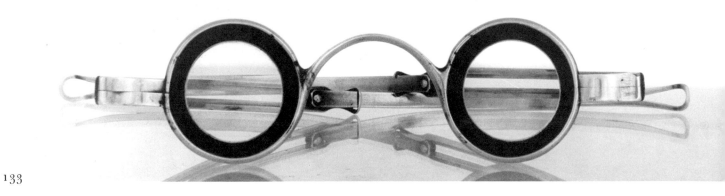

Spectacles, c. 1804

PLATE 133

EDMUND HUGHES, working in Hampton 1804; in Middletown with John Ward 1805–1806, with Jonathan Bliss also 1806, and with Julius C. Francis 1806–1809.

Circular lens holders filled with clear glass lenses set within tortoise-shell frames; earpieces adjustable in length by means of sliding bar and pin device. Stamped 14 on outside of left earpiece.

Mark: E. HUGHES (capitals) on inside of right earpiece near hinge.

Length: 5 5/16 inches between hinges.

These spectacles belonged to General Epaphroditus Champion (1757–1835) of East Haddam, great-great-grandfather of the donor.

Yale University Art Gallery, gift of Francis B. Trowbridge.

PLATE 134 Tea Set, c. 1800

JAMES WARD, probably working alone in Hartford in 1800; before and after with partners.

Three-piece set consisting of teapot, covered sugar bowl, and cream jug. Teapot has bulbous body of rectangular plan set on four ball feet; double-tiered top with hinged lid carrying cast dolphin ornament; reverse-curved spout, handle of squared bracket shape, both rectangular in cross section, the handle fitted with ebony insulators. United States coin of the period 1815–1830 soldered to top of spout, an unusual feature. Body decorated with Greek fret band around neck, with gadrooned molding at edge of mouth for lid, and with molded band of stars within circles around base. Cream jug has single, and the sugar bowl two, solid, scroll handles; in other respects they match the teapot.

Inscription: I T (script) on two sides of each piece.

Mark: J. WARD (capitals within rectangle) on bottom of each.

Height: teapot, 7 inches; sugar bowl, 5¾ inches; cream jug, 6 inches.

This is the only three-piece tea set from Hartford known to the authors. The coin is probably a later addition to the spout of the teapot, since the style of the set is indicative of a date before, rather than after, 1815. Ward could have made pieces bearing his name alone while he was in partnership, but it seems unlikely.

An uninscribed oviform chalice, 5⅛ inches in height, marked WARD/ HARTFORD, probably made c. 1800, belongs to Trinity Church in Newtown.

Collection of Philip Hammerslough.

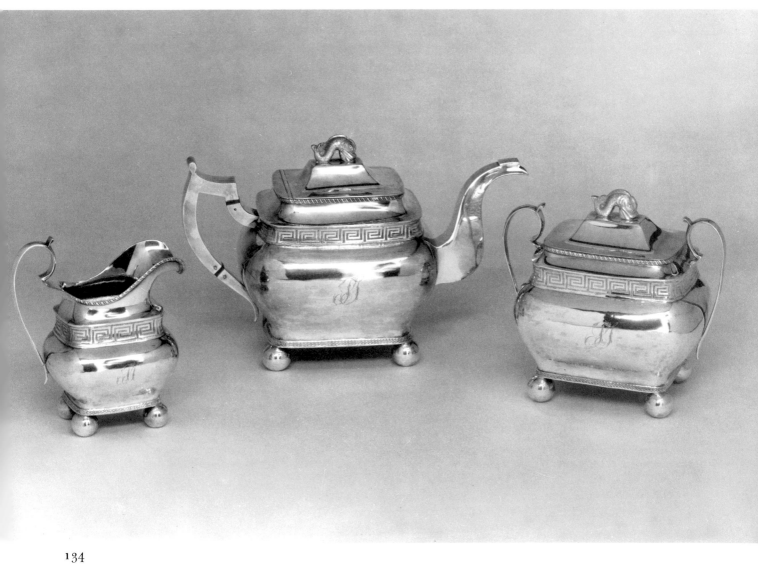

134

135

PLATE 135 Baptismal Basin, c. 1802

WARD, BARTHOLOMEW & T——— (James Ward, Roswell Bartholomew, and an unidentified partner), working in Hartford c. 1802.

Simple, flat-bottomed bowl with wide-flanged rim molded at edge.

Inscription: The gift of Ezekiel Williams Esquire to the first Church in Wethersfield Anno Domini 1802 (script) on upper surface of rim.

Mark: W. B. & T (capitals within rectangle) on bottom.

Diameter: 10 inches at outside of rim.

The First Church of Christ, Wethersfield.

136

137

162 EARLY CONNECTICUT SILVER, 1700–1840

Communion Plate, c. 1806

PLATE 136

WARD & BARTHOLOMEW (James Ward and Roswell Bartholomew), working in Hartford 1804–1809.

Circular plate with shallow bowl; rim has beaded edge.

Inscription: E W (foliate script capitals), 1806 below, encircled by the words Gift of Ezekiel Williams, Esq^r. to the First Church in Wethersfield — (script), at the center of the upper surface of the bowl.

Mark: W & B (incised capitals) on bottom.

Diameter: 13¼ inches at outside of rim.

The First Church of Christ, Wethersfield.

Communion Plate, c. 1806

PLATE 137

One unmarked, the other by WARD & BARTHOLOMEW (James Ward and Roswell Bartholomew), working in Hartford 1804–1809.

Circular plates with shallow bowls; rims have beaded edges.

Inscription: Purchased by the First Church in Wethersfield for their use. ——— (script) encircling the date 1806 at the center of the upper surface of each plate.

Mark: One has Ward & Bartholomew Hartford (capitals and lower case, within separate rectangles); the other is unmarked.

The plates are identical except for the absence of a maker's mark on one of them.

The First Church of Christ, Wethersfield.

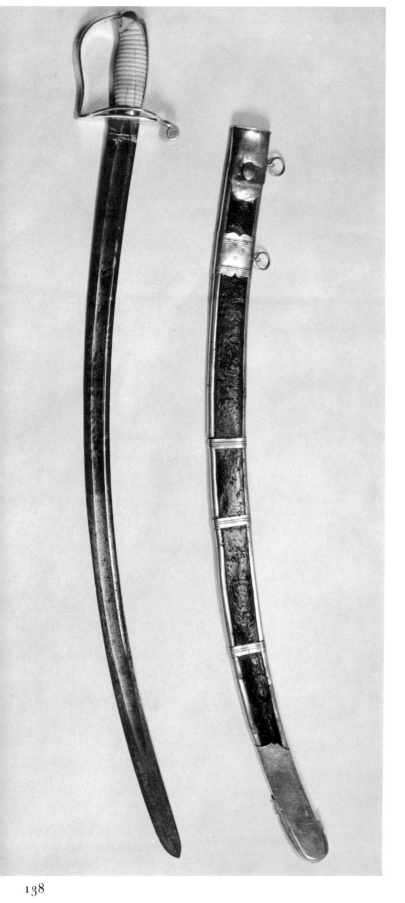
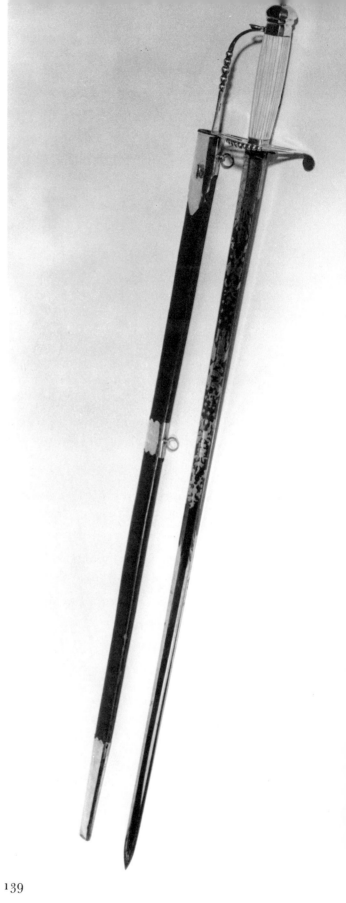

138

139

Mounted Officer's Saber, 1804–1809

PLATE 138

WARD & BARTHOLOMEW (James Ward and Roswell Bartholomew), working in Hartford 1804–1809.

Simple silver cap pommel and backstrap, conventional knuckle bow, counterguard, and quillon; ribbed ivory grip; curved blade with fuller, upper 17 inches etched with floral designs. Scabbard with following silver fittings: throat and middle band with carrying rings, drag-type tip, and three supplementary reinforcing straps.

Mark: W & B (incised capitals) on inside of knuckle bow.

Length: 40½ inches overall.

Collection of Hermann Warner Williams, Jr.

Mounted Officer's Saber, 1804–1809

PLATE 139

WARD & BARTHOLOMEW (James Ward and Roswell Bartholomew) working in Hartford 1804–1809.

Octagonal pillow pommel with finial; rounded rectangular knuckle bow, with graduated beading on it and on counterguard; longitudinally ribbed ivory grip; straight blade etched, blued and gilded for half its length; scabbard has three silver mounts and two carrying rings.

Mark: W & B (incised capitals) on inside of knuckle bow, and W & B HARTFORD (capitals) engraved on blade.

Length: 38 inches overall; blade 32⅛ inches.

Made for Captain Julius Demming of Litchfield.

Collection of Philip Hammerslough.

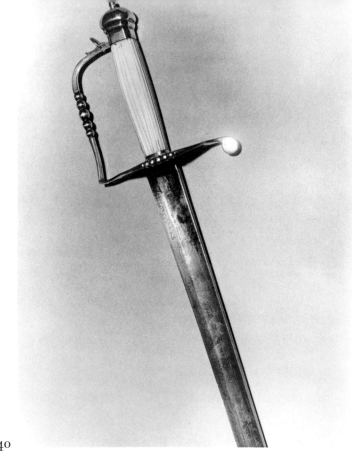

140

PLATE 140 Mounted Officer's Saber, 1804–1809

WARD & BARTHOLOMEW (James Ward and Roswell Bartholomew) working in
 Hartford 1804–1809.

Octagonal pillow pommel with finial; rounded rectangular knuckle bow
with graduated beading on it and on counterguard; longitudinally ribbed
ivory grip; straight blade etched for half its length.

Mark: W & B (incised capitals) on reverse of knuckle bow.

Length: 38½ inches overall; blade 32½ inches.

Two additional pommel-hilted swords of similar design by Ward & Bartholo-
mew are in the owner's collection.

Collection of Dr. John K. Lattimer.

141

Baptismal Basin, 1804–1809 PLATE 141

WARD & BARTHOLOMEW (James Ward and Roswell Bartholomew), working in Hartford 1804–1809.

Deep hemispherical bowl with broad, everted rim; low, splayed, molded foot.

Inscription: H E (script) on side of body.

Mark: W & B and HARTFORD (incised capitals) on bottom.

Diameter: 6¾ inches.

Formerly used as the baptismal basin in the Congregational Church, Westchester Society, Colchester.

The Connecticut Historical Society.

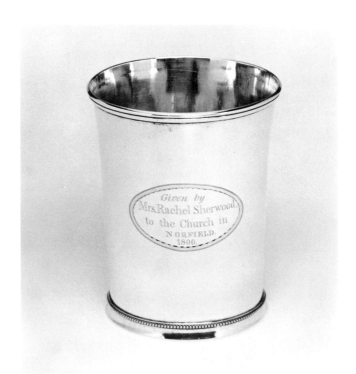

142

PLATE 142 Beaker, c. 1806

WARD & BARTHOLOMEW (James Ward and Roswell Bartholomew), working in Hartford 1804–1809.

Slightly tapered body with molded rim and beaded base molding.

Inscription: Given by/ Mrs. Rachel Sherwood,/ to the Church in/ NOR-FIELD./ 1806. (italics, capitals, and lower case), set within engraved oval medallion on side of body.

Mark: WARD & BARTHOLOMEW and HARTFORD (incised capitals) on bottom.

Height: 4⅝ inches.

Rachel Hyde (1736–1811) was the daughter of a deacon. She married the Rev. Samuel Sherwood in 1754; he was minister of this church at Norfield (now called Weston) from 1757 until his death in 1783.
Two uninscribed beakers, 3¾ inches high, marked W & B (incised) for Ward & Bartholomew 1804–1809, belong to the North Guilford Congregational Church.

The Congregational Church, Weston.

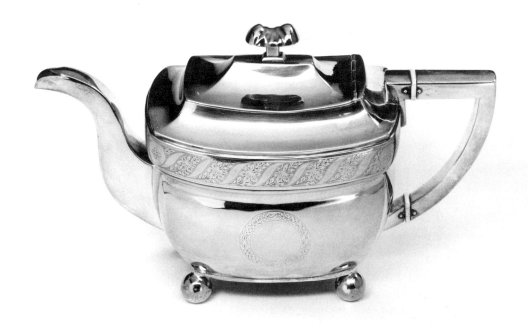

143

Teapot, 1804–1809 PLATE 143

WARD & BARTHOLOMEW (James Ward and Roswell Bartholomew), working in Hartford 1804–1809.

Boat-shaped body of rectangular plan set on four ball feet; double-tiered top with hinged lid carrying cast knop finial; reverse-curved spout, handle with curved grip and horizontal shoulder, all of rectangular cross section; handle fitted with ivory insulators. Body decorated with bright-cut circular, foliate medallion and at shoulder with frieze of strigilated foliate ornament; additional lines of punched meander-work on body and lid.

Mark: W & B (incised capitals) on bottom.

Height: 5 inches.

Collection of Philip Hammerslough.

PLATE 144 Water Pitcher, 1804–1809

WARD & BARTHOLOMEW (James Ward and Roswell Bartholomew), working in Hartford 1804–1809.

Vasiform body set on square platform base supported on four eagle-and-paw feet; curvate spout, cast, scroll handle terminating at upper body juncture in griffin's head and at lower in foliate scroll. Lower part of body decorated with acanthus leaves in flat-chasing and repoussé; shoulder exhibits bright-cut checkered band, while pedestal stem has band of asterisk ornament, and edge of base is decorated with frieze of leaves and roses.

Mark: W & B (capitals within rectangle) on bottom.

Height: 13⅜ inches.

This piece belonged to James Madison (1751–1836), fourth President of the United States (1809–1817).

The New-York Historical Society.

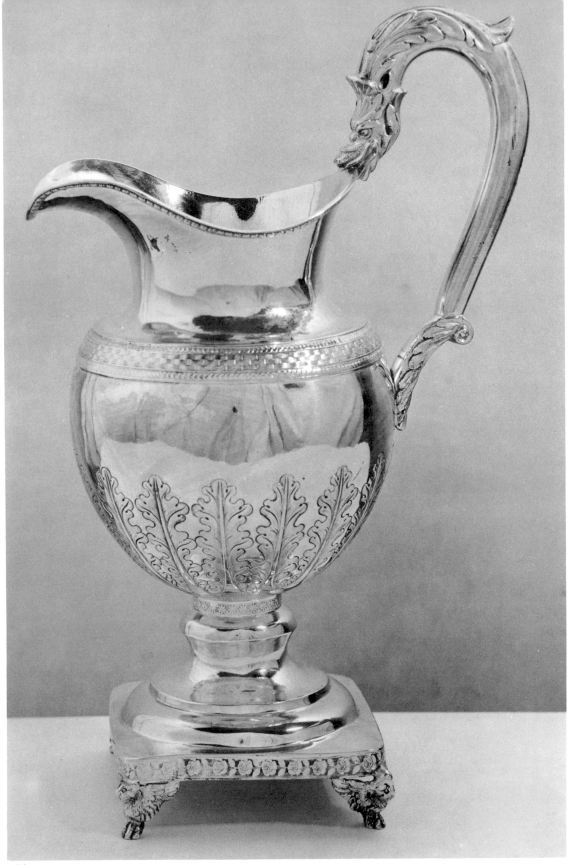

144

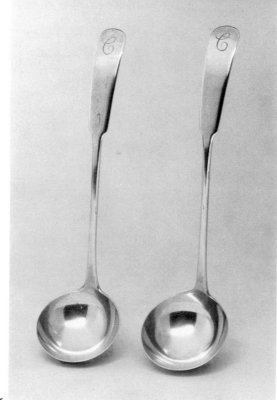

145

PLATE 145 Pair of Ladles, c. 1810

JOSEPH KEELER, working 1810 in Norwalk.

Hemispherical bowls, early fiddleback handles.

Inscription: C (script capital) on each handle obverse.

Mark: I K (capitals within rectangle) on each handle reverse.

Length: 6¾ inches.

Collection of Philip Hammerslough.

PLATE 146 Ladle, after c. 1815

WILLIAM CLEVELAND, apprenticed to Thomas Harland in Norwich; with John Proctor Trott 1792–1794 in New London; c. 1805 alone there or in

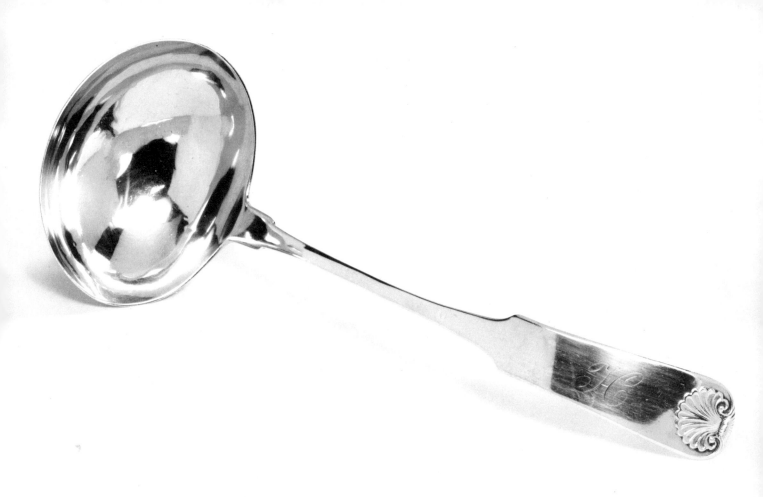

146

Norwich; in Ohio c. 1808 – c. 1812; in Norwich again c. 1812 and probably in partnership there 1815 as Cleveland & Post; probably in partnership as Cleveland & Hart in Norwich c. 1825.

Semiellipsoidal bowl; curved fiddleback handle ornamented on obverse at extremity with shell motif in relief.

Inscription: H (elaborated script) on handle obverse.

Mark: CLEVELAND (capitals within rectangle) on handle reverse.

Length: 14½ inches.

The initial H may be for a member of the Hyde family of Norwich, or possibly for Harland, as the silversmith was apprenticed to Thomas Harland of Norwich.

Wadsworth Atheneum, Hartford.

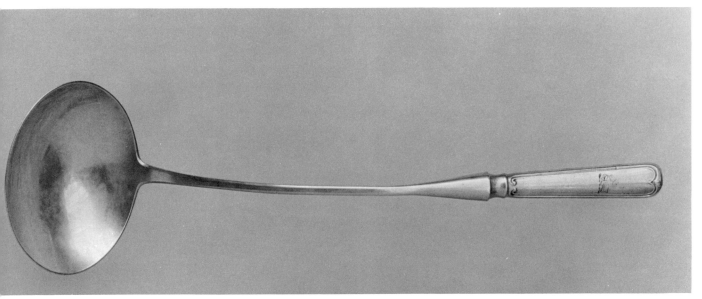

147

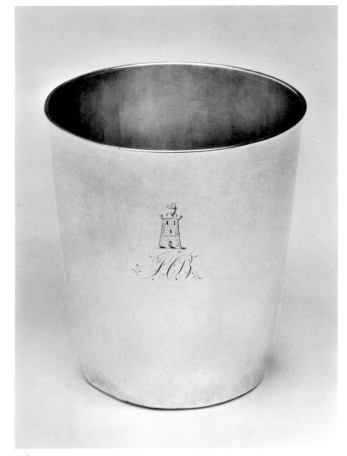

148

174 EARLY CONNECTICUT SILVER, 1700–1840

Ladle, c. 1815

PLATE 147

CLEVELAND & POST (probably William Cleveland; Post not further identified), working in Norwich 1815.

Shallow circular bowl with long, slim handle terminating in upper section decorated in thread pattern.

Inscription: Crest of Holly family, a dexter arm, couped, holding a rose (?), on upper section of handle obverse.

Mark: C & P (capitals within rectangle) on stem reverse.

Length: 12 inches.

Originally owned by Sidney Augustus Holly and his wife, a daughter of Alexander Hamilton. The Holly family was prominent in Stamford as early as 1647.

The Metropolitan Museum of Art, Rogers Fund, 1938.

Beaker, c. 1815

PLATE 148

CLEVELAND & POST (probably William Cleveland; Post not further identified), working in Norwich 1815.

Tapered body with flat base and everted lip.

Inscription: P C B (script capitals) with unidentified crest above tower surmounted by griffin's head.

Mark: C & P (capitals within serrated rectangle) on bottom.

Height: 3¾ inches.

Collection of Philip Hammerslough.

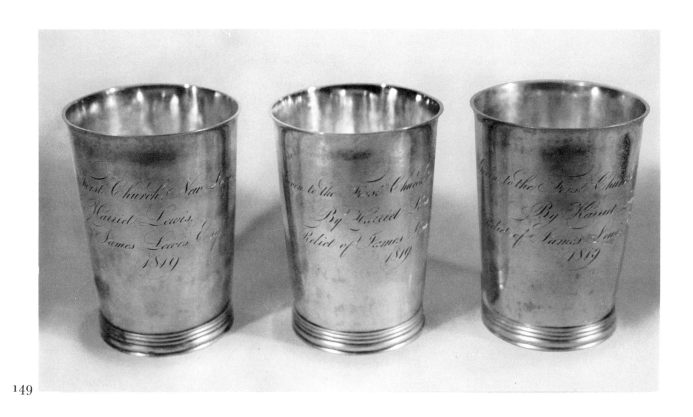

149

Three Beakers, c. 1819, from original set of four.

CLEVELAND & POST (probably William Cleveland; Post not further identified), working in Norwich 1815.

Tapered bodies with molded bases and everted lips.

Inscriptions: (all three) Given to the First Church, New London/ By Harriet Lewis,/ Relict of James Lewis Esq/ 1819 (script).

Mark: C & P (capitals within serrated rectangle) on bottom of each.

Height: 4¾ inches.

The donor was the daughter of Deacon Guy Richards of this church, and the granddaughter of Elizabeth Richards, who gave a beaker by John Proctor Trott to the church in 1793. She married James Lewis in 1806, and died of consumption in 1818 in Paris, where she was buried. The set of four beakers was probably bought with part of the one thousand dollars that she bequeathed to the church for the building of a session house.

The First Church of Christ, New London.

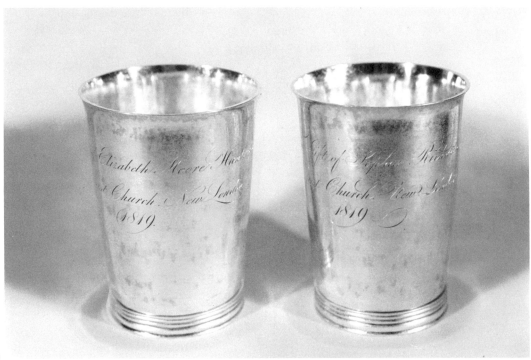

150

Two Beakers, c. 1815 – c. 1819

PLATE 150

CLEVELAND & POST (probably William Cleveland; Post not further identified), working in Norwich 1815.

Tapered bodies with molded bases and everted lips.

Inscriptions (both in script): (left) The Gift of Elizabeth Moore Huntington/ to the first Church, New London/ 1819.
(right) The Gift of Sophia Richards/ to the first Church, New London/ 1819.

Mark: c & p (capitals within serrated rectangle) on bottom of each.

Height: 4¾ inches.

Elizabeth Moor Huntington (1779–1823) was the daughter of Jedediah Huntington, a deacon of this church, and of his second wife Ann Moore. Her father was a general in the Revolutionary army, subsequently a treasurer of the state and delegate to the convention which adopted the constitution of the United States. He was appointed in 1789, by General Washington, collector of customs at the port of New London. The donor's half-sister Ann married Peter Richards, whose sister Sophia Richards gave the beaker at the right, and

whose other sister Harriet Lewis gave the four beakers illustrated in the previous plate. Sophia Richards (b. 1781) was the daughter of Guy Richards, deacon of this church, and granddaughter of Elizabeth Richards, who in 1793 gave the church the gift of a beaker which was made by John Proctor Trott.

The First Church of Christ, New London.

In the beakers illustrated in the previous two plates, Cleveland & Post seem to have followed the design and size of the earlier ones at the church made by John Proctor Trott. William Cleveland had been a partner of Trott earlier, from 1792 until 1794, shortly after both men had completed their training.

Cleveland & Post made c. 1819 a pair of additional beakers (not illustrated) for presentation to the New London church. They are of the same design and size as those illustrated, and bear the same mark. They are inscribed: The Gift of the Widow Eliz^a Fox/ to the first Church in N.London/ 1742 (script). An account of this gift appears in the diary of Joshua Hempstead, who was her husband's cousin. On her deathbed, in 1742, she expressed a wish to Pygan Adams, the New London silversmith, to give a pint-sized silver tankard to this church, which desire was realized in 1744 through Joshua Hempstead. Apparently that tankard was one of those melted down after 1794, when it was voted to convert them into cups "as more convenient for the service of the table."

151

Gold Wedding Ring, 1787–1802

PLATE 151

MARCUS MERRIMAN, working alone in New Haven 1787–1802; later with partners to at least 1826.

Plain gold band.

Mark: M.M. (capitals within rectangle) on inside of band.

Diameter: ¾ inch.

Collection of Philip Hammerslough.

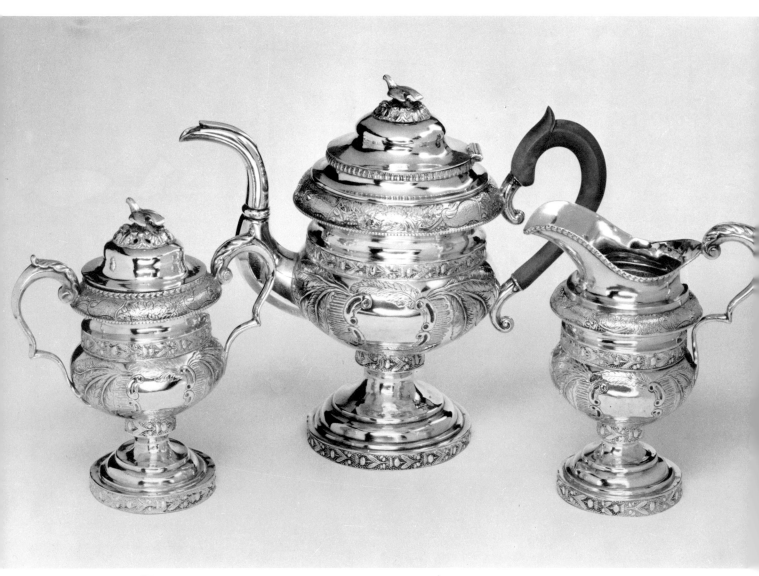

152

Tea Set

PLATE 152

MARCUS MERRIMAN, working alone in New Haven 1787–1802; later with partners to at least 1826.

Three piece set consisting of teapot, covered sugar bowl, and cream jug. Teapot is of developed vasiform type, with bulbous body, circular pedestal foot, multi-staged top and hinged lid with cast, bird finial; gooseneck spout with mid-band; wooden C-scroll handle with silver sockets. Cream jug has one and sugar bowl has two cast scrolled handles with cresting; in other respects they match the teapot. All three have original bands of leaf and thistle decoration in repoussé around bases, pedestal stems, and above bulbous sections of bodies. Latter areas and shoulders of all three pieces exhibit later "Second Rococo" leafwork and cartouches in flat-chasing and repoussé.

Mark: MM (capitals within serrated rectangle) on bottom.

Height: teapot, 8¾ inches; sugar bowl, 6¾ inches; cream jug, 6 inches.

The Connecticut Historical Society, gift of Philip Hammerslough.

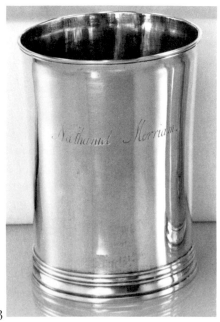

153

PLATE 153 Beaker, c. 1806

MARCUS MERRIMAN, working alone in New Haven 1787–1802; later with partners to at least 1826.

Straight sides, molded base.

Inscription: Nathaniel Merriam (script) on side of body and AD 1806 on bottom.

Mark: MM (capitals within serrated rectangle) on bottom.

Height: 4⅜ inches.

Nathaniel Merriam (1734–1807) was a farmer and wheelwright. In 1756 he married Martha Berry, daughter of Thomas Berry, who in 1772 gave the church a £3 bequest from which a beaker was made by Ebenezer Chittenden.

The Center Congregational Church, Meriden.

154

Pair of Salt Spoons, 1787–1802

PLATE 154

MARCUS MERRIMAN, working alone in New Haven 1787–1802; later with partners to at least 1826.

Shell bowls, rounded down-turned handles.

Inscription: PL (script) on obverse of each handle.

Mark: MM (capitals within serrated rectangle) on reverse of each stem.

Length: 4¼ inches.

Collection of Mr. and Mrs. John Devereux Kernan.

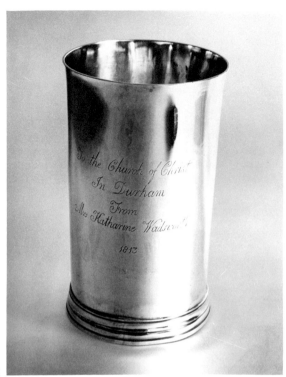

155

PLATE 155 Beaker, c. 1813

MARCUS MERRIMAN & Co. (Marcus Merriman with Bethuel Tuttle, to 1813, and Zebul Bradley), working in New Haven 1802–1817.

Tall slightly tapered body with everted lip and molded base.

Inscription: To the Church of Christ/ In Durham/ From/ Mrs. Katharine Wadsworth/ 1813 (script).

Mark: M·M & Co. (capitals and lower case within serrated rectangle) with grapevine in oval on bottom.

Height: 5¾ inches.

Katharine Guernsey (1732–1813) married James Wadsworth in 1757. He was town clerk, colonel of militia, and a member of the council of safety.

Yale University Art Gallery, the Mabel Brady Garvan Collection.

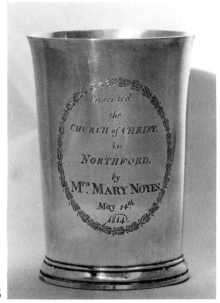

156

Beaker, c. 1814

PLATE 156

MARCUS MERRIMAN & Co. (Marcus Merriman with Bethuel Tuttle, to 1813, and Zebul Bradley), working in New Haven 1802–1817.

Straight, tapered body, slightly flared lip, molded base.

Inscription: Presented/ the/ CHURCH of CHRIST/ in/ NORTHFORD,/ by/ Mrs MARY NOYES/ May 14th/ 1814. (script and block capitals) within a bright-cut oval wreath on side of body.

Mark: M·M & Co. (capitals and lower case within serrated rectangle) with grapevine in oval on bottom.

Height: 4 11/16 inches.

The donor (d. 1851) was the daughter of the Rev. Stephen Johnson of Lyme. In 1790 she married the Rev. Matthew Noyes, son of Judge William Noyes of Lyme. Her husband was pastor of the Northford Society of North Branford. Their daughter Mary Ann Noyes, who died young, though described as "Mrs.," gave the church in 1816 the gift of a beaker made by Merriman & Bradley.

Yale University Art Gallery, the Mabel Brady Garvan Collection.

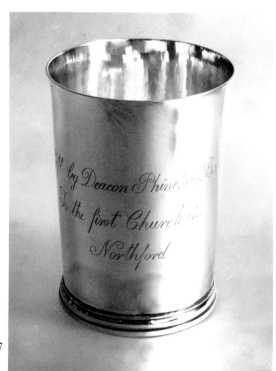

157

PLATE 157 Beaker, c. 1817

MARCUS MERRIMAN & Co. (Marcus Merriman with Bethuel Tuttle, to 1813, and Zebul Bradley), working in New Haven 1802–1817.

Slightly tapered body with molded base and everted lip.

Inscription: A Gift by Deacon Phinehas Baldwin/ To the first Church in/ Northford (script).

Mark: M·M & Co. (capitals and lower case within serrated rectangle) with grapevine in oval on bottom.

Height: 4⅜ inches.

In his will of 1812, proved in 1817, Deacon Baldwin gave twelve dollars to this church "to procure a sacramental cup." In 1819 his second wife Martha gave the church another beaker, which was made by Merriman & Bradley.

Yale University Art Gallery, the Mabel Brady Garvan Collection.

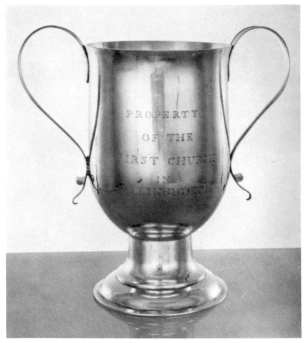

158

Two-handled Cup, 1817–1826

PLATE 158

MERRIMAN & BRADLEY (Marcus Merriman and Zebul Bradley, with Charles O'Neil after 1823), working in New Haven 1817–1826.

Inverted bell-shaped body, short stem, molded and domed foot, solid, cast S-scroll handles.

Inscription: Property/ of the/ First Church/ in/ Killingworth (block capitals).

Mark: M & B (capitals within serrated rectangle) flanked by two incised rayed suns, on bottom.

Height: 5⅝ inches.

See also the two similar cups made earlier (before 1812) for the same church by Ebenezer Chittenden of New Haven (Plate 71).

The First Church of Christ, Congregational, Clinton.

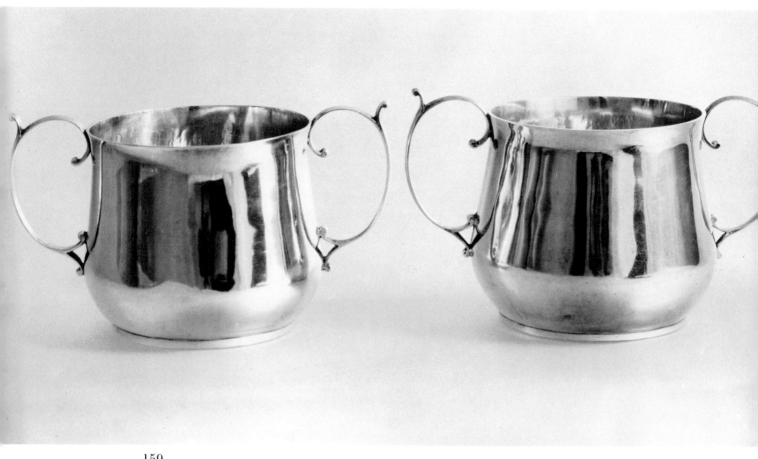

159

PLATE 159 Pair of Caudle Cups, 1817–1826

MERRIMAN & BRADLEY (Marcus Merriman and Zebul Bradley, with Charles O'Neil after 1823), working in New Haven 1817–1826.

Gourd-shaped bodies on flat bases; everted lips; pairs of thin, cast C-scroll handles bifurcated at lower ends.

Mark: M & B (capitals within serrated rectangle) on bottom of each.

Height: 3¾ inches.

The United Congregational Church, New Haven.

160

Cann, 1817–1826 PLATE 160

MERRIMAN & BRADLEY (Marcus Merriman and Zebul Bradley, with Charles O'Neil after 1823), working in New Haven 1817–1826.

Bulbous body with everted lip set on low, splayed, molded foot; S-scroll strap handle with oval terminus.

Inscription: T H C (script) on front of body, and E A, A B (block letters) on base.

Mark: M & B (capitals within serrated rectangle) on bottom.

Height: 4 3/16 inches.

The New Haven Colony Historical Society.

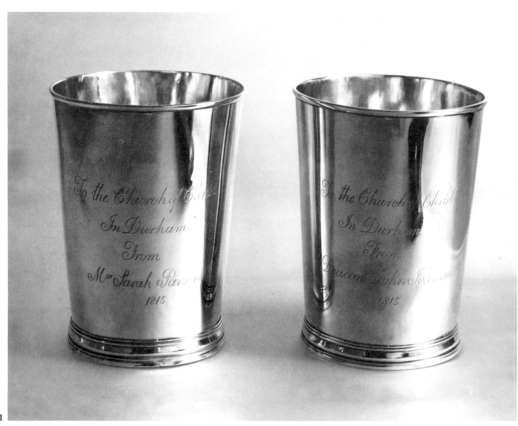

161

PLATE 161 Pair of Beakers, 1817–1826

MERRIMAN & BRADLEY (Marcus Merriman and Zebul Bradley, with Charles O'Neil after 1823), working in New Haven 1817–1826.

Tapered bodies with molded bases and lips.

Inscriptions (both in script): (left) To the Church of Christ/ In Durham/ From/ Mʳˢ Sarah Parsons/ 1815 (right) To the Church of Christ/ In Durham/ From/ Deacon John Johnson/ 1815

Mark: M & B (capitals within serrated rectangle) with grapevine in oval, on bottom of each.

Height: 4 11/16 inches.

The donor was the daughter of Colonel Elihu and Mary Chauncey. She married Lemuel Guernsey (d. 1794) and was the second wife of Simeon Parsons (d. 1819). Her grandfather, the Rev. Nathaniel Chauncey, her brother-in-law, the Rev. Elizur Goodrich, and her niece's husband, the Rev. David Smith,

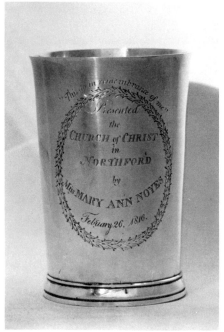

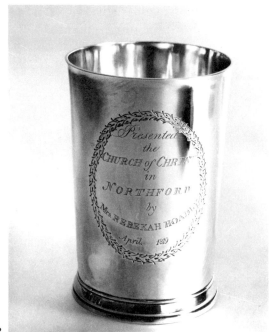

162 163

had been successively ministers of this church. The inscribed date 1815 probably indicates the date of the monetary bequest to the church rather than the year in which the beakers were made.

Yale University Art Gallery, the Mabel Brady Garvan Collection.

Beaker, 1817–1826

PLATE 162

MERRIMAN & BRADLEY (Marcus Merriman and Zebul Bradley, with Charles O'Neil after 1823), working in New Haven 1817–1826.

Straight tapered body, slightly flared lip, molded base.

Inscription: Presented/ the/ CHURCH OF CHRIST/ in/ NORTHFORD/ by/ Miss MARY ANN NOYES/ February 26, 1816. (script and block capitals) set within bright-cut oval wreath, surmounted by inscription "This do in remembrance of me" (script).

Mark: M & B (capitals within serrated rectangle) with grapevine in oval, on bottom.

Height: 4 11/16 inches.

Mary Ann Noyes, though described as "Mrs.," actually died young. She was

the daughter of Rev. Matthew Noyes, pastor of the Northford Society of North Branford, and Mrs. Mary Noyes, who in 1814 gave the church a beaker made by Marcus Merriman & Co. The inscribed date 1816 probably indicates the date of the monetary bequest to the church rather than the year in which the beaker was made.

Yale University Art Gallery, the Mabel Brady Garvan Collection.

PLATE 163 Beaker, c. 1819

MERRIMAN & BRADLEY (Marcus Merriman and Zebul Bradley, with Charles O'Neil after 1823), working in New Haven 1817–1826.

Slightly tapered body with molded base and everted lip.

Inscription: Presented/ the/ CHURCH of CHRIST/ in/ NORTHFORD/ by/ Mrs. REBEKAH HOADLY/ April. 1819 (script and capitals) within an engraved oval foliate wreath.

Mark: M & B (capitals within serrated rectangle) with grapevine in oval, on bottom.

Height: 4¾ inches.

Rebekah Linley (1747–1819) married Jared Tainter in 1772 and Timothy Hoadley in 1781. Her second husband was a captain of the company in the Northford militia during the revolutionary war, and he represented Branford in the general assembly between 1780 and 1810.

Yale University Art Gallery, the Mabel Brady Garvan Collection.

PLATE 164 Beaker, c. 1819

MERRIMAN & BRADLEY (Marcus Merriman and Zebul Bradley, with Charles O'Neil after 1823), working in New Haven 1817–1826.

Straight tapered body, slightly flared lip, molded base.

Inscription: Presented/ by/ Mrs MARTHA BALDWIN/ To/ THE FIRST CHURCH/ in/ Northford/ 1819 (script and block letters) on side of body.

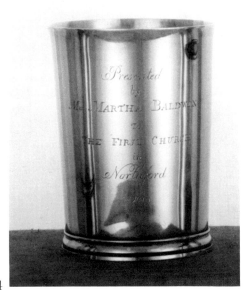

164

Mark: M & B (capitals within serrated rectangle) with grapevine in oval, on bottom.

Height: 4⅜ inches.

Martha Peck of Wallingford became the second wife of Deacon Phinehas Baldwin in 1761. Her husband, whom she survived, gave this church in his will twelve dollars for a beaker, which was made c. 1817 by Marcus Merriman & Co.

Yale University Art Gallery, the Mabel Brady Garvan Collection.

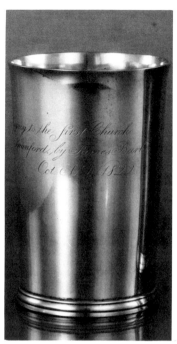

165

PLATE 165 Beaker, c. 1823

MERRIMAN & BRADLEY (Marcus Merriman and Zebul Bradley, with Charles O'Neil after 1823), working in New Haven 1817–1826.

Straight tapered body, slightly flared lip, molded base.

Inscription: A Legacy to the first Church/ in Branford, by James Barker Esq./ Oct. A.D. 1822 (script).

Mark: M & B (capitals within serrated rectangle) with grapevine in oval, on bottom.

Height: 4⅞ inches.

James Barker (1753–1822) at the time of his death was styled Colonel, having been captain of the third company in the second regiment of Connecticut militia. In his will of 1822, proved in January of 1823, he directed his executors "to procure a decent silver cup for the use of the first Church at Branford at their communion service of which I am a member."

The First Congregational Church — United Church of Christ, Branford.

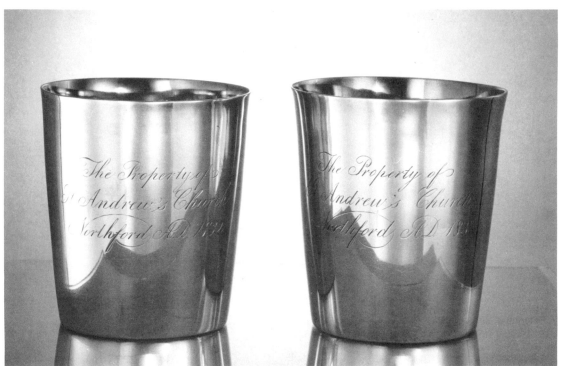

166

Pair of Beakers, c. 1832

PLATE 166

BRADLEY & MERRIMAN (Zebul Bradley and Marcus Merriman, Jr.), working in New Haven 1826–1842.

Plain bodies, flaring slightly to the rim.

Inscription: The Property of/ St Andrew's Church/ Northford AD 1832 (script) on each.

Mark: B & M (capitals within serrated rectangle) on bottom of each.

Height: 3½ inches.

In 1830, the Vestry voted "That the money that is in the Treasury be laid out for Communion Cups."
Three similar uninscribed beakers, 3¾ inches in height, marked B & M for Bradley & Merriman, belong to North Guilford Congregational Church.

St. Andrew's Church, Northford.

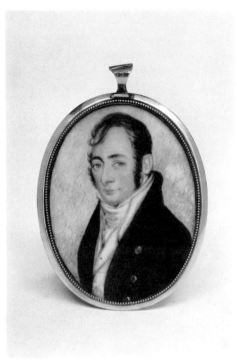

167

PLATE 167 Gold Frame for Miniature Portrait, 1811–1821

GOODWIN & DODD (Horace Goodwin and Thomas Dodd), working in Hartford 1811–1821.

Elliptical, with beaded molding on inner edge; hanging ring fastened to top; reverse side has elliptical aperture for exhibiting plaited hair under glass.

Mark: G & D (capitals within rectangle) on hanging ring.

Length: 3⅝ inches.

The subject of this painted miniature is unidentified.

Collection of Philip Hammerslough.

168

Cup, 1821–1825

PLATE 168

H. & A. GOODWIN (Horace and Allyn Goodwin), working in Hartford 1821–1825, or perhaps by Horace Goodwin alone after 1825.

Slightly tapered body with everted lip, set on low, flat pedestal foot.

Inscription: A F (script) on side of body.

Mark: GOODWIN and HARTFORD (capitals within rectangles) on bottom.

Height: 3¾ inches.

Anonymous owner.

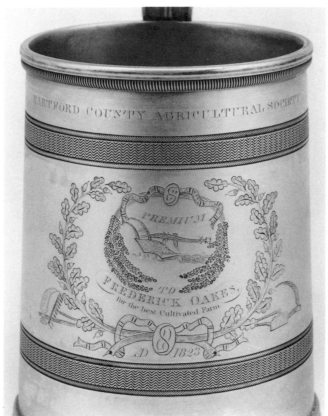

169

Mug, c. 1823 PLATE 169

H. & A. GOODWIN (Horace and Allyn Goodwin), working in Hartford 1821–1825.

Round body tapering from base to rim, both of which have heavy ribbed and plain moldings; hollow cast S-scroll handle with acanthus leaf crest and roseate upper and lower termini; body decorated with upper and lower bands of wire-twist and zigzag ornament.

Inscription: HARTFORD COUNTY AGRICULTURAL SOCIETY (capitals) above upper decorative band; PREMIUM/ TO/ FREDERICK OAKES/ for the best Cultivated Farm/ AD 1823 (shaded capitals, capitals, and lower case), above and below a plough flanked by wheat ears, all within flanking crossed oak twigs and agricultural hand implements.

Mark: GOODWIN and HARTFORD (capitals within rectangles) on bottom.

Height: 4½ inches.

Frederick Oakes (1782–1835) worked in Hartford as a gold and silversmith, clock and watchmaker and jeweler from c. 1803 on, usually in partnership with another craftsman until 1820, after which date he worked alone. He was also active in the real estate business, and was a gentlemen farmer. He created a prize-winning farm in West Hartford, for which he received this mug from the Hartford County Agricultural Society, one of a number of prizes which he won up to 1829 while a member of the Society. (See January 1967 Bulletin of the Connecticut Historical Society for a full discussion.)

Collection of Philip Hammerslough.

170

PLATE 170 Pair of Beakers, (from set of three), c. 1815 – c. 1825

GEORGE KIPPEN, working from 1815 to c. 1829 in Bridgeport, at times probably with Barzillai Benjamin and with Elias Camp; c. 1830 in Albany, N.Y.

Slightly tapered bodies with molded feet and rims.

Mark: G Kippen (italics within rectangle) on bottom of each.

Height: 4 3/16 inches.

A third beaker is inscribed: First Congregational Church/ Bridgeport/ Isaac Sherman/ 1836 (script and block letters).

The United Congregational Church, Bridgeport.

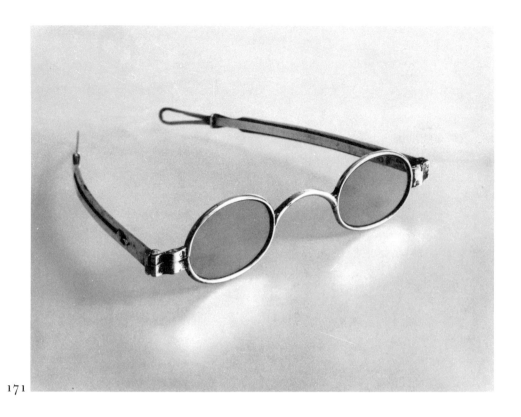

171

Spectacles

PLATE 171

GEORGE KIPPEN, working from 1815 to c. 1829 in Bridgeport, at times proba-
bly with Barzillai Benjamin and with Elias Camp; c. 1830 in Albany, N.Y.

Elliptical lens holders filled with tinted, blue-green glass; earpieces ad-
justable in length by means of sliding bar and pin device.

Mark: Kippen (script within rectangle) upside down on inside of left ear-
piece near hinge.

Length: 4⅜ inches between hinges.

Yale University Art Gallery, the Mabel Brady Garvan Collection.

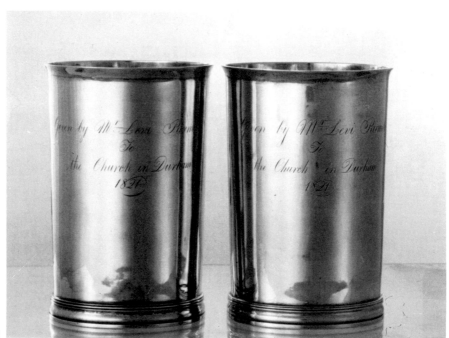

172

PLATE 172 Pair of Beakers (from set of three), c. 1821

CHARLES BREWER, in business in Middletown with Judah Hart 1800–1803; with Alexander Mann 1803–1805; firm C. Brewer & Co. c. 1810.

Slightly tapered bodies with everted lips and molded bases.

Inscription: Given by M$^{r}_{"}$ Levi Parmelee/ To/ the Church in Durham/ 1821 (script) on side of each.

Mark: C · BREWER (capitals within serrated rectangle) on bottom of each.

Height: 4 13/16 inches.

Levi Parmelee was born in Guilford in 1745. He was a blacksmith. In his will of 1818, proved in April 1819, be bequeathed thirty dollars to the church for these communion cups. See also the marrow spoon made c. 1800 by Charles Brewer.

Yale University Art Gallery, the Mabel Brady Garvan Collection.

173

Masonic Jewels, c. 1812

PLATE 173

CHARLES BREWER, in business in Middletown with Judah Hart 1800–1803; with Alexander Mann 1803–1805; firm of C. Brewer & Co. c. 1810.

Eleven symbolic "jewels" of the Masonic Order in various shapes, such as crossed sabers, crossed keys, cornucopiae, compasses and set square, etc.

Attributed to Charles Brewer in Plate xxxiii of George Munson Curtis, *Early Silver of Connecticut and its Makers,* 1913. The two additional sets of jewels which he illustrated, those at the Hartford lodge by Samuel Rockwell and James Tiley, and at the Essex lodge by Nathan Pratt, seem to have since disappeared.

St. John's Lodge, Free & Accepted Masons, Middletown.

174

PLATE 174 Two Beakers, c. 1825

BARZILLAI BENJAMIN, working before 1819 in Bridgeport; New Haven 1819–1829 (and New York City 1825–1827); subsequently in Bridgeport again. Slightly tapered bodies with everted lips and molded bases.

Inscriptions (both in script): (left) Miss Lydia Fowler. Donor 1825 (right) Mrs Anna Stone. Donor 1825.

Mark: B BENJAMIN (capitals within rectangle) on bottom of each.

Height: 4½ inches.

Lydia Fowler (1763–1816) died unmarried and intestate. The beaker at the left is one of a pair believed to have been bought with money, due to the estate, which came in after the settlement. Anna Griswold (1769–1846) became the wife of Timothy Stone (1768–1846).

The First Congregational Church, Guilford.

PLATE 175 Tea Set, c. 1830–1844

BARZILLAI BENJAMIN, working before 1819 in Bridgeport; New Haven 1819–1829 (and New York City 1825–1827); subsequently in Bridgeport again.

Three-piece set consisting of teapot, two-handled, covered sugar bowl, and

cream jug. Teapot is of developed vasiform type with bulbous, multi-lobed body set on circular pedestal foot, multi-staged top with hinged lid having radially-lobed cresting and urn finial; gooseneck spout and rectangular scroll handle of square cross section with ebony insulators. Sugar bowl and cream jug of matching design. All three pieces exhibit band of rose and leaf ornament at shoulder; teapot and sugar bowl also carry bands of acorn and oak leaf ornament around bases and upper lips; creamer has similar band around base but shell molding around lip.

Inscription: Brooks (script) with crest above consisting of mailed fist holding dagger, on side of pot and bowl and on front of jug.

Mark: B B and BRIDGEPORT (capitals within rectangles) within foot to either side of center punch on underside of body of each.

Height: Teapot, 10½ inches; sugar bowl, 9¾ inches; cream jug, 7¼ inches.

John Brooks, a wealthy merchant, and his son of the same name, were prominent in Bridgeport affairs in the first half of the nineteenth century.

Collection of Frederick C. Kossack.

Hollowware and Selected Flatware 205

PLATE 176 Teapot, c. 1825–1844

BARZILLAI BENJAMIN, working before 1819 in Bridgeport; New Haven 1819–1829 (and New York City 1825–1827); subsequently in Bridgeport again.

Developed vasiform type with bulbous, multilobed lower body set on circular pedestal foot, multi-staged top with hinged lid having radially-lobed cresting and pine cone finial; gooseneck spout and rectangular scroll handle of square cross section with ebony insulators. Repoussé ornamental band of rose and leaf work at shoulder, and of acorn and oak leaf around base and lip of body.

Mark: BB (capitals within rectangle) on bottom.

Height: 10¾ inches.

Mrs. G. Harold Welch of the Mary Clap Wooster Chapter, D.A.R., brought this piece to light, and has informed the authors that a matching sugar bowl, but no cream jug, is also in the possession of the Chapter.

Mary Clap Wooster Chapter, Daughters of the American Revolution Inc., New Haven.

176

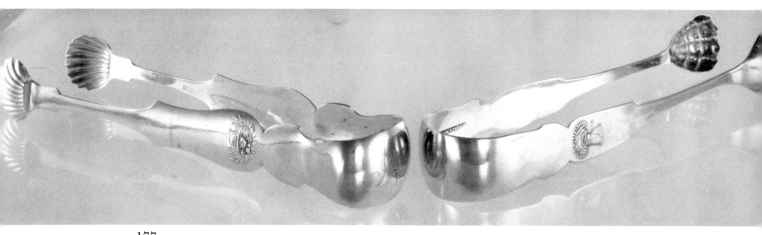

177

PLATE 177 Sugar Tongs, c. 1825

BARZILLAI BENJAMIN, working before 1819 in Bridgeport; in New Haven 1819–1829 (and New York City 1825–1827); subsequently in Bridgeport again.

Left: bow shape with scalloped bow, fiddle stems with basket of flowers at top, shell grips. Right: bow shape, fiddle and straight stems with sheaf of wheat at top, claw grips.

Inscriptions (both in script): (left) SHS on outside of bow; (right) AB on outside of bow.

Marks: B. BENJAMIN (capitals within rectangle) on inside of stem of tongs at left and on inside of bow of tongs at right.

Lengths: left, 7 inches; right, 6⅝ inches.

Tongs at left from the collection of Mrs. Harold G. Duckworth; at right from the collection of Philip Hammerslough.

PLATE 178 Set of four ladles, before 1819, or 1830–1844

BARZILLAI BENJAMIN, working before 1819 in Bridgeport; New Haven 1819–1829 (and New York City 1825–1827); subsequently in Bridgeport again.

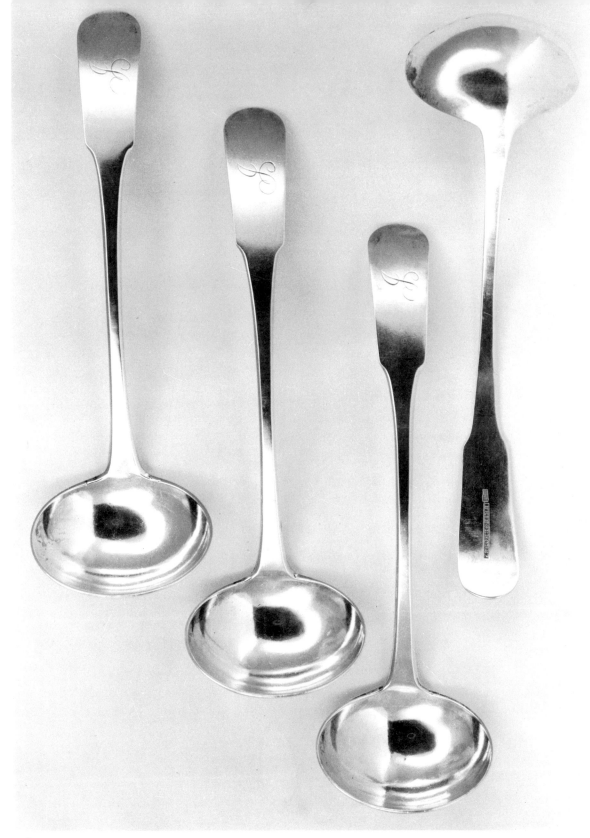

178

Elliptical bowls with down-curved, fiddleback handles.

Inscription: J (or possibly I) (elaborated script) on the obverse of the handle of each.

Mark: BB and BRIDGEPORT (capitals within rectangles) on the reverse of the wide part of the handle of each.

Length: 8⅛ inches.

Collection of Philip Hammerslough.

PLATE 179 Serving Spoon, c. 1820 – c. 1840

BARZILLAI BENJAMIN, working before 1819 in Bridgeport; in New Haven 1819–1829 (and New York City 1825–1827); subsequently in Bridgeport again.

Pointed, ovoid bowl with broad, rounded drop, sugar-loaf shouldered stem, fiddleback up-curved handle with King's pattern on front.

Inscription: EUC (script) on handle reverse.

Mark: B. BENJAMIN (capitals within rectangle) on stem reverse.

Length: 8 15/16 inches.

The New Haven Colony Historical Society, gift of Carl R. Kossack.

179

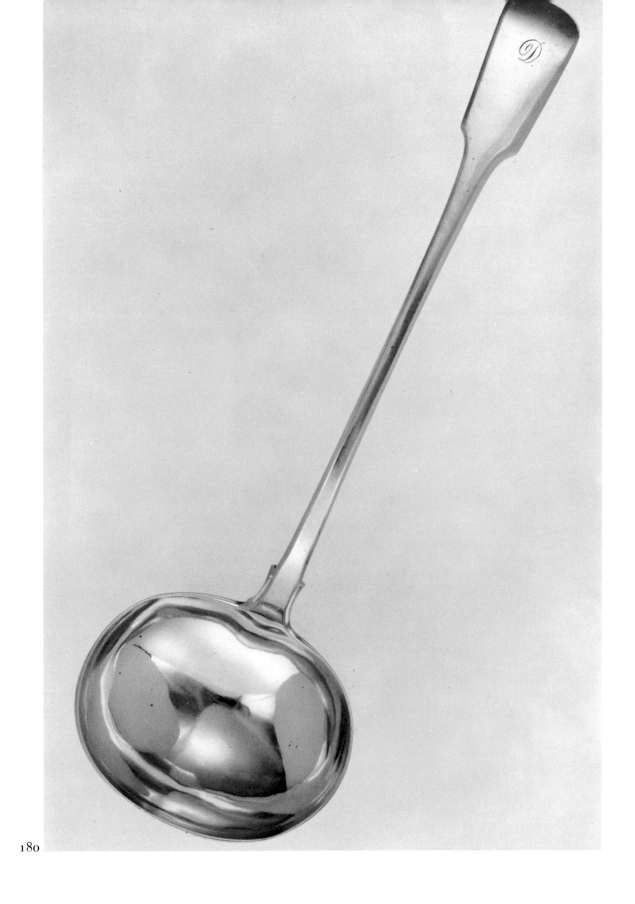

180

212 EARLY CONNECTICUT SILVER, 1700–1840

Ladle, c. 1815 – c. 1820

PLATE 180

CHARLES HEQUEMBOURG, JR., working in New Haven 1809–1822; subsequently in New York.

Broad ovoid bowl, shouldered stem, fiddleback handle.

Inscription: D. (script) on handle obverse.

Mark: C · H (capitals within rectangle) on handle reverse.

Length: 13 inches.

The New Haven Colony Historical Society.

Gold Spectacles, 1825–1850

PLATE 181

ALVAN WILCOX, working in Norwich 1805–1807 in partnership, in 1816 alone; thereafter in New Jersey and North Carolina; in New Haven from 1824 on — in 1841 as silver worker, in 1850 as gold and silver thimble and spectacle maker, and in 1857 as silver plater.

Elongated octagonal frames, with curved nosepiece; simple bar earpieces ending in closed loops. Stamped 18 on outside of left earpiece near hinge.

Inscription: C. M. Hatch (script) on top of right frame.

Mark: WILCOX (incised capitals) on inside of right earpiece near hinge.

Width: 4⅜ inches between hinges.

Collection of Alan R. Kossack.

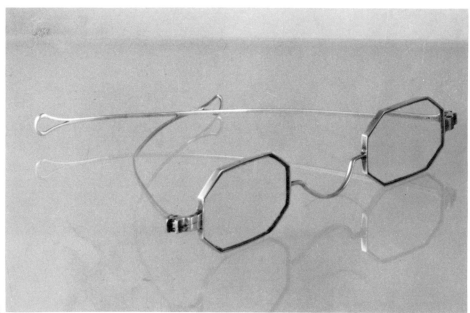

181

PLATE 182 Ladle, c. 1830 – c. 1835, possibly later

EVERARD BENJAMIN, in 1829 succeeded his father Barzillai in business in New Haven; from before 1835 to after 1840 there as E. Benjamin & Co.; Benjamin & Ford later.

Elliptical, scalloped bowl with thread-pattern, fiddleback handle and up-turned end.

Inscription: SC (elaborated script) on handle obverse.

Mark: E. BENJAMIN (capitals) and pseudo-hallmarks on reverse of handle.

Length: 11 inches.

Collection of Alan R. Kossack.

182

183

216 EARLY CONNECTICUT SILVER, 1700–1840

Ladle, c. 1840

PLATE 183

A. JACKSON, working in Norwalk 1840.

Hemispherical bowl and long curving handle ending in rounded up-turned tip; handle obverse decorated at end with relief border of "Second Rococo" type, forming cartouche. Thread pattern, shaped drop on back of bowl at handle juncture.

Inscription: S & E A L (script) on handle obverse within cartouche.

Mark: A · JACKSON and NORWALK (incised capitals within rectangles) on stem reverse.

Length: 14½ inches.

Collection of Alan R. Kossack.

184

PLATE 184 Cann

JOHN HALLAM, working in New London from 1773.

Pyriform body with molded rim on splayed, molded foot; S-C scroll cast handle.

Inscription: Lucretia Christophers/ b. Jan.19. 1750 — d. Mch.19.1825/ Married May 13.1770/ John Mumford/ b. Dec.3.1740 — d. July 14. 1825/ Grandparents of/ Lucretia Mumford Woodbridge Mitchell (script) added probably about the middle of the nineteenth century, or later.

Mark: HALLAM (capitals within rectangle).

Height: 6¼ inches.

Collection of Alfred Bingham.

This piece was added just before publication and appears out of stylistic-chronological order.

Biographical Notes on the Silversmiths

THE FOLLOWING INDEX contains the names of silversmiths and companies recorded as having been in Connecticut. It does not pretend to be exhaustive, but is included as a convenient summary of relevant, known biographical information. Where dates or places are not given, these are not known. In many instances where only one known working date is shown, the man may have been working also before and after that date. Where the state is not indicated the town is in Connecticut.*

Adams, Pygan (1712–1776). He was born in New London where he was working before 1735; he was active also in civic affairs, 1753–1765. He died in New London. His nephew John Gardner was apprenticed to him.

Adgate, Elijah (1739–1775). Worked in Norwich. Brother of William.

Adgate, William (1744–1779). He was born in Norwich, where he worked and died. Brother of Elijah.

Allen, Joel (1755–1825). Allen was born in Southington and worked at first in the nearby town of Plantsville. He moved to Middletown in 1790, where he engraved for silversmiths, principally Samuel Canfield, 1790–1792. G. M. Curtis, in *Early Silver of Connecticut and Its Makers*, mentions a daybook in existence, running from 1787 to 1792. Allen was also a brass worker, carpenter, and general-store keeper in Middletown, apparently up to the time of his death.

* As *Early Connecticut Silver* was being prepared for publication, an excellent reference work appeared which provides the most complete biographical information so far made available. It is Henry N. Flynt and Martha Gandy Fales, *The Heritage Foundation Collection of Silver, With Biographical Sketches of New England Silversmiths, 1625–1825*, The Heritage Foundation, Old Deerfield, Massachusetts, 1968. Although it does not discuss Connecticut silver in detail, its thoroughly researched biographical section should be consulted for more detailed information on any Connecticut silversmith working before 1825. Advantage was taken of the appearance of this reference work to correct some of the entries in our own Biographical Notes. It will be noted, however, that some of our entries differ in detail, and in those instances we believe our information to be the more accurate.

Allyn, Nathan. Working in Hartford in partnership with Frederick Oakes as Allyn & Oakes until December 1804, when the partnership was dissolved. He advertised there in 1807, and sold his business to Horace Goodwin in 1810.

Allyn & Oakes. Nathan Allyn and Frederick Oakes, working in Hartford before December 1804, when the partnership was dissolved.

Atterbury, J. Working 1799 in New Haven.

Austin, Ebenezer (1733 – after 1818). Austin was born in Charlestown, Massachusetts where he may have been apprenticed to his relative Josiah Austin. Around 1761 he moved to Hartford, where he worked until about 1787 as goldsmith and jeweler. He was living in New York City c. 1788, was a pensioner there in 1818, and probably died there.

Austin, John (1757–1825). He was born in England, and was working c. 1770 in Hartford. From 1802–1809 he was in Philadelphia, and c. 1820 in Charleston, South Carolina.

Austin, Joseph (b. 1719). Working c. 1740 in Hartford.

Avery, John (1732–1794). Avery was born in Preston and was a farmer and later a self-taught silversmith and clockmaker. He opened his shop near Preston in 1760. Four of his sons were silversmiths: John, Jr., Robert Stanton, Samuel, and William. He died in Preston.

Avery, John, Jr. (1755–1815). Son of John, he was born and died in Preston. Working in Preston in 1780.

Avery, Robert Stanton (1771–1846). Son of John, he was born and died in Preston. Worked in Preston. When his father died in 1794 he abandoned the trade.

Avery, Samuel (1760–1836). Son of John, he was born in Preston. Working from c. 1779 on in Preston.

Avery, William (1765–1798). Son of John, he was born in Preston. Worked in Preston, died in Stonington.

Babcock, Samuel (1788–1857). Babcock was born in Saybrook and was customs collector there. He moved to Middletown in 1812, in which year he advertised. An 1850 census there listed him and his son, Samuel Jr. as spectacle makers. He was buried in Middletown.

Bailey, Smith. Working in East Windsor in 1773 as goldsmith and jeweler.

Baker, Eleazer (1764–1849). He was born in Tolland and worked in Ashford, advertising in 1793 as goldsmith, clockmaker, and watchmaker. His house is still standing.

Balch, Ebenezer (1723–1808). Balch was born in Boston and learned his trade there. He moved to Harwinton c. 1744; to Hartford in 1756. He was also a clockmaker. Joseph was his son.

Balch, Joseph (1760–1855). Son of Ebenezer, from whom he learned his trade. He worked as a clockmaker and silversmith in Wethersfield from c. 1782 until 1794 when he moved to Williamstown, Massachusetts. He was in Johnstown, New York and Albany, New York c. 1810.

Baldwin, Ebenezer. Working 1810–1819 in Hartford.

Barber, William. Working c. 1843 in Hartford.

Barret, James. Worked for René Grignon of Norwich up to the latter's death in 1715, and alone there in 1717.

Barrows, James Madison (b. 1809). Barrows was born in Mansfield. In 1828 he was working in Tolland. He may also have been a partner in the firm Eddy & Barrows, working in Tolland c. 1832.

Bartholomew, Roswell (1781–1830). Bartholomew was born in Harwinton. He was apprenticed to Beach & Ward until 1797 in Hartford. He was a partner there with James Ward and an unidentified silversmith c. 1802 in a firm whose mark was W. B. & T. By 1804 the firm was known as Ward & Bartholomew. In 1809 Charles Brainard joined this firm, which then became known as Ward, Bartholomew & Brainard until Bartholomew's death in 1830. As a businessman he also dealt in jewelry, hardware and real estate.

Beach, A. Working c. 1823 in Hartford.

Beach, Isaac. Working c. 1788–1794 in New Milford.

Beach, John. Working in Hartford. In 1813 he was taken into partnership by his father, Miles Beach.

Beach, Miles (1742–1828). Beach was born in Goshen and may have died in Hartford. He worked from before 1771 to 1785 in Litchfield and went into partnership there with Isaac Sanford as Beach & Sanford. In 1785 the firm moved to Hartford, where they were engravers, clockmakers, and watchmakers, as well as silversmiths until c. 1788. Beach continued in business there with his former apprentice, James Ward, as Beach & Ward, from 1790 to 1797. Harvey Sadd worked for him briefly after 1801. In 1813 he took his son John into partnership.

Beach & Sanford. Miles Beach and Isaac Sanford; working before 1785 in Litchfield; working 1785 – c. 1788 in Hartford. They were engravers and makers of clocks and watches, as well as silversmiths.

Beach & Ward. Miles Beach and his former apprentice, James Ward; working

1790–1797 in Hartford. They were also engravers, clockmakers, and watchmakers. Roswell Bartholomew was apprenticed to them until 1797.

Beecher, C., & Co. Clement Beecher; working c. 1820 in Meriden.

Beecher, Clement (1778–1869). Beecher was born in Harwinton. He was working 1801 in Berlin as goldsmith, silversmith, and brass founder. By 1818, he was living in Cheshire. He was in Meriden c. 1820 in the firm of C. Beecher & Co. At times he was an itinerant silversmith in the Cheshire-Meriden-Berlin area.

Belcher, Gilbert. He worked as a silversmith in Hebron, where he was married in 1761. In 1764 he was convicted in Windham for counterfeiting and heavily fined. He then left Connecticut and continued counterfeiting in Great Barrington, Massachusetts. He apparently extended his activities into territory claimed by New York, and was imprisoned in Albany, New York where he was sentenced to death and hanged in April, 1773.

Benham, Morris. Working c. 1843 in Hartford.

Benjamin, Barzillai (1774–1844). Benjamin was born in Milford and died in Bridgeport. He was working in 1819 in Bridgeport; 1819–1829 in New Haven, also 1825–1827 in New York; c. 1829–1844 again in Bridgeport. George Kippen was his partner for a short time in Bridgeport, probably in 1815. Benjamin's son Everard became his successor in New Haven in 1829. His son Samuel C. also worked with him c. 1819.

Benjamin, E., & Co. Everard Benjamin; working before 1835 until after 1840 in New Haven.

Benjamin, Everard (1807–1874). In 1829 Everard succeeded his father, Barzillai, in business in New Haven. The firm of E. Benjamin & Co. was working there from before 1835 until after 1840. He was associated with George H. Ford in the firm of Benjamin & Ford, probably in later years. He died in New Haven.

Benjamin, John (1699–1773). Born in Watertown, Massachusetts. Working in Stratford from c. 1725 on. He may have worked with Robert Fairchild, who was in Stratford from 1747 until c. 1766.

Benjamin, Samuel C. (1801–1831). Son of Barzillai, for whom he worked at first, but he had his own shop in New Haven c. 1819 to after 1821; later he was a schoolteacher there.

Benjamin & Ford. Everard Benjamin and George H. Ford; working in New Haven in mid-nineteenth century.

Bennett, John W. Died 1812 in Norwich. Probate records (in Hartford) list him as jeweler, watchmaker and silversmith.

Billings, Andrew (1743–1808). He was born in Stonington and worked at first in Preston, then in Fishkill and Poughkeepsie, New York where he died. He was the brother of Daniel.

Billings, Daniel. He was born in Stonington in 1749 and worked 1790–1795 in Preston. Brother of Andrew.

Bingley, ———. Possibly working c. 1790 in Connecticut (town unknown).

Blackman, F. S., & Co. Frederick Starr Blackman; working from 1840 on in Danbury.

Blackman, Frederick Starr (1811–1898). Working in Danbury from 1830. He was apprenticed to his father John Starr Blackman, to whose business he succeeded. He was working as F. S. Blackman & Co. in 1840. John Clark Blackman was his brother.

Blackman, J. C., & Co. John Clark Blackman; working c. 1835 in Bridgeport.

Blackman, John Clark (1808–1872). Apprenticed to his father, John Starr Blackman, in Danbury. He was in Bridgeport in 1827 and in business there as J. C. Blackman & Co. c. 1835. Frederick Starr Blackman was his brother.

Blackman, John Starr (1775–1851). Blackman worked in Danbury from 1805 on as a clockmaker as well as a silversmith. John Clark Blackman and Frederick Starr Blackman were his sons, and the latter succeeded his father in business in Danbury after 1840. Levi Clark, his son-in-law, was also his apprentice.

Blakslee, William (1795–1879). Born and worked in Newtown. He was the son of silversmith Ziba Blakslee. At age 21 he went to St. Louis, Missouri to perfect his silversmithing skills with French artisans there. He also learned engraving and clockmaking. After four years he returned to Newtown, where he at first used his father's shop. He advertised there first in 1853 as silversmith, goldsmith and repairer of watches, clocks and jewelry. He died in Newtown.

Blakslee, Ziba or Zeba (1768–1834). Blakslee was born in Plymouth. He moved to Newtown in 1791 where, in addition to silversmithing, he also made clocks, watches, surveyors' instruments, and church bells. He died in Newtown. William Blakslee was his son.

Blakeslee, C. Working c. 1825 in Connecticut (town unknown).

Bliss, Jonathan. Working in Middletown in 1800. He was in partnership with Judah Hart there 1803–1804 as Hart & Bliss, and with Edmund Hughes in 1806 as Hughes & Bliss. He moved to Cleveland, Ohio with his brother William in 1815, and also worked in New York, probably later.

Bolles, ———. Partner in Bolles & Day, working c. 1825 in Hartford; and in Bolles & Childs, working c. 1840, also in Hartford.

Bolles & Childs. Working c. 1840 in Hartford.

Bolles & Day. Working c. 1825 in Hartford.

Bontecou, Timothy (1693–1784). Bontecou was born in New York City and learned his trade in France. He was in Stratford in 1735 and contributed to a new church there in 1743–1744. After 1735 he was working in New Haven, and in 1765 was first warden of Trinity Church there. He probably trained his son, Timothy, Jr., and may have worked with him in New Haven. He sold his shop in New Haven in 1775, and died there nine years later.

Bontecou, Timothy Jr. (1723–1789). Bontecou was born in France. He was working 1749–1789 in New Haven, where he died. Timothy, Jr., was probably trained by his father in New Haven and may have worked with him there.

Botsford, Gideon B. (1776–1856). Working in Woodbury from 1797 on.

Bradley, Aner (1753–1824). Bradley was born in New Haven, learned his trade there, and, except for some time during the Revolution (he was wounded at Danbury in 1777), he worked there from 1774 to 1783. After the war he worked in Watertown, where he died. He was the brother of Phinehas Bradley.

Bradley, Gustavus. Working in New Haven in mid-nineteenth century. He worked with his father Zebul, probably from before 1840, later as Z. Bradley & Son.

Bradley, Luther (1772–1830). Bradley was born and died in New Haven. He worked there from 1798 to 1830. The inventory of his estate indicates that he became a liveryman. He was the son of Phinehas.

Bradley, Phinehas (1745–1797). Phinehas, brother of Aner Bradley and father of Luther, was born in Litchfield and worked c. 1766–1797 in New Haven, where he died.

Bradley, Richard (1787–1867). He was born and died in Hartford, where he worked from 1825 to 1839; c. 1830 – c. 1835 with a silversmith named Bunce, as Bradley & Bunce.

Bradley, Z., & Son. Zebul Bradley and his son Gustavus; working in mid-nineteenth century in New Haven, probably from before 1840, later with this firm name.

Bradley, Zebul (1780–1859). Zebul was born in Guilford. He worked from 1802 to after 1842 in New Haven, where he died. He was apprenticed to Marcus Merriman, with whom he and Bethuel Tuttle (to 1813) worked as Marcus Merriman & Co., 1802–1817. From 1817 to 1826 the firm was named Merriman & Bradley and included Charles O'Neil after 1823. Bradley was with Marcus Merriman, Jr., as Bradley & Merriman from 1826 to 1842. At times he also worked alone and, probably from before 1840, with his son Gustavus, later as Z. Bradley & Son. He died in New Haven.

Bradley & Bunce. Richard Bradley, Bunce's first name unknown; working c. 1830 – c. 1835 in Hartford.

Bradley & Merriman. Zebul Bradley and Marcus Merriman, Jr.; working 1826–1842 in New Haven.

Brady, F. Working c. 1805 or later in Norwalk.

Brainard, C., & Son. Charles Brainard and his son Charles H.; working c. 1835–1850 in Hartford.

Brainard, Charles (1786–1850). Brainard was born in Hartford. He worked there 1809–1830 as a member of the firm of Ward, Bartholomew & Brainard. From c. 1835 to 1850 he and his son Charles H. worked there as C. Brainard & Son.

Brainard, Charles H. Worked with his father, Charles Brainard, as C. Brainard & Son from c. 1835 to 1850 in Hartford.

Breed, John (1752–1803). Breed was born in Stonington and died in Colchester, where he was working in 1776. He was also a tavern keeper and farmer in his later years.

Brewer, C., & Co. Charles Brewer; working c. 1810 in Middletown.

Brewer, Charles (1778–1860). Brewer was born in Springfield, Massachusetts, and learned his trade from Jacob Sargeant of Springfield and Hartford. He began business in Middletown in 1800 with partner Judah Hart as Hart & Brewer, and from 1800 to 1803 they made clocks and repaired watches, as well as being goldsmiths and silversmiths. From October 1803 to April 1805 he was in partnership with Alexander Mann as Brewer & Mann in Middletown and was still there c. 1810 as C. Brewer & Co. Brewer is thought to have been mainly a jeweler in later years; he may have died in Middletown. George Kippen probably learned his trade from him.

Brewer & Mann. Charles Brewer and Alexander Mann; working October 1803 to April 1805 in Middletown.

Brewster, Abel (1775–1807). He was born in Preston and began working 1796 in Canterbury; in 1804 he moved to Norwich. In 1805, because of poor health, he sold his place of business to Judah Hart and Alvan Wilcox.

Brooks, Jona. Probably the partner of John Proctor Trott in Trott & Brooks, working 1798 in New London.

Brooks, ———. A partner in Wheelers & Brooks, a firm whose mark is sometimes found with that of Seymour & Hollister, working in Hartford in 1845.

Brown, ———. Working c. 1805 in Connecticut (town unknown) as Brown & Mann (possibly Alexander Mann).

Brown, George B. Working in New Haven perhaps before 1830. He was the partner of John Burgis Kirby as Brown & Kirby, 1834–1850.

Brown & Kirby. George B. Brown and John Burgis Kirby; working 1834–1850 in New Haven and succeeded by the John B. Kirby Co.

Brown & Mann. Working c. 1805 in Connecticut (town unknown). Nothing is known of Brown; Mann may be Alexander Mann of Middletown.

Buel, Abel (1742–1822). Buel, known also as an inventor, type founder, engraver, and manufacturer, was born in Killingworth and died in New Haven. He learned his trade from his brother-in-law Ebenezer Chittenden in East Guilford (now Madison). He worked in Killingworth in 1762 but was convicted of counterfeiting, and he spent part of the time until 1766 in jail in New London and Killingworth. In Boston in 1767. In 1770 he worked for Chittenden in New Haven. He was in that city 1770–1774, 1777–1789 and 1796–1799. He was assisted in New Haven in 1774 by James Gordon, a journeyman goldsmith from Philadelphia. He worked also in Pensacola, Florida, 1774–1776; in England 1789 – c. 1793; in Hartford c. 1799 – c. 1803 and in Stockbridge, Massachusetts c. 1810. Samuel Shethar was his apprentice in 1774 in New Haven and continued with him briefly in Pensacola. He was the brother of John Buel. He was the partner of Mix as Buel & Mix in New Haven in 1798 and may be the Buel of Buel & Greenleaf (David, Jr.?) in Hartford c. 1801.

Buel, D. H. Working 1825 in Hartford.

Buel, John (1744–1783). Born in Killingworth, brother of Abel Buel. Working 1779–1780 in New Haven and 1781–1782 in Derby. He died in New Haven.

Buel, Samuel (1742–1819). Born in Killingworth, working 1777 in Middletown and 1780 in Hartford. Later, he moved to Westfield, Massachusetts, where he died.

Buel & Greenleaf. Abel(?) Buel and David, Jr.(?) Greenleaf; working c. 1801 in Hartford.

Buel & Mix. Abel Buel and a silversmith not further identifiable; working 1798 in New Haven.

Bull, Caleb (1746–1797). Bull was born in Hartford and was in partnership there with Norman Morrison c. 1780 as Bull & Morrison. Morrison was lost at sea in 1783. In 1788 Bull married Morrison's widow and in 1791 he advertised a set of silversmithing tools for sale. G. M. Curtis, in *Early Silver of Connecticut and Its Makers,* suggests that "Morrison was the silversmith of the firm," implying that Bull was simply a businessman. He died in Hartford.

Bull, G. W. Working 1840 in East Hartford.

Bull, Martin (1744–1825). Born and worked in Farmington. He was also known as an engraver, in which work Thomas Lee assisted him for a time.

Bull & Morrison. Caleb Bull and Norman Morrison; working c. 1780–1783 in Hartford.

Bunce, ———. Working c. 1830 – c. 1835 in Hartford with Richard Bradley as Bradley & Bunce.

Burdick, William S. Burdick was the partner of Thomas Ufford as Ufford & Burdick in New Haven from 1812 to 1814. He was in Ithaca, New York in 1815.

Burnap, Daniel (1760–1838). Burnap learned his trade from Thomas Harland of Norwich and began business in Coventry c. 1781. He moved c. 1785 to East Windsor, where he made gold beads, spoons and jewelry, and to Andover c. 1797. He considered clockmaking his principal trade before c. 1791 but he also worked as a silversmith, and later (before 1808) he taught silversmithing to Nathaniel Olmsted. Lewis Curtis probably learned his trade from Burnap in East Windsor.

Burnap, Ela (1784–1856). Burnap was born in Coventry. In 1810 in Boston, Massachusetts, he was listed in the directory as a watchmaker. He was working in Hartford in 1813, in New York City in 1817, in Eatontown, Georgia, in 1821, and in Rochester, New York (where he died) from 1825 to 1844.

Burnham, George (b. 1753). Working from 1776 in Hartford as goldsmith and jeweler.

Burr, Nathaniel (1698–1784). Born in Fairfield, where he worked as a watchmaker, jeweler and silversmith.

Burrill, Theophilus (d. 1739). Burrill probably worked before c. 1736 in Boston, Massachusetts; he worked c. 1736–1739 in New London, where he died.

Bushnell, Phineas (1741–1836). Bushnell was born in Saybrook. He moved to Guilford c. 1795. He died in Branford.

Camp, E. & E. E., & Co. Elias Camp and unidentified partner, working in Bridgeport in 1829.

Camp, Elias. Working 1825 in Bridgeport with George Kippen. Advertised there in 1829 in the firm of E. & E. E. Camp & Co.

Candee, L. B., & Co. Lewis Burton Candee; working from c. 1835 on in Woodbury.

Candee, Lewis Burton (1806–1861). Burton was born in Oxford. He was working c. 1825 in Woodbury; c. 1826 – c. 1831 with Daniel Curtiss there as Curtiss, Candee & Co.; with the addition of Benjamin Stiles, a former apprentice, c. 1831 – c. 1835, as Curtiss, Candee & Stiles. The firm of L. B. Candee & Co. also

worked in Woodbury, probably after 1835, although it is also recorded in other books as c. 1830.

Canfield, Samuel. Canfield lived in Middletown from 1780 to 1801 and advertised there from 1792 on. He had William B. Johonnot as an apprentice from 1782 to 1787 and was assisted by Joel Allen, who engraved clock faces for him from 1790 to 1792. Another apprentice was William Hamlin. Canfield was in partnership with William Foot(e) c. 1795–1796 as Canfield & Foot(e). He moved to Lansingburg, New York, in 1801 and was in partnership with someone named Hall in New York City in 1805 as Canfield & Hall. He was in Scanticoke, New York in 1807.

Canfield & Foot(e). Samuel Canfield and William Foot(e); working 1795–1796 in Middletown.

Carpenter, Charles. Carpenter was born in Norwich and trained there by his father Joseph with whom he worked in 1790. After his father's death he set up business in Boston, Massachusetts, where he was working from 1807 on.

Carpenter, Joseph (1747–1804). Carpenter was born in Woodstock. He was in business in Norwich in 1769 in a shop belonging to his stepfather. He taught his son Charles with whom he worked in 1790, and probably Rufus and Henry Farnum, all three of whom became silversmiths in Boston, and also Roswell Huntington. Carpenter advertised in 1797 in Canterbury. He was also an engraver and a clockmaker.

Case, George. Working 1779 in East Hartford as goldsmith, jeweler and watch repairer.

Chaffee, ———. Partner in Root & Chaffee, whose mark appears together with that of W. Pitkin on East Hartford spoons c. 1820 – c. 1830.

Champlin, John (1745–1800). Champlin worked in New London, where he advertised 1768–1785. His shop was robbed in 1779 and then destroyed by the British in the burning of New London in September 1781. By November he had erected a new shop on Main Street.

Chapell, Hiram F. Working c. 1845 – c. 1850 in Hartford; with L. D. Roberts there c. 1850 as Chapell & Roberts.

Chapell & Roberts. Hiram F. Chapell and L. D. Roberts; working c. 1850 in Hartford.

Chapin, Aaron (1753–1838). He was born in Windsor and worked in Hartford. He is known as a cabinet maker, but the Hartford Directory of 1825 listed him as a jeweler. George Munson Curtis, *Early Silver of Connecticut and its Makers, 1913,* mentions silver spoons bearing his name found in Hartford and vicinity.

Chapin, Alexander. Working c. 1838 or c. 1846 in Hartford.

Childs, ———. Partner in Bolles & Childs, working c. 1840 in Hartford.

Chittenden, Beriah (1751–1827). Beriah, probably trained by his father Ebenezer Chittenden, was working 1787 in New Haven. He worked also in Durham, Milford, and Salisbury; in Kinderhook, New York, c. 1800; and in Middlebury, Ohio, probably in the 1820's.

Chittenden, Ebenezer (1726–1812). Chittenden, father of Beriah Chittenden, was born in East Guilford (now Madison). He worked at first in East Guilford and from c. 1770 to 1812 in New Haven, where he died. Abel Buel, his brother-in-law, learned the trade from him in East Guilford and worked with him in 1770. Chittenden assisted Eli Whitney.

Church, Joseph (1794–1876). Church was born in East Hartford and moved as a child to Lee, Massachusetts. He returned to Hartford as a youth to learn the silversmith's trade, probably from Jacob Sargeant. He also worked with Horace Goodwin in Hartford before setting up in business by himself there c. 1818. William Rogers, C. C. Strong, and L. T. Welles were among his apprentices, and he was a partner with Rogers in Hartford as Church & Rogers from 1825 to 1836. Church sold his business to Strong and Welles in 1840 and became an insurance company and bank executive. The painter Frederick E. Church was his son.

Church & Rogers. Joseph Church and William Rogers; working 1825–1836 in Hartford.

Clark, ———. Working 1820 in Norwich with Thomas Chester Coit as Clark & Coit.

Clark, Joseph (d. 1821). Clark was working in New York City in 1768. He was living in Danbury c. 1777 and advertised from there until 1791 as goldsmith, silversmith, clockmaker and watchmaker. From before 1811 to after 1817 he was in Newburgh, New York. Subsequently he moved to Alabama, where he died.

Clark, Levi (1801–1875). Clark was born in Danbury and learned his trade there from his father-in-law, John Starr Blackman. By 1825 he was in business in Norwalk, probably as a partner in Clark & Brother.

Clark, Peter G. (1793–1860). Began working 1810 in New Haven; died in Cheshire.

Clark, William (1750–1798). Clark was born in Colchester and died in New Milford. He settled in New Milford c. 1774 as a silversmith, clock and watchmaker, and tavernkeeper, and advertised there in 1774 and 1777.

Clark & Brother. Working c. 1825 in Norwalk. Probably Levi Clark; brother's name is not known.

Clark & Coit. Working 1820 in Norwich. Clark's first name is unknown; his partner is Thomas Chester Coit.

Cleveland, Aaron Porter (1782–1843). He was born and worked in Norwich, but died in Boston. Brother of William.

Cleveland, William (1770–1837). Cleveland was born in Norwich and died in Black Rock, New York. He was apprenticed to Thomas Harland in Norwich and worked as a silversmith, jeweler, and clockmaker. From 1792 until 1794 he was in partnership with John Proctor Trott in New London as Trott & Cleveland. He was in Norwich or New London c. 1805 and perhaps worked for a time in New York. From c. 1808 to c. 1812 he was in Ohio, working in Salem, Worthington, and Putnam (now Zanesville). He was back in Norwich c. 1812 and was probably in partnership there in 1815 in the firm of Cleveland & Post. He may also have been a partner there c. 1825 in Cleveland & Hart (possibly with Eliphaz Hart). He was a brother of Aaron Cleveland and a grandfather of President Grover Cleveland.

Cleveland & Hart. Working c. 1825 in Norwich. Neither partner's identity is certain; they were possibly, William Cleveland and Eliphaz Hart.

Cleveland & Post. Working 1815 in Norwich. Probably William Cleveland, but Post has not been identified. It is unlikely that this is Samuel Post of New London, who would have been seventy-nine years old at this time, unless he had been in business earlier with William Cleveland in Norwich and the name of the firm was retained later.

Coit, Edward (1802–1839). He was born and worked in Norwich as a gold and silversmith and jeweler. He was the brother of Thomas Chester Coit.

Coit, Thomas Chester (1791–1841). Coit was born in Norwich. His family moved to Pomfret and then to Canterbury, where he was apprenticed to a jeweler at age fourteen. He worked fourteen years in Norwich, part of the time (1816–1819) with Elisha Hyde Mansfield as Coit & Mansfield. In 1820 he was working with someone named Clark as Clark & Coit. By 1826 he had moved to Natchez, Mississippi and in 1835 to New York, where he died. He was the brother of Edward Coit.

Coit & Mansfield. Thomas Chester Coit and Elisha Hyde Mansfield; working 1816–1819 in Norwich.

Cole, John A. Working 1830–c. 1839 in the New Britain–Berlin area with Asa Harris Rogers as Rogers & Cole; working in New York City 1840–1859.

Connor, John H. Working 1836 in Norwalk.

Cook, ———. Partner in King & Cook, working early in the nineteenth century in

a Westfield, perhaps Westfield, Connecticut. (There are towns named West-
field in most of the northeastern states.)

Copp, Joseph (1732–1813). Working c. 1757 – c. 1776 in New London.

Cornwell, Nathaniel (1776–1837). Worked in Danbury and 1816–1817 in Hudson,
New York.

Crittenden, Jonathan. Working 1793 in Berlin.

Crittenden, Nathaniel (1752–1828). He was born in Guilford, but worked for
twenty-one years in Berlin before moving to Middletown, and later to New
Haven and Hamden, where he died.

Cummings, George. Working c. 1843 in Hartford.

Curtis, Francis. Working c. 1845 in Woodbury.

Curtis, Joel (1786–1844). Silversmith and clockmaker. Born and worked at first in
Wolcott. Around 1810 he was working in Cairo, New York, and c. 1830 there
as J. Curtis & Co. He died there.

Curtis, Lewis (1774–1845). Curtis was born in Coventry and probably learned his
trade from Daniel Burnap in East Windsor. He worked as silversmith and
clockmaker in Farmington, where he advertised in 1797 and 1799. He moved
to Burlington, Vermont around 1803, to St. Charles, Missouri in 1820, and
later to Hazel Green, Wisconsin, where he died.

Curtiss, ——. Of Curtiss & Company, working early in the nineteenth century,
possibly D. Curtiss in Woodbury.

Curtiss, Daniel (1801–1878). Curtiss worked in Woodbury from 1825: c. 1826 – c.
1831 with Lewis Burton Candee as Curtiss, Candee & Company; c. 1831 – c.
1835 with the firm's former apprentice Benjamin Stiles in addition, as Curtiss,
Candee & Stiles; after c. 1835 as Curtiss & Stiles to 1840, when the business was
discontinued.

Curtiss, ——, & Co. Working early in the nineteenth century, possibly D. Curtiss
in Woodbury.

Curtiss & Stiles. Daniel Curtiss and Benjamin Stiles; working in Woodbury from
c. 1835 to 1840, when the business was discontinued.

Curtiss, Candee & Co. Daniel Curtiss and Lewis Burton Candee; working c. 1826 –
c. 1831 in Woodbury.

Curtiss, Candee & Stiles. Daniel Curtiss, Lewis Burton Candee, and Benjamin
Stiles; working c. 1831 – c. 1835 in Woodbury.

Cutler, Eben. Working in New Haven before and after 1820 and in Massachusetts, 1846.

Cutler, R., & Sons. Richard Cutler and his sons Richard Jr. and William; working 1800–1810 in New Haven.

Cutler, Richard (1736–1810). Cutler was born in Fairfield, and worked from 1760 to 1810 in New Haven. In 1767 he advertised there with Hezekiah Silliman and Ambrose Ward as goldsmiths and jewelers. He took his sons Richard Jr., and William into business with him as R. Cutler & Sons, 1800–1810. He died in New Haven.

Cutler, Richard, Jr. (1774–1811). Probably born and died in New Haven where he worked with his father and his brother William as R. Cutler & Sons, 1800–1810.

Cutler, William (1785–1817). Probably born and died in New Haven, where he worked with his father and brother Richard, Jr. as R. Cutler & Sons, 1800–1810.

Davi(d)son, Barzillai (1740–1828). Born in Pomfret and worked in Norwich, where he advertised in 1775 and 1795, and where he died.

Davi(d)son, Charles. Working 1805 in Norwich.

Day, ———. Partner in Bolles & Day, working c. 1825 in Hartford.

Deming, ———. Partner in Deming & Gundlach, working c. 1840 in Hartford.

Deming & Gundlach. Working c. 1840 in Hartford.

Dennis, Ebenezer (b. 1753). Working 1782–1785 in Hartford as silversmith, jeweler, brazier and founder. Brother of George, Jr.

Dennis, George, Jr. (b. 1749). Working in Norwich from where he advertised in 1778 and 1780. Brother of Ebenezer.

Deshon, Daniel (1698–1781). Deshon was born in Norwich, where he was apprenticed to René Grignon, who bequeathed Deshon his tools in 1715. He finished his apprenticeship under a Boston silversmith, probably John Gray, who was probably working in New London after 1713. Deshon set up in business in New London.

Dexter, Minerva (b. 1785). Dexter was born in North Coventry and worked in Middletown, from where he advertised in 1807 and 1810.

Dickinson, Anson (1780–1852). He is known as a miniaturist but apparently made a few silver spoons. Originally in Litchfield, he moved to New York c. 1800.

Disbrow, Charles E. Working 1815–1840 in Norwalk; also listed c. 1825 in New York City.

Dodd, Thomas (1787–1824). Formed partnership 1811 in Hartford with Horace Goodwin as Goodwin & Dodd until c. 1821. They were clock and watchmakers, and gold and silversmiths.

Dodge, Ezra (1766–1798). He was apprenticed to Thomas Harland in Norwich, and worked in New London, from where he advertised 1787–1795 as a clock and watchmaker. He died in New London in the yellow fever epidemic of 1798. His obituary states that he was also a gold and silversmith, brass founder, gunsmith, locksmith and grocer.

Doolittle, Amos (1754–1832). Doolittle was born in Cheshire. He learned his trade from Eliakim Hitchcock, probably in Cheshire. Around 1775 Doolittle began working in New Haven. Although he started his career as a silversmith and jeweler, he is better known as an engraver. He died in New Haven.

Doolittle, Enos (1751–1806). Working 1772–1802 in Hartford. He was principally a clock and watchmaker, brass founder (c. 1787) and bell founder (c. 1790) but apparently also worked as a silversmith.

Doolittle, Isaac (1721–1800). Doolittle was born and died in New Haven, and worked there from 1748 to 1800. He has previously been known only as a clockmaker, but silversmith's tools are listed as part of his estate inventory.

Douglas, Robert (1740–1776). Advertised as a gold and silversmith 1766–1769 in New London. He died in Canterbury during the Revolution, on his way home from Boston to New London.

Eddy, ———. Working in Tolland c. 1832. His partner in the firm of Eddy & Barrows may have been James Madison Barrows.

Eddy & Barrows. Eddy (first name unknown) and possibly James Madison Barrows; working c. 1832 in Tolland.

Elderkin, Alfred (1759–1833). Born in Windham, he was working there 1790–1792 as the partner of John Staniford in Elderkin & Staniford.

Elderkin, Elisha (1754–1822). Born in Killingworth, Elderkin was working in New Haven by 1777. After the Revolution he returned to Killingworth. He died in Clinton.

Elderkin & Staniford. Alfred Elderkin and John Staniford; working 1790–1792 in Windham.

Elliott, John Aaron (1788–1864). He was born and worked the early part of his life in Sharon. At first a printer, then a watchmaker and silversmith, Elliott

lived for a time in Red Hook, New York c. 1850, and in Michigan. He eventually returned to Sharon and is listed in the Connecticut Business Directory in 1857.

Ellsworth, David (1742–1821). Working from 1763 on in Windsor, where he advertised thefts from his shop in 1771 and 1774. He was also a clockmaker, watch repairer, gunsmith, and dentist.

Fairchild, Joseph. Working 1824–1837 in New Haven.

Fairchild, Robert (1703–1794). Born in Stratford, Fairchild moved with his family to Durham, where he learned his trade. He was prominent in civic affairs 1739–1745. After 1747 he moved back to Stratford, where John Benjamin may have worked with him. He was still working there in 1764. He worked in New Haven 1767–1789; he advertised there in 1767 and 1774 as goldsmith and jeweler, then in 1784 as publican (having previously advertised West India rum in 1779). After 1789 he moved to Pawling, New York where he died.

Fitch, Allen (1785–1839). Working from 1808 in New Haven as gold and silversmith, watch repairer, and jeweler. In partnership there with Joshua Hobart as Fitch & Hobart in 1813. Fitch worked in New Bern, North Carolina from c. 1817 until after 1828. He died in New Haven.

Fitch & Hobart. Allen Fitch and Joshua Hobart; working 1813 in New Haven.

Foot(e), William (b. 1772). Foot(e) was born in Colchester. From c. 1795 until 1796 he worked with Samuel Canfield in Middletown in the firm of Canfield & Foot(e). They seem to have dealt especially in clocks and watches. He moved to East Haddam in 1796. He also lived in Colchester, Glastonbury and Middle Haddam. Later he moved to Michigan, where he died.

Ford, George H. Associated with Everard Benjamin in the firm of Benjamin & Ford, working in New Haven, mid-nineteenth century.

Fox, Andrew W. Working c. 1843 in Hartford.

Francis, Julius C. (1785–1858). Originally from Wethersfield, he worked in Middletown. He was associated with Edmund Hughes there as Hughes & Francis, 1806–1809, in the watch and clockmaking and jewelry business, although they did handle some silverware. He died in Middletown.

Francis, Justus. Working c. 1850 in Hartford.

Freeman, ———. Partner in Norton & Freeman, whose mark appears together with that of W. Pitkin on East Hartford spoons c. 1820 – c. 1830.

Gallup, Christopher (1764–1849). Born and worked in North Groton (now Ledyard).

Gardner, John (1734–1776). Born in New London, where he was working from c. 1760 on. He learned the silversmith's trade from his uncle Pygan Adams.

Gilbert, Samuel (1775–1850). He was born and died in Hebron, where he advertised in 1798.

Gillet, Samuel. Working 1800–1805 in Berlin; also a watch repairer. Possibly the Samuel Gillett, Jr. who was born c. 1759 and was living in Canaan, New York, in 1790.

Goodwin, Allyn (1797–1869). Worked in Hartford with his younger brother Horace as H. & A. Goodwin 1821–1825. Allyn may not have been trained as a silversmith. He died in Hartford.

Goodwin, H. & A. The brothers Horace and Allyn Goodwin; working 1821–1825 in Hartford.

Goodwin, Horace (1787–1864). He was born and died in Hartford, where he learned the trades of silversmith and jeweler. He located at first in New Britain, then he moved to Vermont. In 1810 he returned to Hartford and bought Nathan Allyn's business. In 1811 he took over the business of Heydorn & Imlay with a partner, Thomas Dodd, with whom he worked as Goodwin & Dodd until July 1821. Joseph Church trained with them there before 1818. From 1821 to 1825 he was in partnership with his older brother Allyn Goodwin as H. & A. Goodwin. Thereafter he advertised alone in Hartford until 1852, when he went into the music business.

Goodwin, Ralph (1793–1866). Born and died in Hartford, where he was listed in the 1828 Directory.

Goodwin & Dodd. Horace Goodwin and Thomas Dodd; working 1811–1821 in Hartford.

Gordon, ———. Working c. 1825 or later in New London.

Gorham, John (1789–1874). Gorham was born in New Haven and was working there as silversmith and jeweler before and after 1813–1815. He died in Hamden. He was a nephew of Miles Gorham and a cousin of Richard Gorham.

Gorham, Miles (1756–1847). Gorham was born and died in New Haven. He worked there 1790–1840. Uncle of John Gorham, and father of Richard Gorham.

Gorham, Richard (1775–1841). Son of Miles. Working 1806–1809 in New Haven, with Samuel Shethar as Shethar & Gorham. He died in New Haven. He was a cousin of John Gorham.

Graham, Daniel (1764–1798). He was born in West Suffield, from where he advertised in 1789 and later.

Gray, John (1692–1720). Gray was born in Boston, Massachusetts, and died in New London. He learned his trade from John Coney. He came from Boston to New London c. 1713 to administer the estate of his brother, the silversmith Samuel Gray. He may have had Daniel Deshon as apprentice, probably in New London, after the death in 1715 of Deshon's first master, René Grignon.

Gray, Samuel (1684–1713). Gray, the brother of John Gray, was born in Boston, Massachusetts, where he learned the silversmith's trade from John Coney. He then moved to New London, where he was married in 1707, and where he died in 1713.

Green, ———. Working c. 1843 in Hartford.

Green, Thomas. Advertised in Bridgeport in 1821 as a clockmaker, silversmith, and jeweler from London.

Greenleaf, David (1737–1800). Greenleaf was born in Bolton, Massachusetts. He began business in Norwich c. 1761. From c. 1769 to c. 1772 he worked in Lancaster, Massachusetts. He then moved to Windham, and from c. 1778 on he was in Coventry, where he died. David, Jr. and William were his sons.

Greenleaf, David, Jr. (1765–1835). Born in Norwich, son of David Greenleaf. Apprenticed to Thomas Harland in Norwich. Working from 1788 on in Hartford as a clockmaker and silversmith. Elijah Yeomans worked with him c. 1793; perhaps in partnership with Abel Buel c. 1801. In partnership with Frederick Oakes as Greenleaf & Oakes 1804–1807 in Hartford. Around 1811 discontinued silversmithing in favor of dentistry and real estate. He died in Hartford.

Greenleaf, Joseph (1778–1798). Died in New London of yellow fever.

Greenleaf, William. Born in Coventry, son of David, Sr., who probably taught him the trade. Working c. 1804 in Hartford, and from July 1810 on in Stockbridge, Massachusetts, where he probably died sometime after 1854.

Greenleaf & Oakes. David Greenleaf, Jr. and Frederick Oakes; working 1804–1807 in Hartford.

Grignon, René (d. 1715). Grignon, a Huguenot, came to America in the late seventeenth century and joined the French settlement at Oxford, Massachusetts, but trouble with the Indians forced him to move to East Greenwich, Rhode Island. About 1696 he went to Boston, Massachusetts. He moved back to Oxford in 1699, but left again after the Deerfield massacre of 1704, probably settling in Norwich before 1708. He died in Norwich, leaving his tools to his apprentice Daniel Deshon, and releasing another apprentice, James Barrett.

Griswold, Gilbert (b. 1788). Born in Killingworth. Working c. 1810 – c. 1825 in Middletown and Portland. Brother of William.

Griswold, William. Probably born in Killingworth. Working c. 1820 in Middletown and Portland. Brother of Gilbert.

Gundlach, ———. Partner in Deming & Gundlach, working c. 1840 in Hartford.

Gunn, E., & Co. Enos Gunn; working in the first decade of the nineteenth century in Waterbury.

Gunn, Enos (1770–1813). Gunn was born in the Middlebury-Naugatuck region known as Gunntown. He worked in Waterbury c. 1792, and later there, in the first decade of the nineteenth century, as E. Gunn & Co. He died in Waterbury.

Gurley, William (1769–1844). Born in Mansfield; advertised 1804 in Norwich. Probably died in Mansfield.

Hall, ———. Partner of Nathaniel Wade in Hall & Wade, working c. 1793 – c. 1798 in Newfield. They appear to have been principally in the clock and watch business.

Hall, D. G. His mark is found together with those of L. T. Welles (working c. 1840 in Hartford) and A. S. Tain.

Hall & Wade. ——— Hall (not further identifiable) and Nathaniel Wade, working c. 1793 – c. 1798 in Newfield.

Hallam, John (1752–1800). Born in New London, where he was working from 1773 on as goldsmith, jeweler, and engraver. He died in New London.

Hamlin, William (1772–1869). Hamlin was born in Providence, Rhode Island. He was apprenticed to Samuel Canfield in Middletown and set up his business there c. 1791. By 1795 he had returned to Providence, where his principal trade was engraving. He died in Providence.

Hanks, Benjamin (1755–1824). Hanks was born in Mansfield; he may have been apprenticed for a few years to Thomas Harland in Norwich. He worked 1777–1779 in Windham, 1779–1790 in Litchfield, and after 1790 in Mansfield. He was a watch and clockmaker, gold and silversmith, also an inventor of "air clocks" and a bell founder.

Harland, Thomas (1735–1807). Harland was born in England and died in Norwich. He was apprenticed in England and traveled extensively on the Continent. In 1773, he arrived in Boston and soon settled in Norwich, where he worked as a watchmaker, clockmaker, jeweler, and silversmith. Among his apprentices were David Greenleaf, Jr., Nathaniel Shipman, William Sloan, William Cleveland, and the clockmakers Eli Terry, Daniel Burnap, Ezra Dodge, and possibly Benjamin Hanks. Thomas Harland, Jr., was his son.

Harland, Thomas, Jr. (1781–1806). Son of Thomas Harland; worked in Norwich, where he appears to have been principally in the watch business.

Hart, ———. Partner in Cleveland & Hart, working c. 1825 in Norwich. Neither partner's identity is certain. They were, possibly, William Cleveland and Eliphaz Hart.

Hart, Eliphaz (1789–1866). Hart was born in New Britain. He learned his trade in Norwich from his brother, Judah Hart. Eliphaz settled in the Greenville section of Norwich, where he worked with Judah as Hart & Hart, c. 1810 – c. 1816, and where he may also have been a partner (possibly with William Cleveland) in Cleveland & Hart, c. 1825.

Hart, Judah (1777–1824). Hart was born in New Britain. He began business as a watch and clockmaker in 1800 in Middletown in partnership with Charles Brewer as Hart & Brewer. In 1803 he formed a new partnership there with Jonathan Bliss as Hart & Bliss. In 1805 he moved to Norwich, where with Alvan Wilcox he purchased the business of Abel Brewster, operating as Hart & Wilcox. In 1807 Wilcox sold his share of the business to Hart. He worked c. 1810 – c. 1816 as Hart & Hart with his brother Eliphaz, to whom he had taught the trade. In 1816 he sold his business to Coit & Mansfield and moved to Griswold, Maryland, and from there to Brownsville, Ohio, in 1822, where he died.

Hart & Bliss. Judah Hart and Jonathan Bliss; working 1803–1805 in Middletown.

Hart & Brewer. Judah Hart and Charles Brewer; working 1800–1803 in Middletown.

Hart & Hart. The brothers Judah and Eliphaz Hart; working c. 1810 – c. 1816 in Norwich.

Hart & Wilcox. Judah Hart and Alvan Wilcox; working 1805–1807 in Norwich.

Hayes, W. Working c. 1780, possibly in Connecticut.

Hempsted, Daniel B. (1784–1852). Worked and died in New London. Probably the partner of Asa Spencer in the firm of Spencer & Hempsted, working 1806 in New London. (A silversmith of this name was in business with Nathaniel Saltonstall as Daniel B. Hempsted & Co. around 1821 in Eatonton, Georgia.) Daniel's business was continued by his son of the same name.

Hempsted, Elisha. Working as watch and clock repairer and silversmith in Litchfield in 1823.

Hequembourg, Charles (1788–1875). Son of Charles Hequembourg, Jr.; working 1809–1820 in New Haven; also worked in St. Louis, Missouri. He died in Webster Groves, Missouri.

Hequembourg, Charles, Jr. (1760–1851). Hequembourg, Jr. was born in France. He came to Hartford c. 1790; in 1804 he bought land in New Haven and adver-

tised from there as watchmaker and silversmith 1809–1822. He worked in Albany, New York, 1823–1826; in New York City 1827–1829; then in Buffalo, New York, 1835–1842. He was principally a jeweler and watchmaker. Charles Hequembourg was his son.

Heydorn, C. Partner with R. Imlay in Heydorn & Imlay, working 1809 in Hartford.

Heydorn & Imlay. C. Heydorn and R. Imlay, working 1809 in Hartford. They sold their place of business to Horace Goodwin and Thomas Dodd in 1811.

Hill, C. F. Working c. 1845 in Canandaigua, New York; c. 1850 in Hartford.

Hilldrup, Thomas (d. 1804). Hilldrup was probably born in Great Britain. He was trained in London as a watchmaker, jeweler, and silversmith. He moved c. 1772 from London to Hartford, where he advertised 1772–1775. He was appointed Postmaster in 1777, and continued to advertise 1783–1794, especially for watch repair.

Hitchcock, Eliakim (1726–1788). Hitchcock was born and died in Cheshire. He worked from 1757 to 1787, part of the time in Cheshire, the rest in New Haven. Amos Doolittle was apprenticed to him, probably in Cheshire.

Hobart, Joshua. Partner of Allen Fitch in Fitch & Hobart, working 1813 in New Haven. Hobart also worked in 1809 in Boston, Massachusetts, and at some time in New Bern, North Carolina.

Hollister, Julius (1818–1905). Partner of Oliver D. Seymour in Seymour & Hollister, working 1845 in Hartford. Hollister worked in Owego, New York, in 1846, and also in Greenfield, Massachusetts.

Holmes, Israel (1768–1802). Holmes was born in Greenwich but had moved to Waterbury by 1790. He died in British Guiana while on a visit there for a silver-mining company.

Hopkins, Jesse (1766–1836). He was born in Waterbury, where he learned the silversmith's trade from his father Joseph. He followed this trade in Waterbury for a time, then he moved to New York. He died in Henderson, New York. Brother of Joseph Hopkins, Jr.

Hopkins, Joseph W. (1730–1801). He was born in Waterbury and was in business there c. 1760. His shop, which was burglarized three times between 1766 and 1772, burned down in 1780. Later in life Hopkins became a Judge of the Probate Court. Jesse and Joseph, Jr. were his sons.

Hopkins, Joseph, Jr. (1760–1829). Born in Waterbury, son of Joseph, brother of Jesse. Died in Rutland, New York.

Hopkins, Stephen (1721–1796). Born and worked in Waterbury. Died in Goshen.

Hotchkiss, Hezekiah (1729–1761). Born in New Haven, where he worked from 1748 on. Hotchkiss was primarily a clockmaker, but Probate Records list silversmith's equipment as part of his estate. He was also a blacksmith and practiced dentistry.

Hoyt, George B. Working 1829 in Middletown. Worked 1830–1850 in Albany, New York, where he formed partnerships with George Kippen as Hoyt & Kippen c. 1830 and with William Boyd as Boyd & Hoyt, 1830–1832.

Hughes, Edmund (1787–1851). Trained by Eleazer Baker in Ashford, Hughes was working in Hampton in 1804. He also worked in Middletown, where he formed partnerships with John Ward as Ward & Hughes, 1805–1806; with Jonathan Bliss as Hughes & Bliss in 1806; and with Julius C. Francis as Hughes & Francis, 1806–1809. He was buried in Middletown.

Hughes & Bliss. Edmund Hughes and Jonathan Bliss; working 1806 in Middletown.

Hughes & Francis. Edmund Hughes and Julius C. Francis; working 1806–1809 in Middletown.

Huntington, Philip (1770–1825). Working from c. 1795 on in Norwich.

Huntington, Roswell (1763–1836). Huntington was born in Norwich, where he learned his trade from Joseph Carpenter. He was working there in 1784 as a goldsmith and jeweler, but moved to Hillsboro, North Carolina in 1786 and subsequently to Alabama, where he died.

Imlay, R. Partner with C. Heydorn in Heydorn & Imlay, working 1809 in Hartford.

Jackson, A. Working 1840 in Norwalk.

Jackson, Thomas (1727–1806). Clockmaker and silversmith originally from England. Working in Portsmouth, New Hampshire; Kittery, Maine; and Preston, where he died.

Jarvis, Munson (1742–1825). Working from 1765 on in Stamford as a silversmith and blacksmith. As a loyalist, Jarvis left the country in 1783 and settled in Saint John, New Brunswick, where he died.

Jastram, ———. Partner in Robinson & Jastram, working from 1810 on in New Haven.

Jennings, Jacob (1739–1817). Born in Fairfield, working before 1763 in Norwalk. His son Jacob, Jr., and his nephew, Isaac Marquand, were apprenticed to him there, the latter from 1780 to 1787.

Jennings, Jacob, Jr. (b. 1779). Born in Norwalk, where he was working c. 1810. He

learned his trade from his father, Jacob Jennings. Subsequently he moved to New London.

Johnson, Miles. Working 1767 in Wallingford.

Johonnot, William B. (1766–1849). Born in Middletown. Apprenticed in 1782 to Samuel Canfield in Middletown for five years; he began business there in 1787. Partner of Isaac Sanford as Sanford & Johonnot in Hartford 1789–1790. In 1792 he moved to Windsor, Vermont, where he worked as a jeweler and silversmith.

Keeler, A. Working c. 1800 in Norwalk.

Keeler, Joseph (1786–1824). Silversmith and watchmaker; working 1810 in Norwalk.

Kierstede (Kierstead), Cornelius (1675–1757). Kierstede was born in New York City and died in New Haven. He was made a freeman in New York City in 1698. He worked in New York City until c. 1724 and also in Albany, New York c. 1704–c. 1706. He worked in New Haven c. 1724–c. 1750. In 1721, Kierstede and two other New York men leased land in Mount Carmel (near Hamden) and Wallingford to mine copper, an enterprise which apparently proved unsuccessful. A New Haven map of 1724 shows Kierstede's home, but a New Haven deed of 1727 calls him "a goldsmith of New York" (a title by which he might still have been known for several years after moving to New Haven, however). Because of his advanced age and infirmities, he was placed in 1753 in the care of a conservator in New Haven.

King, ———. Partner in King & Cook, working early in the nineteenth century in a Westfield, perhaps Westfield, Connecticut. (There are towns named Westfield in most of the northeastern states.)

King, Joseph. Working 1776 in Middletown, but was apparently not successful in business. He was in residence there in 1807.

King & Cook. Working early in the nineteenth century in a Westfield, perhaps Westfield, Connecticut. (There are towns named Westfield in most of the northeastern states.)

Kinne, I. Working 1830 in Norwich.

Kinney or Kinne, Thomas (1785–1824). Working 1807 in Norwich.

Kippen, George (1790–1845). Kippen was born in Middletown, where he probably learned his trade from Charles Brewer. He was in Bridgeport in 1815 at which time he may have been in partnership with Barzillai Benjamin. He was in business by himself in 1821, and worked there with Elias Camp in 1825. Around 1830 he was in Albany, New York, working with George B. Hoyt as Hoyt & Kippen.

Kirby, John B., Co. Successor, in 1850, to the firm of Brown & Kirby in New Haven.

Kirby, John Burgis (1813–1880). Kirby was born in Middletown and died in New Haven. He was working 1834–1880 in New Haven, in partnership with George B. Brown as Brown & Kirby until 1850. The firm of Brown & Kirby was succeeded by the John B. Kirby Co.

Kirtland (Kirkland), Joseph P. (b. 1770). Born in Norwich; working c. 1797 – c. 1799 in Middletown.

Lathrop, Rufus (1731–1805). Worked in Norwich.

Lee, I. or J. Working probably c. 1800 in Connecticut, perhaps in or near Middletown.

Lee, Thomas (1717–1806). Worked in Farmington, part of the time with Martin Bull.

Lewis, Isaac (1773–1860). Lewis was born in Monroe and was working in Huntington in 1796. By 1809 he had moved to Ridgefield, where he was working in 1815. Probably made only spoons.

Lindergreen, Magnus. Working c. 1807 – c. 1809 in Litchfield as gold and silversmith.

Lindsley, Clark. Working 1843–1850 in Hartford.

Lord, Benjamin (1770–1843). Lord was born in Norwich and may have worked there. He worked in Stockbridge, Massachusetts in 1796; in Rutland, Vermont with Nicholas Goddard as Lord & Goddard, c. 1797–1807; and in Athens, Georgia with William P. Sage as B. B. Lord & Co., 1831–1839. He died in Athens.

Loud, Asa (1765–1823). Working 1792 in Hartford, in which year he sold his shop to a James Spencer. Loud is reported to have absconded in 1807.

Main, David (1752–1843). Born and worked in Stonington.

Mann, ———. Partner in Brown & Mann, working c. 1805 in Connecticut (town unknown). Mann may be Alexander Mann of Middletown.

Mann, Alexander (b. 1777). Mann was born in Hebron. From October 1803 to April 1805, he was the partner in Middletown of Charles Brewer as Brewer & Mann. He may have been the Mann of Brown & Mann, working c. 1805 in Connecticut (town unknown). Mann later became a gunmaker.

Mansfield, Elisha Hyde (b. 1793). Born and died in Norwich, where he was work-

ing from 1816 on. In partnership there with Thomas Chester Coit as Coit & Mansfield 1816 – c. 1819. They had bought the business of Judah Hart.

Marble, Simeon (1777–1856). Working alone in New Haven in 1800; in partnership there with Clark Sibley 1801–1806 as Sibley & Marble. Marble then worked alone, advertising until 1822, and perhaps continued to use the Sibley & Marble punch mark at first. He seems to have been a purveyor of gold and silver ware, as well as a silversmith, and also a dentist. He died in New Haven.

Marquand, Isaac (1766–1838). Marquand was born in Fairfield and died in Brooklyn, New York. He was apprenticed 1780–1787 to his uncle Jacob Jennings in Norwalk. Around 1787 he was in Fairfield, working as the partner of B. Whiting from Norwich, as Whiting & Marquand. From 1791 to 1796 he was in business as gold and silversmith, clock and watchmaker in Edenton, North Carolina; he then returned to Fairfield. In 1800, he set up business as a jeweler and watchmaker in Savannah, Georgia, and from 1804 until after 1823 he was a partner in a number of goldsmiths' firms there. He also maintained a jewelry and watchmaking business in New York City from before 1809 on. Later this firm was an importer of Sheffield plate. He was also associated with a goldsmith's firm in New Orleans, Louisiana.

Marsh, Samuel, 4th. Working 1793 in Hartford.

Merriman, Marcus (1762–1850). Merriman was born in Wallingford and died in New Haven. He was working alone in New Haven 1787–1802; he went on to form partnerships there in 1802 with his former apprentice Bethuel Tuttle as Merriman & Tuttle; and 1802–1817 with Tuttle (to 1813) and Zebul Bradley, also formerly his apprentices, as Marcus Merriman & Co. From 1817 to 1826, he and Bradley (and Charles O'Neil after 1823) were working together as Merriman & Bradley. Merriman was the son of Silas Merriman, the brother of Samuel, and the father of Marcus, Jr.

Merriman, Marcus, & Co. Marcus Merriman, Bethuel Tuttle (to 1813), and Zebul Bradley; working 1802–1817 in New Haven.

Merriman, Marcus, Jr. (1792–1864). Son of Marcus Merriman; working 1826–1842 in New Haven with Zebul Bradley as Bradley & Merriman.

Merriman, Reuben (1783–1866). Born probably in Torrington. Working 1810 in Cheshire and from 1827 on in Litchfield as clock and watchmaker, jeweler and silversmith. He is buried in Litchfield.

Merriman, Samuel (1771–1805). Merriman was born in Cheshire and died in New Haven where he worked from 1794 to after 1803. He was the son of Silas Merriman and the brother of Marcus.

Merriman, Silas (1734–1805). Merriman was born in Wallingford and died in New Haven. He was probably apprenticed to Macock Ward in Wallingford. He

moved from Cheshire to New Haven in 1766, where he was in business until 1805. Merriman, also know as a clockmaker, was the father of Marcus and Samuel Merriman.

Merriman & Bradley. Marcus Merriman and Zebul Bradley, with Charles O'Neil after 1823; working 1817–1826 in New Haven.

Merriman & Tuttle. Marcus Merriman and Bethuel Tuttle; working 1802 in New Haven.

Merrow, Nathan (1758–1825). Born in Lyme. Working 1783 in East Hartford, where he died.

Minor, Richardson (1736–1797). Working in Stratford, where he died.

Mix, ———. Partner of Abel Buel in Buel & Mix, working 1798 in New Haven.

Morgan, Chauncey. Working c. 1850 in Hartford.

Morgan, Lewis. Working c. 1843 in Hartford.

Morrison, Norman (d. 1783). Working c. 1780–1783 in Hartford as the partner of Caleb Bull in Bull & Morrison. Morrison was lost at sea in 1783. Bull married his widow in 1788 and in 1791 he advertised a set of silversmith's tools for sale.

Moss, Isaac Nichols (1761–1840). Born in Derby, where he was working in 1781.

Munson, Amos (1753–1785). Working 1776 in New Haven, where he was born and died.

Munson, Cornelius (b. 1742). Born and worked in Wallingford up to the Revolution. Munson was reported to have died in the British army.

Myers, Myer (1723–1795). Myers was born and died in New York City, where he worked from 1745 on; in the firm of Halsted & Myers c. 1763–1764. He received a grant of land in Underhill, Vermont in 1763; and purchased another tract in Woodbury in 1765. During the Revolution (c. 1776) he moved to Connecticut, where he lived in Norwalk, and for a short time in Stratford, until after 1780. Around 1782–1783 he was working in Philadelphia, Pennsylvania; from 1784 on he was back in New York City.

Mygatt, Comfort Starr (1763–1823). Mygatt, the son of Eli Mygatt, was born in Danbury, where he worked as a goldsmith, silversmith, clockmaker, and watchmaker. He was in partnership with his brother David from 1804 until 1807, when he moved to Canfield, Ohio, where he died.

Mygatt, David (1777–1822). Mygatt was born in Danbury, where he was working in 1800. He was in partnership with his brother Comfort Starr from 1804 to 1807. David was in South East, New York, in 1811. He was the son of Eli Mygatt.

Mygatt, Eli (1742–1807). Born in Danbury, where he was working in 1793. Mygatt started out in the general store and drug business with a Dr. Daniel Noble Carrington as partner. In 1793 Mygatt and Carrington advertised that they had gone into the silversmithing business with Najah Taylor. Father of the silversmiths David and Comfort Starr Mygatt.

Newbury, Edwin C. Newbury was born in Mansfield and apprenticed in Hartford. He began business in Brooklyn in 1828.

North, Phineas (1762–1810). Worked in Torrington. North was made a freeman in 1790, and worked as a farmer, blacksmith, silversmith, and maker of brass clocks.

North, William B. (1787–1838). North was born in New Haven and worked there 1808–1818. He was in New York City in 1823 and in business there 1824–1826 as W. B. North & Co. and 1827–1829 with Thomas Mather as Mather & North. He may have worked in New Britain in 1831.

Norton, ———. Partner in Norton & Freeman, whose mark appears together with that of W. Pitkin on East Hartford spoons c. 1820 – c. 1830. Perhaps was C. C. or J. H. Norton.

Norton, Andrew (1765–1838). Silversmith and tavernkeeper, working 1787 in Goshen.

Norton, C. C. This mark appears with that of W. Pitkin on East Hartford spoons c. 1820 – c. 1830.

Norton, J. H. His mark appears alone and with that of W. Pitkin on Hartford spoons c. 1820 – c. 1830.

Norton, Thomas (1773–1834). Working 1796–1806 in Farmington. He also worked 1806–1808 in Philadelphia, Pennsylvania and in New York State, c. 1820 in Clinton, 1823–1827 in Morrisville, and 1827–1834 in Albion, probably where he died.

Norton & Freeman. The mark of this firm appears with that of W. Pitkin on East Hartford spoons c. 1820 – c. 1830.

Noyes, Charles W. Working in Norwich in 1783.

Noyes, N. & T. F. Possibly working in Connecticut (town and dates unknown).

Noyes, Samuel (1747–1781). Noyes was born in Groton and worked in Norwich from 1770 on as a goldsmith and jeweler. He probably learned his trade from his uncle, Charles Whiting, there. Noyes died in Norwich.

Oakes, Frederick (1782–1855). In partnership in Hartford with Nathan Allyn as Allyn & Oakes until December, 1804, and with David Greenleaf, Jr. as Green-

leaf & Oakes from 1804 until 1807. With Nathaniel Spencer as Oakes & Spencer from 1811 until 1820. Oakes then continued alone until 1830. He was also a gentleman farmer and dealt in real estate. He died in Nyack, New York.

Oakes & Spencer. Frederick Oakes and Nathaniel Spencer; working 1811–1820 in Hartford.

Oliver, William G. Working c. 1830 in Bristol; listed as a jeweler in the Buffalo, New York, Directory 1839–1848.

Olmsted, N., & Son. Nathaniel Olmsted; working 1847 in New Haven as jewelers and silversmiths.

Olmsted, Nathaniel (1785–1860). Olmsted was born in East Hartford and learned his trade from Daniel Burnap, probably in Andover. Olmsted began business in Farmington in 1808. From 1826 on he was in New Haven, where he was working in 1847 as N. Olmsted & Son, jewelers and silversmiths.

O'Neil, Charles. Working 1823–1839 in New Haven; from 1823 to 1826, as the partner of Marcus Merriman and Zebul Bradley in the firm of Merriman & Bradley. He appears to have been a clock and watch-repairer as well as a silversmith.

Otis, Jonathan (1723–1791). Otis was born in Sandwich, Massachusetts, and died in Middletown. He began business in Newport, Rhode Island, and continued there until 1778, when he moved to Middletown during the British occupation of Newport.

Parker, Ephraim, Jr. Working in Windham in 1797.

Parmele, James (1763–1828). Born and worked in Durham.

Parmele(e), Samuel (1737–1807). Born and worked in Guilford, possibly as early as 1756.

Peabody, John Tyng (1756–1822). Born in Norwich; working 1779 in Enfield. After 1787 he moved to Wilmington, North Carolina, where he died.

Peck, ———. Partner in Peck & Porter, working 1827 in Bridgeport.

Peck, B. Working c. 1820, possibly in Connecticut.

Peck, Timothy (1765–1818). Peck was born in Litchfield and worked in Middletown until 1791, when he sold his shop to Antipas Woodward. From 1791 on Peck was working in Litchfield.

Peck & Porter. Working 1827 in Bridgeport.

Peddinghaus, J. M. Working in Colchester c. 1815.

Pelletreau, Elias (1726–1810). Born in Southampton, Long Island. He was apprenticed 1741–1748 to Simeon Soumain in New York City and became a freeman there in 1750. He was working in Southampton, Long Island, from 1750. In September, 1776 at the outbreak of the Revolutionary War, he moved to Simsbury, where he stayed until late in 1780, his work confined to spoons and jewelry. He worked in Saybrook in 1781 and 1782, then returned to Southampton. His son John probably worked with him during his stay in Connecticut.

Pelletreau, John (1755–1822). He probably worked with his father, Elias, during the latter's residence in Connecticut from 1776 to 1782, during the Revolution. They made spoons and jewelry there. He returned to Southampton, Long Island, with his father after 1782 and continued his father's business after Elias died in 1810.

Pitkin, Henry (b. 1811). Working 1834 in East Hartford. Primarily a watchmaker. *See also* John O. Pitkin.

Pitkin, Horace E. Working 1832 on in Hartford. *See also* John O. Pitkin.

Pitkin, James F. Primarily a watchmaker, working 1834 in East Hartford. *See also* John O. Pitkin and James Pitkins.

Pitkin, J. O. & W. The brothers John O. and Walter M. Pitkin; working 1826–1840 in East Hartford. A branch of the firm was established in Vicksburg, Tennessee, 1834–1837. In 1840 John O. retired from the business, which was continued by Walter M. until it was destroyed by fire in 1880.

Pitkin, John O. (1803–1891). Pitkin was born in East Hartford and founded the firm of J. O. & W. Pitkin with his brother Walter M. there by 1830, having begun by himself in 1826. A branch of the firm was established in Vicksburg, Tennessee, 1834–1837. Also in 1834, the main silver business in East Hartford was combined with the Hartford watch business of two other brothers, Henry and James F. Pitkin. The watch business later moved to New York City. In 1840, John O. retired from the silver business, which was continued by Walter M. until the East Hartford factory was destroyed by fire in 1880. Silversmiths Horace E. and William L. Pitkin were later collateral members of the family. John was listed in Hartford Directories until 1849, and in Providence, Rhode Island, Directories 1887–1891. After leaving Hartford he was connected with manufacturing enterprises in Manchester, Mansfield, and Coventry, where he died.

Pitkin, W. This mark is found on East Hartford spoons c. 1820 – c. 1830, alone or with those of C. C. Norton, J. H. Norton, H. D. Summer, Norton & Freeman, or Root & Chaffee. It has not been possible yet to establish the identity of this W. Pitkin. He could have been Walter M. if the c. 1830 date is used, but he might have been William J. or perhaps William L.

Pitkin, Walter M. (1808–1885). Pitkin was working in East Hartford in 1830, as the partner of his brother John O. in the silver business of J. O. & W. Pitkin. A branch of the firm was established in Vicksburg, Tennessee, 1834–1837. In 1840, John O. retired from the business, which was continued by Walter M. until it was destroyed by fire in 1880.

Pitkin, William J. Working c. 1820 in East Hartford.

Pitkin, William L. Primarily a watchmaker, working from 1830 on in East Hartford. *See also* John O. Pitkin.

Pitkins, James (b. 1812). Worked in Hartford. It is not clearly established that he is a different person from James F. Pitkin, working 1834 in East Hartford.

Porter, ———. Partner in Peck & Porter, working 1827 in Bridgeport.

Post, ———. Partner, probably with William Cleveland, in Cleveland & Post, working 1815 in Norwich.

Post, Samuel (b. 1736). He was born in Norwich, and was working from 1783 on in New London as silversmith and watchmaker. It is unlikely that this is the Post of Cleveland & Post, working 1815 in Norwich, since Samuel would have been seventy-nine years old in 1815.

Potwine, John (1698–1792). Potwine was born in England and died in Scantic. He was brought to Boston, Massachusetts, as a child and worked there 1721–1737. He then worked 1737–1752 in Hartford, where he also ran a general merchandise store, which business he moved to Coventry in 1753. In 1761 he was back in Hartford, as the partner of Charles Whiting in Potwine & Whiting. Potwine spent his later years in East Windsor, where his son was a pastor.

Potwine & Whiting. John Potwine and Charles Whiting, working 1761 in Hartford.

Pratt, Nathan (1772–1842). Pratt, the son of Phineas Pratt, was born in Saybrook and was working in Essex from 1792. George Spencer was apprenticed to him in 1801. Pratt was the father of Nathan, Jr. He died in Essex.

Pratt, Nathan, Jr. (b. 1802). Born in Saybrook, son of Nathan Pratt; worked in Essex. In later years Nathan, Jr., devoted himself to the ivory comb business begun by his grandfather, the silversmith Phineas Pratt.

Pratt, Phineas (1747–1813). Pratt was born in Saybrook. In 1772 he advertised his silversmith's shop in Lyme for sale. He was associated with David Bushnell, the inventor, in Old Saybrook. In 1799 Pratt took out a patent on a machine for making ivory combs. This business prospered and was carried on by his grandson, Nathan Pratt, Jr., who was also a silversmith. Phineas Pratt was the brother of Seth and father of Nathan, Sr.

Pratt, Seth (1741–1802). Born in Saybrook, brother of Phineas; worked in Lyme.

Prince, Job (1680–1703). Prince was born in Hull, Massachusetts, and died in Milford. He had come to Milford by 1699 and was working there from 1701 on (according to an account book of a Thomas Clarke, recently discovered by Mr. Harry L. Dole of The Milford Historical Society).

Proctor, N. L. Working c. 1840 in Oxford.

Quintard, Peter (1699–1762). Quintard was born in New York City where he was apprenticed to Charles LeRoux. He worked there 1722–1737. From 1737 on he was working in South Norwalk, where he died.

Reed, Frederick. Working 1825 in Norwalk as watchmaker and silversmith.

Reed, Isaac (b. 1746). Reed was born in New Canaan and worked in Stamford in the 1770's. He moved to Nova Scotia during the Revolution but returned to Stamford c. 1790. He was also a clockmaker and jeweler. He took his son Isaac into partnership c. 1810 as Isaac Reed & Son.

Reed, Isaac & Son. Isaac Reed and his son Isaac, working in Stamford c. 1810.

Roath, Roswell Walstein (b. 1805). Born in Norwich, where he was working in 1826. He later moved to Denver, Colorado, where he died.

Roberts, L. D. Working c. 1850 in Hartford with Hiram F. Chapell as Chapell & Roberts.

Robinson, ———. Partner in Robinson & Jastram, working from 1810 on in New Haven. Possibly William S. Robinson.

Robinson, O. Working c. 1790 town unknown, and in New Haven, 1800.

Robinson, William S. Working 1810 in New Haven. Possibly a partner of someone named Jastram there at that time.

Robinson & Jastram. Working from 1810 on in New Haven. Possibly William S. Robinson. Jastram's given name unknown.

Rockwell, ———. Working c. 1839, possibly in Bridgeport.

Rockwell, Samuel (d. 1773). Possibly worked as a silversmith, clock and watchmaker in Middletown.

Rockwell, Thomas (1764–1794). Silversmith and watchmaker, working in Norwalk.

Rogers, A., Jr., & Co. The brothers Asa and William Rogers; working c. 1856 – c. 1858 in Hartford.

Rogers, Asa Harris (b. 1806). Rogers learned his trade at the Hartford firm of Church & Rogers, through his older brother William. From 1830 to c. 1839 Asa was in partnership in the New Britain–Berlin area with John A. Cole as

Rogers & Cole. The company manufactured silver spoons. In 1843 he was working alone making spoons in Hartford. In 1845 he became involved in silver plating; and in 1847 was in this business in Hartford with his brothers William and Simeon as Wm. Rogers & Co., later Rogers Bros. Manufacturing Co.

Rogers, Joseph (1753–1825). Rogers was the brother of Daniel Rogers, silversmith of Newport, Rhode Island. Both brothers were the apprentices and later the partners of Newport silversmith John Tanner. In 1808, Joseph Rogers moved to Hartford, where he died.

Rogers, Simeon (b. 1812). Rogers learned his trade at the Hartford firm of Church & Rogers with his brothers William and Asa, with whom he later worked in the plated silver business as Wm. Rogers & Co., later Rogers Bros. Manufacturing Co.

Rogers, William (1801–1873). Rogers was born and worked in Hartford, where he was apprenticed in 1820 to Joseph Church, with whom he was later in partnership, 1825–1836, as Church & Rogers. After 1836, Rogers was in business for himself. George C. White was apprenticed to him sometime between 1836 and 1845. In 1845 Rogers began to handle plated silver with his brothers Asa and Simeon; in 1847 all three brothers were in this business in Hartford as Wm. Rogers & Co., which became Rogers Bros. Manufacturing Co. in 1853.

Rogers, William, & Son. Working c. 1850 in Hartford. William Rogers of the Rogers Bros. Manufacturing Co. The son was William Henry Rogers, who was made a partner of the firm in 1856.

Rogers, Wm., & Co. The brothers William, Asa, and Simeon Rogers; working 1846–1855 in Hartford.

Rogers & Cole. Asa Harris Rogers and John A. Cole; working 1830–c. 1839 in the New Britain–Berlin area.

Root, ———. Partner in Root & Chaffee, whose mark appears together with that of W. Pitkin on East Hartford spoons c. 1820–c. 1830.

Root, W. M., & Brother. Working c. 1850 in New Haven.

Root & Chaffee. This mark appears together with that of W. Pitkin on East Hartford spoons c. 1820–c. 1830.

Russel, Jonathan (b. 1770). Working by 1804 in Ashford as gold and silversmith, clock and watchmaker. Sold his business and property in 1805. In 1807 he advertised as a watchmaker in Geneva, New York, and from 1807 to 1817 he advertised as a jeweler in Auburn, New York.

Sadd, Hervey (1776–1840). Sadd was born in East Windsor. In 1798 he moved to New Hartford and in 1801 to Hartford, where he worked briefly for Miles

Beach. In Stockbridge, Massachusetts, c. 1807 on. In 1829 he moved to Austin-
burg, Ohio, where he died. He was also a clock and watchmaker and iron
founder.

Sanford, Isaac (d. 1842). In 1785, Sanford moved with the firm of Beach & Sanford
(Miles Beach) from Litchfield to Hartford, where they did engraving, clock-
making, and watchmaking, in addition to silversmithing, possibly to c. 1788.
From 1789 to 1790 he was in partnership there with William Johonnot as
Sanford & Johonnot. Subsequently, he worked alone in Hartford until 1823.
He was in England in 1799 seeking patents for several inventions. In 1824 he
was living in Providence, Rhode Island; later he went to Philadelphia, where
he died. He was also a miniature portrait painter.

Sanford & Johonnot. Isaac Sanford and William Johonnot; working in Hartford
1789–1790.

Sargeant, H. Working 1825, possibly in Hartford. Possibly Henry Sargeant (1796–
1864) of Springfield, Massachusetts.

Sargeant, Jacob (1761–1843). Sargeant was born in Mansfield and died in Hartford.
He was in business in Mansfield in 1784, and in Springfield, Massachusetts, in
1790, where he worked until he moved to Hartford in 1795. He is listed in the
Hartford City Directory in 1838. Joseph Church probably learned the trade
from him in Hartford before 1818, as did Charles Brewer before 1800. Sar-
geant, who was also a jeweler and clockmaker, sold his Springfield, Massachu-
setts, clockmaking business to his younger brother, Thomas, in 1795.

Sawyer, H. I. Working c. 1840 in New York City, with L. P. Coe, in Coe & Upson
and in Coe & Montgomery; worked later in Hartford.

Seymour, Oliver D. Partner of Julius Hollister in Seymour & Hollister, working
1845 in Hartford.

Seymour & Hollister. Oliver D. Seymour and Julius Hollister; working 1845 in
Hartford. This mark is sometimes found together with that of Wheelers &
Brooks.

Shepherd, Henry B. Working from 1811 on in New Haven.

Sherman, Edward. Working c. 1850 in Hartford.

Shethar, Samuel (1755–1815). Shethar was apprenticed to Abel Buel in 1774 in
New Haven and continued with him briefly in Pensacola, Florida. He worked
1776–1777 in Pensacola; c. 1782–1805 in Litchfield, 1796–1805 in partnership
there with Isaac Thom(p)son as Shethar & Thom(p)son; 1806–1808 in New
Haven, with Richard Gorham as Shethar & Gorham.

Shethar & Gorham. Samuel Shethar and Richard Gorham; working 1806–1808 in
New Haven.

Shethar & Thom(p)son. Samuel Shethar and Isaac Thom(p)son; working 1796–1805 in Litchfield.

Shipman, Nathaniel, Jr. (1764–1853). Born and worked 1785 on in Norwich, where from Thomas Harland he learned his trades of silversmith, jeweler and clockmaker. Later he represented the town of Norwich in the state legislature, and from c. 1800 on he probably was a businessman rather than craftsman as a result of his successful investment in West Indies trade. His account book for the years 1785–1836 is in the collections of the Society of Founders of Norwich at the Leffingwell Inn there.

Sibley, Asa (1764–1829). Sibley was born in Sutton, Massachusetts, and was apprenticed to Peregrine White in Woodstock, where Sibley was working from c. 1787 on as a clockmaker and silversmith. From after 1797 until after 1808 he was in Walpole, New Hampshire. He was working in Rochester, New York, around 1820 and was listed in the city directory there in 1827. He died there two years later.

Sibley, Clark (1778–1807). Sibley was born in New Haven and worked there 1801–1806 with Simeon Marble as Sibley & Marble.

Sibley, John. Working 1801–1810 in New Haven.

Sibley & Marble. Clark Sibley and Simeon Marble; working 1801–1806 in New Haven. Simeon Marble may have continued to use the S & M punch mark after Sibley's death in 1807.

Silliman, Hezekiah (1738–1804). Silliman was born in Fairfield and worked 1764–1770 in New Haven. In 1767 he advertised in New Haven with Richard Cutler and Ambrose Ward as goldsmiths and jewelers.

Skinner, Elizer (d. 1858). Working 1826 in Hartford.

Slattery, John. Working c. 1850 in Hartford.

Sloan, William. Working 1794 in Hartford, after being apprenticed to Thomas Harland in Norwich. He was a gold and silversmith, watch and clockmaker.

Smith, Ebenezer (1745–1830). He was born and worked in Brookfield as silversmith, pewterer and clockmaker.

Smith, John L. Working in Middletown in 1822 as silversmith and watch repairer.

Smith, Lyman. Purchased Nathaniel Wade's shop in Stratford in 1802, where he set up in business as a clock and watchmaker, silversmith and jeweler.

Smith, Normand (1772–1860). Born and died in Hartford, where he advertised in 1810.

Spencer, Asa. Working 1804 and 1805 in New London as watch repairer and silversmith. Probably one of the partners in firm of Spencer & Hempsted working there in 1806.

Spencer, George (1787–1878). Spencer was born in Westbrook and in 1801 was apprenticed to Nathan Pratt in Essex. He later gave up the trade to manufacture ivory combs in Deep River. (Nathan Pratt's father, Phineas, invented a machine to make ivory combs in 1799.) He was joined in this business by Nathan Pratt's son, Nathan, Jr. Spencer died in Deep River.

Spencer, James (c. 1775 – c. 1817). Spencer bought Asa Loud's shop in Hartford in 1792.

Spencer, James, Jr. Working 1843 in Hartford.

Spencer, Nathaniel (1788–1823). With Frederick Oakes as Oakes & Spencer 1811–1820 in Hartford, where he died.

Spencer, Noble. Clock and watchmaker, goldsmith and jeweler from London, England. He set up in business in Wallingford in 1796 and removed to Stratford in 1797.

Spencer & Hempsted. Working 1806 in New London. Probably Asa Spencer and Daniel B. Hempsted.

Staniford, John (1737–1811). Working before 1789 in Windham. He was in partnership there with Alfred Elderkin as Elderkin & Staniford, 1790–1792. He died in Windham.

Stanton, D. E. & Z. The brothers Daniel, Enoch, and Zebulon Stanton; working c. 1775 – c. 1780 in Stonington.

Stanton, Daniel (1755–1781). Stanton was born in Stonington and killed in the defense of Fort Griswold, Groton. He was in partnership in Stonington with his brothers Enoch and Zebulon as D. E. & Z. Stanton c. 1775 – c. 1780.

Stanton, Enoch (1745–1781). Stanton was born in Stonington and killed in the defense of Fort Griswold, Groton. He was in partnership in Stonington with his brothers Daniel and Zebulon as D. E. & Z. Stanton c. 1775 – c. 1780.

Stanton, Zebulon (1753–1828). Stanton was born and worked in Stonington, where he was in partnership with his brothers Daniel and Enoch as D. E. & Z. Stanton, c. 1775 – c. 1780.

Starr, Jasper (1709–1792). Born and worked in New London.

Steele, T., & Co. T. S. Steele; working from c. 1815 on in Hartford.

Steele, T. S. Working in Hartford c. 1800; working there from c. 1815 on as T. Steele & Co.

Stiles, Benjamin. Stiles worked c. 1825 – c. 1840 in Woodbury, where he was at first apprenticed to the firm of Curtiss, Candee & Co. He was in partnership there c. 1831 – c. 1835 with Daniel Curtiss and Lewis Burton Candee as Curtiss, Candee & Stiles and with Curtiss as Curtiss & Stiles from c. 1835 to 1840, when the business was discontinued.

Stiles, Samuel (1762–1826). Stiles was born in Windsor. In 1785 he moved to Northampton, Massachusetts, and worked there in 1791 in the firm of Stiles & Baldwin. He returned to Windsor in 1792; but moved shortly afterward to Chester, where he worked until after 1802. He then returned again to Windsor.

Stillman, ———. Possibly Benjamin; working c. 1800 – c. 1808 in New Haven, with Samuel Wilmot as Wilmot & Stillman.

Stillman, E. Working c. 1800 – c. 1820, probably in Stonington.

Stillman, Samuel S. Working 1850 in Hartford.

Strong, C. C. Worked in Hartford. Strong was apprenticed to Joseph Church in Hartford, and in 1840 he and L. T. Welles bought Church's business.

Sumner, H. D. This mark appears with that of W. Pitkin on East Hartford spoons c. 1820 – c. 1830.

Sutton, Robert. Working 1825 in New Haven as clock and watchmaker and purveyor of silverware.

T———. Unidentified partner in the firm of Ward, Bartholomew & T ———, working c. 1802 in Hartford.

Tain, A. S. His mark is found together with those of L. T. Welles (working c. 1840 in Hartford) and D. G. Hall.

Taylor, Najah. In 1793 Eli Mygatt and Dr. Daniel Noble Carrington, partners in Danbury in the general store and drug business, advertised that they had gone into the silversmithing business with Najah Taylor. Taylor was subsequently working in New York City c. 1795 on.

Terry, Geer (1775–1858). Born in Enfield. He worked in Worcester, Massachusetts, 1801–1814, then returned to Enfield where he died.

Terry, L. B. Working 1810 in Enfield; 1830–1835 Albany, New York.

Terry, Wilbert. He may have worked in Enfield from 1785; he advertised in Mechanic Town, New York, in 1799 and was listed in the 1805 Directory of New York City as a watchmaker. He was a partner with John Taylor in 1820 in the goldsmithing firm of Terry & Taylor in New York City.

Thom(p)son, Isaac. Working 1801–1805 in Litchfield with Samuel Shethar as Shethar & Thom(p)son, subsequently alone. He moved to Brattleboro, Vermont, in 1811.

Tiley, James (1740–1792). Working in Hartford from before 1765 to 1785, when he ran into financial difficulties. Later he advertised that he had opened a "house of entertainment" named the Free Mason's Arms in Hartford. He was assisted in 1774–1775 by James Gordon, a journeyman goldsmith from Philadelphia. Tiley died in the South.

Tisdale, William. Advertised as goldsmith with watches for sale 1761 in Lebanon. May be the same craftsman who was in New Bern, North Carolina, in 1770 and later.

Tompkins, Edmund (b. 1757). Working 1779 in Waterbury.

Tracy, Erastus (1768–1796). Born in Norwich; brother of Gurdon Tracy. Probably apprenticed to Thomas Harland. Working 1790 in Norwich. Erastus moved to New London after 1792, when his brother died there.

Tracy, Gurdon (1767–1792). Gurdon, the brother of Erastus Tracy, was born in Norwich. He was working there in 1787, and in 1791 in New London, where he died.

Trott, J. P., & Son. John Proctor Trott and a son whose name is unknown; working 1820 in New London.

Trott, John Proctor (1769–1852). Trott was born in Boston, where he learned his trade from his father, Jonathan Trott. He worked in New London with William Cleveland as Trott & Cleveland, 1792–1794; with Brooks (probably Jona Brooks) as Trott & Brooks, 1798; at other times alone and, in 1820, as J. P. Trott & Son. His son's name is not known. He was the brother of Jonathan, Jr.

Trott, Jonathan (1730–1815). Trott was trained and worked in Boston, Massachusetts. He moved to Norwich in 1772 and was running the Peck Tavern there by 1784. He then moved to New London, where he died. His sons, Jonathan Jr. and John Proctor, were also silversmiths.

Trott, Jonathan, Jr. (1771–1813). Born in Boston, where he learned his trade from his father Jonathan. Working 1795 in New London, where he advertised in 1800, and where he died. He was the brother of John Proctor Trott.

Trott & Brooks. John Proctor Trott and a partner named Brooks, working 1798 in New London.

Trott & Cleveland. John Proctor Trott and William Cleveland, working 1792–1794 in New London.

Tuttle, Bethuel (1779–1813). Tuttle was working in New Haven with Marcus Merriman, to whom he had been apprenticed, as Merriman & Tuttle in 1802; then with Marcus Merriman and Zebul Bradley as Marcus Merriman & Co., from 1802 to 1813. He was the father of William Tuttle.

Tuttle, William (1800–1849). Tuttle worked in New Haven and died in Suffield. He was the son of Bethuel Tuttle.

Ufford, Thomas. Partner of William S. Burdick as Ufford & Burdick working 1812–1814 in New Haven; subsequently alone.

Ufford & Burdick. Thomas Ufford and William S. Burdick; working 1812–1814 in New Haven.

Wade, Nathaniel. Apprenticed in Norwich. Working 1793 – c. 1798 in Newfield as a silversmith and clockmaker with another craftsman named Hall as Hall & Wade. In Stratford from c. 1798 to 1802, when his business and shop were purchased by Lyman Smith.

Wadsworth, William. Working 1806 in Hartford. His account book for the years 1809–1813 is in the collections of the Connecticut Historical Society at Hartford.

Walworth, Daniel (1760–1830). Walworth was born in Groton and worked from 1785 on in Middletown, where he died.

Ward, Ambrose (1735–1808). Ward was born and died in New Haven, where he worked from 1761 to 1808. In 1767 he advertised there with Richard Cutler and Hezekiah Silliman as goldsmiths and jewelers. He was the brother of William Ward of New Haven and Litchfield.

Ward, Bilious (1729–1777). Ward was born in Guilford, and died in Wallingford. He was working in Middletown in 1750; he also worked in Guilford. He was the son of William Ward, Jr., of Guilford, who may possibly have been a silversmith, and the father of James Ward.

Ward, James (1768–1856). Ward was born in Guilford, son of Bilious Ward, and worked in Hartford, where he was apprenticed to Miles Beach. From 1790 to 1797 he was in partnership there with Beach as Beach & Ward; c. 1802 with Roswell Bartholomew and another, unidentified partner in a firm whose mark appears as W. B. & T (Ward, Bartholomew and T———); 1804–1809, in partnership with Roswell Bartholomew as Ward & Bartholomew; 1809–1830, with Charles Brainard in addition, as Ward, Bartholomew & Brainard.

Ward, John. In 1805 Ward bought the shop in Middletown formerly occupied by Judah Hart, who had moved to Norwich. Ward was working in Middletown until 1806 as the partner of Edmund Hughes in Ward & Hughes.

Ward, Macock (1702–1783). Son of William Ward of Wallingford, where he

worked principally as a clockmaker from 1724. He was the brother of William Ward, Jr., of Guilford.

Ward, Timothy (b. 1742). Ward was born in Middletown and is thought to have been lost at sea between July 1767 and May 1768.

Ward, William (1678–1768). He was born in Killingworth, worked and died in Wallingford. He was the father of William Ward, Jr.

Ward, William, Jr. (1705–1761). Son of William Ward of Wallingford, father of Bilious Ward; worked in Guilford as a blacksmith and possibly as a silversmith. He was the brother of Macock Ward of Wallingford.

Ward, William (1736–1829). Ward was born in New Haven and died in Litchfield. He was working 1766–1768 in New Haven, subsequently in Litchfield. He was the brother of Ambrose Ward of New Haven.

Ward & Bartholomew. James Ward and Roswell Bartholomew; working 1804–1809 in Hartford.

Ward & Hughes. John Ward and Edmund Hughes; working 1805–1806 in Middletown.

Ward, Bartholomew & Brainard. James Ward, Roswell Bartholomew, and Charles Brainard; working 1809–1830 in Hartford.

Ward, Bartholomew & T———. James Ward, Roswell Bartholomew and an unidentified partner, working c. 1802 in Hartford.

Wardin, Daniel. Working 1811 in Bridgeport.

Welles, Alfred or Andrew (1783–1860). Working 1804 in Hebron; 1806–1811 in Boston, Massachusetts, with his brother George I. Welles as A. & G. Welles. Some sources give the alternative name Andrew Welles.

Welles, L. T. Apprenticed to Joseph Church in Hartford. Welles and C. C. Strong bought Church's business in 1840; also worked with A. S. Tain and D. G. Hall, possibly in Hartford.

Welles, William (b. 1766). Working 1828 in Hartford.

Wheelers, ———. A partner in Wheelers & Brooks.

Wheelers & Brooks. This mark is sometimes found together with that of Seymour & Hollister, who were working in Hartford in 1845.

White, Amos (1745–1825). Working c. 1766–1773 in East Haddam; later, in Meriden. White was both silversmith and sea captain.

White, George C. Apprenticed at some time between 1836 and 1845 to William Rogers of Hartford.

White, Peregrine (1747–1834). Born in Woodstock where he worked as a clock-maker and silversmith from 1774 on. Asa Sibley was apprenticed to him.

White, Peter (1718–1803). Working from 1738 on in Norwalk.

Whiting, B. Partner of Isaac Marquand in Whiting & Marquand, working c. 1787 – c. 1790 principally as clockmakers in Fairfield.

Whiting, Bradford. Born 1751 in Norwich. Later moved to Great Barrington, Massachusetts.

Whiting, Charles (1725–1765). Working after c. 1750 in Norwich. Partner of John Potwine in Potwine & Whiting, working 1761 in Hartford. Brother of Eben-ezer and William Bradford Whiting.

Whiting, Ebenezer (1735–1794). Born in Hartford; brother of Charles and William Bradford Whiting. In Savannah, Georgia, 1786–1788; in Norwich after 1788, later in Westfield, Massachusetts, where he died.

Whiting, S. Working c. 1700 in Norwich; also in New York City.

Whiting, William Bradford (1731–1796). Born in Norwich; brother of Ebenezer and Charles Whiting. Spent most of his later life in New York state as a judge and state senator. He died in Canaan, New York.

Whiting & Marquand. B. Whiting and Isaac Marquand, working c. 1787 – c. 1790 in Fairfield.

Wilcox, Alvan (1783–1870). Wilcox, the brother of Cyprian Wilcox, was born in Berlin. In 1805 he moved to Norwich, where with Judah Hart he purchased the business of Abel Brewster, operating until 1807 as Hart & Wilcox; in 1816 he was working alone there. Wilcox worked thereafter in New Jersey; in Fayetteville, North Carolina, c. 1819–1823; and in New Haven from 1824 on. He is listed in the 1841 New Haven Directory as a silver-worker; in the 1850 Directory as a gold and silver thimble and spectacle maker; and in the 1857 Directory as a silver plater. He died in New Haven.

Wilcox, Cyprian (1795–1875). Wilcox, the brother of Alvan Wilcox, was born in Berlin and died in Ithaca, New York. He was working in Sparta, Georgia, from 1817 on. From 1827 to 1840 he was working as a silversmith and clockmaker in New Haven, where he subsequently went into business as an iron founder.

Willard, James. Working 1815 in East Windsor.

Williams, Deodat (d. 1781). Working 1776 in Hartford; advertised as silversmith and jeweler.

Williams, Oliver S. Working c. 1850 in Hartford.

Wilmot, Samuel (1777–1846). Wilmot was working in New Haven 1798–1825; from 1800 to 1808 he was in partnership there with (Benjamin?) Stillman as Wilmot & Stillman. He was in Georgetown, South Carolina, in 1825; in Charleston, South Carolina, c. 1837 in the firm of Wilmot and Richmond. He was perhaps related to Thomas Wilmot. He died in New Haven.

Wilmot, Thomas (1756–1815). Wilmot worked in New Haven before 1796; in Rutland, Vermont, 1796–1800 as the partner of William Storer; and by himself in Poultney, Vermont, 1800–1809; Fairhaven, Vermont, 1809–1815. He was perhaps related to Samuel Wilmot.

Wilmot & Stillman. Samuel Wilmot and (Benjamin?) Stillman; working 1800–1808 in New Haven.

Wing, Moses (1760–1809). Born in Rochester, Massachusetts. Moved to Windsor Locks in 1775 where he worked probably from c. 1781 on as gold and silversmith and clockmaker. In Worcester, Massachusetts, 1805–1809. He died in Windsor.

Woodward, Antipas (1763–1812). Woodward was born in Waterbury and died in Bristol. In May of 1791 he began business in Middletown in a shop purchased from silversmith Timothy Peck. After this shop was destroyed by fire, Antipas moved to a shop formerly occupied by Jonathan Otis. In 1792 Woodward advertised as goldsmith and clockmaker. He subsequently moved to Bristol, where he made wire pendulum rods for Bristol clockmakers.

Woodward, Eli. Working 1812 in Hartford and c. 1847–1852 in Boston, Massachusetts, in the firm of Woodward & Grosjean.

Wynkoop, Benjamin, Jr. (1705–1766). Wynkoop was trained in New York City, probably by his father, Benjamin. Wynkoop, Jr., was working in Fairfield c. 1755 and may have been there possibly as early as 1730.

Yeomans, Elijah (1738–1794). Yeomans was born in Tolland and was working from 1771 to 1783 in Hadley, Massachusetts, as a goldsmith and clockmaker. In 1777 he advertised in the *Hartford Courant* that silver bullion had been stolen from him. In 1792 he was working in Middletown in the shop of Samuel Canfield, and then he went to Hartford to work with David Greenleaf. He advertised in Hartford in 1794, the year of his death.

Young, Levi. Working 1824–1827 in Bridgeport.

Youngs, C. Working c. 1835 in Bridgeport.

Youngs, Ebenezer (b. 1756). Born in Hebron. Possibly apprenticed to David Ellsworth in Windsor in 1776. Working in Hebron 1778 on as clockmaker and goldsmith.

Index of Marks

T HIS INDEX has been illustrated where possible with photographs of the original marks. Those for which photographs were not available are reproduced in drawings from several previously published sources cited below.

The punch marks of early Connecticut silversmiths were usually confined to their initials, sometimes within an elaborated border or with "pellet" punctuation marks between. These small initials marks were placed on the bottom of a piece, on the body near the handle, on the back of a spoon handle, or in some other unobtrusive spot. Objects of more than one part sometimes bore the mark on each. Occasionally a mark was repeated two or three times in the same or differing locations. These punch marks should not be confused with the large letters, in block capitals or script, which were engraved on the fronts or lids of tankards, the handles of porringers and spoons, and elsewhere on other forms; these large initials were those of the owner, or, when three letters appear, of husband and wife. There are rare instances of a silversmith's having identified his work by scratching his name or initials on it in large letters: S · · Shethar, for Samuel Shethar of New Haven and Litchfield, Connecticut, appears on the bottom of a beaker he made around 1800 for the Middlebury church and S. Ford/1798 was scratched inside a gold miniature frame (now at Yale) by Samuel Ford of Philadelphia.

From the second quarter of the eighteenth century on, some silversmiths used their full name, or first initial and surnames, or surnames alone, for their punch marks, but many continued to use only their initials. As punches wore out, new ones were employed, perhaps differing slightly in the style of lettering, the presence or absence of pellets, or the shape of the border. Sometimes several punches were used during the same period, initials being placed on small objects while the full surname appeared on larger pieces, although the size of an object was not consistently a determining factor.

Needless to say, the use of initials only, of more than one style of mark, and of surname only, as well as the absence of town and date marks, has made the identification and attribution of American silver a difficult, although fascinating, study. The marks are often badly worn through polishing and are almost illegible. Many silversmiths had the same initials; these alone, therefore, do not positively identify even the state in which a piece was made. Indeed, there are English provincial pieces, usually flatware, that could be mistaken for American silver because they carry only makers' initials instead of the complete set of hallmarks.

The *exact* appearance of the punch mark then becomes extremely im-

portant in the identification, and the specialist uses a glass of fifteen or twenty power magnification to aid in discovering the minute differences in shape of letters and reserve and the kind of wear on the punches. Occasionally, however, the marks of two different silversmiths are almost indistinguishable in appearance. In considering a mark that could be attributed to either of two craftsmen, one of whom worked early in the 1700s, the other late in the same century, the specialist therefore often makes a decision on the basis of the style of the piece on which the mark occurs. A marked spoon is an especially good indicator in this kind of test, since stylistic changes in spoons are distinctive and fall into fairly well-defined periods.

Marks consisting only of initials have sometimes been identified by comparing the unattributed piece with one which has come down to us through a family or church possessing early records of its purchase from a named silversmith. Other attributions have been made by a process of elimination, where the names of silversmiths in written records have been matched up with existing initials marks.

SOURCES OF THE MARKS

Boston	The Museum of Fine Arts, Boston
Burke	Collection of Harry Burke
Conn. Hist. Soc.	The Connecticut Historical Society, Hartford
Currier	Ernest M. Currier, *Marks of Early American Silversmiths.* Portland, Maine: The Southworth–Anthoensen Press, 1938
Ensko II and III	Stephen G. C. Ensko, *American Silversmiths and Their Marks.* New York: Robert Ensko, Inc. Vol. II, 1937; Vol. III, 1948
French	Hollis French, *A List of Early American Silversmiths and Their Marks.* New York: Walpole Society, 1917
Graham	James Graham, Jr., *Early American Silver Marks.* New York: James Graham, Jr., 1936
Hammerslough	Collection of Philip Hammerslough
Johnson	Collection of Mr. and Mrs. Philip Johnson
Kernan	Collection of Mr. and Mrs. John Devereux Kernan
Kossack	Collection of Alan R. Kossack
Liverant	Collection of Israel Liverant
Metropolitan	The Metropolitan Museum of Art
'67 N.H. Cat.	*Early Silver by New Haven Silversmiths,* catalogue of an exhibition at the New Haven Colony Historical Society, 1967
Winterthur	The Henry Francis du Pont Winterthur Museum
Wethersfield	First Church of Christ, Wethersfield
Yale	Yale University Art Gallery, New Haven
'35 Yale Cat.	*Early Connecticut Silver, 1700–1830,* exhibition catalogue, Connecticut Tercentenary, Gallery of Fine Arts, Yale University, New Haven, 1935

Mark	Name	Source	Object
	Abel Buel	'67 N.H. Cat.	
	A. Beach	Ensko III	
	A. Beach	Kossack	spoon
	Aner Bradley	Winterthur	spoon
	Aaron Cleveland	Graham	
	Aaron Cleveland	Ensko III	
	Aaron Cleveland	Ensko III	
	Amos Doolittle	Yale	spoon
	Alfred Elderkin	Ensko III	
	John Aaron Elliott	Ensko III	
	John Aaron Elliott	Currier	
	A. Jackson	Kossack	ladle
	Joel Allen (attr. to)	Winterthur	spoon
	Andrew Norton	Winterthur	spoon
	Asa Sibley	Boston	spoon
	Ebenezer Austin	Yale	spoon
	Ambrose Ward	Ensko III	
	Ambrose Ward	Hammerslough	spoon
	Antipas Woodward	Ensko III	
	Andrew (Alfred) Welles	Currier	
	Amos White	Hammerslough	spoon
	Alvan Wilcox	Kossack	spoon
	Alvan Wilcox	'67 N.H. Cat.	
	Samuel Babcock	Ensko III	
	Ebenezer Baldwin	Winterthur	spoon
	Ebenezer Baldwin	Kossack	ladle
	Barzillai Benjamin	Kossack	spoon
	Barzillai Benjamin	Kossack	spoon
	Beriah Chittenden	'67 N.H. Cat.	

Mark	Name	Source	Object
	Miles Beach	Yale	spoon
	Buel & Greenleaf	Hammerslough	spoon
	Benjamin Hanks	Kossack	spoon
BINGLEY	——— Bingley	French	
BLACKMAN	John Clark Blackman	Ensko III	
	Benjamin Lord	Hammerslough	spoon
	Bradley & Merriman	Hammerslough	spoon
BOLLES&CHILDS	Bolles & Childs	Winterthur	spoon
	Bolles & Day	Kossack	spectacles
	Gideon B. Botsford	Winterthur	spoon
	B. Peck	Kossack	spoon
BREWSTER	Abel Brewster	Ensko III	
	Brown & Kirby	Kossack	spoon
	Beach & Sanford	Kossack	spoon
	Abel Buel	Yale	cup
	William S. Burdick	Kossack	spoon
	Beach & Ward	Kossack	spoon
	Bilious Ward	Yale	spoon
	Bilious Ward	Graham	
	Benjamin Wynkoop, Jr.	Hammerslough	spoon
	B. Whiting	Yale	spoon
	John A. Cole	Graham	
	Samuel Canfield	Hammerslough	spoon
CB	Clement Beecher	Ensko III	
	Clement Beecher	Winterthur	spoon
	C. Blakeslee	Kossack	spoon
	Charles Brewer	Yale	spoon
C·BREWER	Charles Brewer	Ensko III	
	C. Brewer & Co.	Kossack	spoon
CC	Charles Carpenter	Ensko III	

Mark	Name	Source	Object
	Curtiss, Candee & Stiles	Kossack	spoon
	See W. Pitkin and C. C. Norton		
	Charles Davi(d)son	Winterthur	spoon
	C. E. Disbrow	Kossack	spoon
	Christopher Gallup	Hammerslough	spoon
	Charles Hequembourg, Jr.	'67 N.H. Cat.	
	Charles Hequembourg, Jr.	Kossack	spoon
	Church & Rogers	Kossack	spoon
	Cornelius Kierstede	Yale	spoon
	Cornelius Kierstede	Yale	cup
	Cornelius Kierstede	Yale	tankard
	Levi Clark	Hammerslough	sugar tongs
	Clark & Brother	Ensko III	
	Clark & Brother	Ensko II	
	Clark & Coit	Hammerslough	sugar tongs
	William Cleveland	Yale	spoon
	Clark Lindsley	Yale	spoon
	Coit & Mansfield	Kossack	spoon
	Cornelius Munson	Hammerslough	spoon
	Comfort Starr Mygatt	Yale	spoon
	Charles O'Neil	'67 N.H. Cat.	
	Cleveland & Post	Hammerslough	beaker
	— Curtiss & Co.	Kossack	spoon
	Curtiss & Stiles	Ensko II	
	Curtiss & Stiles	Currier	
	Curtiss, Candee & Co.	Kossack	spoon
	Curtiss, Candee & Stiles	Currier	
	Charles Whiting	Hammerslough	spoon
	Charles Whiting	Yale	spoon
	Cyprian Wilcox	Kossack	spoon

Mark	Name	Source	Object
C. WILCOX	Cyprian Wilcox	Currier	
BRIDGEPORT C. YOUNGS	C. Youngs	Hammerslough	sugar tongs
DB	Daniel Burnap	Hammerslough	spoon
DB	poss. Daniel Burnap	Winterthur	spoon
D.B. HEMPSTED	Daniel B. Hempsted	Winterthur	spoon
D. Billings	Daniel Billings	Hammerslough	spoon
DBThompson	D. B. Thompson	Ensko III	
DD	Daniel Deshon	Yale	creamer
DEMING & GUNDLACH	Deming & Gundlach	Hammerslough	spoon
DENIS	poss. Ebenezer Dennis	Hammerslough	spoon
D.G. HARTFORD	David Greenleaf (Jr.)	Yale	spoon
D. Greenleaf	David Greenleaf (Sr.)	Ensko III	
Greenleaf	David Greenleaf (Sr.)	Hammerslough	spoon
DM	David Mygatt	Ensko III	
D.MYGATT	David Mygatt	Yale	spoon
D.MYGATT	David Mygatt	Ensko III	
D.Stanton	Daniel Stanton	Ensko III	
D.WILLIAMS	Deodat Williams	Hammerslough	spoon
E.A	Ebenezer Austin	'35 Yale Cat.	
	Elijah Adgate	Hammerslough	spoon
EB	Eleazer Baker	Ensko III	
EB	Eleazer Baker	'35 Yale Cat.	
EB&Cº	E. Benjamin & Co.	'67 N.H. Cat.	
E·BAKER	Eleazer Baker	'35 Yale Cat.	
E.BALCH	Ebenezer Balch	Hammerslough	spoon
E.BENJAMIN	Everard Benjamin	'67 N.H. Cat.	
E.BENJAMIN C1S3C	Everard Benjamin	Yale	sugar tongs
E.BENJAMIN&Cº	E. Benjamin & Co.	Yale	spoon
E.BURNAP HARTFORD	Ela Burnap	Hammerslough	spoon
EC	Ebenezer Chittenden	Yale	beaker

Mark	Name	Source	Object
	Ebenezer Chittenden	Yale	spoon
	Elias Camp	Ensko III	
	Elias Camp	Kossack	spoon
	Ebenezer Chittenden	'67 N.H. Cat.	
	Ebenezer Chittenden	Ensko III	
	E. Coit	Winterthur	spoon
	E. Coit	Hammerslough	spoon
	Eben Cutler	Graham	
	Enos Gunn	Ensko III	
	E. Gunn & Co.	Kossack	spoon
	Eliakim Hitchcock	Yale	spoon
	Eliphaz Hart	Kossack	spoon
	Edmund Hughes	Yale	spectacles
	Edwin C. Newbury	Hammerslough	spoon
	Enos Gunn	Currier	
	Elias Pelletreau	Yale	gold clasp
	Enoch Stanton	Ensko III	
	Enoch Stanton	Hammerslough	spoon
	E. Stillman	Kossack	spoon
	F. Brady	Winterthur	spoon
	Francis Curtis	Hammerslough	spoon
	Fitch & Hobart	'67 N.H. Cat.	
	F. S. Blackman & Co.	Winterthur	spoon
	Frederick Starr Blackman	Kossack	spoon
	Frederick Starr Blackman	Currier	
	Gideon B. Botsford	Currier	
	Goodwin & Dodd	Hammerslough	gold frame
	George B. Hoyt	Graham	
	George B. Brown	'67 N.H. Cat.	
	George Kippen	Ensko III	

Mark	Name	Source	Object
	George Kippen	Kossack	spoon
	Horace Goodwin	Hammerslough	spoon
	Horace Goodwin	Ensko III	
	Goodwin & Dodd	Kossack	spoon
	——— Gordon	Hammerslough	spoon
	Samuel Gray	Ensko III	
	David Greenleaf (Sr.)	Ensko III	
	Gilbert or William Griswold	Kossack	spoon
	Geer Terry	Currier	
	Gurdon Tracy	Ensko III	
	G. W. Bull	Ensko III	
	H. & A. Goodwin	Kossack	spoon
	William Hamlin	Hammerslough	spoon
	Thomas Harland, Jr.	Hammerslough	spoon
	Thomas Harland	Johnson	porringer
	Hart & Brewer	Kossack	spoon
	See W. Pitkin and H. D. Sumner		
	Hart & Hart	Hammerslough	spoon
	Charles Hequembourg, Jr.	Ensko III	
	Horace Goodwin	Yale	spoon
	Heydorn & Imlay	Yale	spoon
	Heydorn & Imlay	Kossack	beaker
	H. I. Sawyer	Hammerslough	spoon
	Joseph W. Hopkins	Yale	spoon
	Joseph W. Hopkins	Ensko III	
	Henry Pitkin	Ensko III	
	Hezekiah Silliman	Winterthur	spoon
	Hezekiah Silliman	'67 N.H. Cat.	
	Hervey Sadd	Ensko III	

Mark	Name	Source	Object
	H. Sargeant	Ensko III	
	H. Sargeant	Yale	spoon
	Roswell Huntington	Graham	
	Hart & Wilcox	Yale	spoon
	John Avery	Yale	spoon
	John Avery	Hammerslough	spoon
	John Benjamin	Hammerslough	spoon
	John Benjamin	Winterthur	spoon
	Jonathan Bliss	Hammerslough	sugar tongs
	poss. Joseph Carpenter	Hammerslough	spoon
	Joseph Carpenter	Ensko III	
	poss. John Champlin	Winterthur	spoon
	poss. John Champlin	Kossack	spoon
	John Champlin	Ensko III	
	Joseph Copp	Hammerslough	spoon
	John Gardner	'35 Yale Cat.	
	John Gardner	Hammerslough	spoon
	John Gardner	Conn. Hist. Soc.	gold clasp
	John Gray	Graham	
	John Hallam	Hammerslough	spoon
	Jacob Jennings (Sr.)	Ensko III	
	Jacob Jennings (Sr.)	Winterthur	spoon
	Joseph Keeler	Ensko III	
	Joseph Keeler	Hammerslough	spoon
	Isaac Lewis	Ensko III	
	Isaac Lewis	Kossack	spoon
	Jonathan Otis	Graham	
	Job Prince	Yale	caster
	John Potwine	'35 Yale Cat.	
	John Potwine	Yale	beaker

Mark	Name	Source	Object
I·P I·P I·Potwine I·Potwine	John Potwine	Graham	
	J. P. Trott & Son	Kossack	spoon
I·R I·R I·R	Joseph Rogers	Graham	
IS	poss. Isaac Sanford	Hammerslough	spoon
IT	Jonathan Trott, Jr.	Ensko III	
I·THOMSON	Isaac Thom(p)son	Ensko III	
I·Tiley	James Tiley	Ensko III	
I·TILEY	James Tiley	Hammerslough	spoon
I·TROTT	Jonathan Trott	Graham	
IA IA IA	John Avery (Sr.)	Currier	
	John Aaron Elliott	Kossack	spoon
J.B.KIRBY	John Burgis Kirby	'67 N.H. Cat.	
BLACKMAN	John Starr Blackman	Hammerslough	spoon
JC	Joseph Clark	Ensko III	
J.C.B.&C° BRIDGEPORT	J. C. Blackman & Co.	Kossack	spoon
	Joseph Church	Hammerslough	spoon
	Joseph Clark	Winterthur	spoon
J·CLARK	Joseph Clark	Ensko III	
	Joseph Copp	Yale	spoon
J·FAIRCHILD	Joseph Fairchild	Kossack	spoon
JG	John Gardner	Ensko III	
J·GARDNER	John Gardner	Hammerslough	spoon
J·GORHAM	John Gorham	'67 N.H. Cat.	
J·HART NORWICH	Judah Hart	Yale	spoon
J·HART J·Hart	Judah Hart	Graham	
J.H.CONNOR J.H.CONNOR	John H. Connor	Graham	
J·HOBART	Joshua Hobart	Graham	

Mark	Name	Source	Object
	Julius Hollister	Winterthur	spoon
	J. Lee	Kernan	spoon
	James Madison Barrows	Hammerslough	spoon
	J. M. Peddinghaus	Liverant	spoon
	John O. Pitkin	Winterthur	spoon
	Jonathan Otis	Yale	beaker
	J. O. & W. Pitkin	Hammerslough	spoon
	John Tyng Peabody	Hammerslough	sugar tongs
	John Proctor Trott	Winterthur	spoon
	John Proctor Trott	Winterthur	spoon
	John Proctor Trott	Graham	
	John Proctor Trott & Son	Graham	
	John Proctor Trott	Winterthur	spoon
	Joseph Rogers	Graham	
	Jonathan Russel	Winterthur	spoon
	John Staniford	Yale	spoon
	Jacob Sargeant	Yale	spoon
	John Starr Blackman	Ensko III	
	John Sibley	Ensko III	
	Jonathan Trott	Kossack	spoon
	Jonathan Trott	Ensko II	
	Jonathan Trott	Currier	
	Jonathan Trott	Graham	
	James Ward	Ensko III	
	James Ward	Yale	spoon
	James Ward	Ensko III	
	Joseph Keeler	Kossack	spoon
	King & Cook	Yale	spoon
	George Kippen	Yale	spectacles
	Luther Bradley	'67 N.H. Cat.	

Mark	Name	Source	Object
	L. B. Candee & Co.	Kossack	spoon
	L. B. Terry	Graham	
	Lewis Curtis	Kossack	spoon
	Lewis Curtis	Kossack	spoon
	L. T. Welles	Yale	spoon
	L. T. Welles	Yale	spoon
	poss. Marcus Merriman	Kossack	spoon
	poss. Marcus Merriman	Yale	gold ring
	Marcus Merriman	Graham	
	Alexander Mann	Winterthur	spoon
	Merriman & Bradley	Yale	beaker
	Martin Bull or Miles Beach	Hammerslough	spoon
	Marcus Merriman	Ensko III	
	Miles Gorham	Yale	spoon
	Miles Gorham	Ensko III	
	Miles Gorham	Yale	ladle
	Munson Jarvis	Ensko III	
	Munson Jarvis	Winterthur	spoon
	Myer Myers	Burke	gold box
	Myer Myers	Yale	gold buckle
	Myer Myers	Graham	
	Marcus Merriman	Yale	spoon
	Marcus Merriman	'67 N.H. Cat.	
	Marcus Merriman	'67 N.H. Cat.	
	Marcus Merriman & Co.	Yale	spoon
	Myer Myers	Metropolitan	spoon
	Myer Myers	Graham	
	Moses Wing	Ensko III	
	Nathaniel Burr	Yale	spoon
	N. Cornwell	Hammerslough	spoon
	N. L. Proctor	Kossack	spoon

Mark	Name	Source	Object
	Nathan Merrow or Norman Morrison	Kossack	spoon
	Nathaniel Olmsted	Yale	spoon
N.OLMSTED	Nathaniel Olmsted	Currier	
N.O MSTED			
N OLMSTED & SON	N. Olmsted & Son	Kossack	spoon
NORTON & FREEMAN	See W. Pitkin and Norton & Freeman		
N·PRATT	Nathan Pratt	Ensko III	
N.S	Nathaniel Shipman	Hammerslough	spoon
NS N·SHIPMAN	Nathaniel Shipman	Ensko III	
OAKES	Frederick Oakes	Winterthur	spoon
O. D. S	Oliver D. Seymour	Yale	spoon
O·ROBINSON	O. Robinson	Ensko III	
O & S	Oakes & Spencer	Kossack	spoon
Otis OTIS	Jonathan Otis	Yale	beaker
PA	Pygan Adams	Yale	spoon
PA PA	Pygan Adams	Ensko III	
PA	Pygan Adams	Currier	
PB	Phinehas Bradley	Currier	
PB	Phinehas Bradley	Hammerslough	spoon
PB	Phineas Bushnell	Hammerslough	spoon
P.CLARK	Peter G. Clark	'67 N.H. Cat.	
PH PH PH	Philip Huntington	Ensko III	
P.H	Philip Huntington	Hammerslough	sugar tongs
PQ	Peter Quintard	Yale	tankard
P·Q	Peter Quintard	Hammerslough	spoon
P·WHITE	Peregrine White	Yale	spoon
R·B	Roswell Bartholomew	Winterthur	spoon
R CUTLER	Richard Cutler	Yale	spoon
RD	Robert Douglas	Hammerslough	cup
RD RD R·D	Robert Douglas	Graham	

Mark	Name	Source	Object
	Robert Fairchild	Yale	chafing dish
	Robert Fairchild	'67 N.H. Cat.	
	Robert Fairchild	Yale	beaker
	René Grignon	Yale	porringer
	Richard Gorham	Kossack	spoon
	Reuben Merriman	Kossack	spoon
	Reuben Merriman	Kossack	spoon
	Reuben Merriman	Ensko III	
	Reuben Merriman	Ensko III	
	Reuben Merriman	Kossack	spoon
	Thomas Rockwell	Currier	
	Thomas Rockwell	Currier	
	See W. Pitkin and Root & Chaffee		
	Robert Sutton	'67 N.H. Cat.	
	Jonathan Russel	Ensko III	
	Roswell Walstein Roath	Hammerslough	spoon
	Samuel Avery	Ensko III	
	Samuel Avery	Yale	spoon
	Samuel Avery	Currier	
	Samuel Buel	Hammerslough	spoon
	Seymour & Hollister	Yale	spoon
	Samuel Gray	Ensko III	
	Samuel Gilbert	Winterthur	spoon
	Samuel Gilbert	Kossack	spoon
	Samuel Gray	Ensko II	
	Stephen Hopkins	Winterthur	spoon
	Seymour & Hollister with Wheelers & Brooks	Currier	
	Clark Sibley	Ensko III	
	Samuel Merriman	'67 N.H. Cat.	

Mark	Name	Source	Object
	Silas Merriman	'67 N.H. Cat.	
	Silas Merriman	Yale	spoon
	Silas Merriman	'67 N.H. Cat.	
	Sibley & Marble	'67 N.H. Cat.	
	Simeon Marble	Kossack	spoon
	Samuel Merriman	Yale	spoon
	Samuel Parmele(e)	Yale	spoon
	Samuel Parmele(e)	Yale	spoon
	Samuel Parmele(e)	Yale	spoon
	Samuel Parmele(e)	'35 Yale Cat.	
	Samuel Shethar	Hammerslough	spoon
	Samuel Shethar	'67 N.H. Cat.	
	Shethar & Thom(p)son	Kossack	spoon
	John Staniford	Yale	spoon
	John Staniford	Ensko III	
	Zebulon Stanton	Ensko III	
	S. Whiting	Hammerslough	spoon
	Samuel Wilmot	Hammerslough	spoon
	Samuel Wilmot	'67 N.H. Cat.	
	Timothy Bontecou	Yale	tankard
	Timothy Bontecou, Jr.	'67 N.H. Cat.	
	Timothy Bontecou, Jr.	Winterthur	spoon
	Trott & Brooks	Ensko III	
	Thomas Chester Coit	Hammerslough	spoon
	Trott & Cleveland	Ensko III	
	Thomas Chester Coit	Ensko III	
	Geer Terry	Yale	spoon
	Thomas Harland	Hammerslough	spoon
	Thomas Jackson	Hammerslough	spoon
	James Tiley	Ensko III	

Mark	Name	Source	Object
	Thomas Kinney	Ensko III	
	Thomas Kinney	Metropolitan	spoon
	Thomas Kinney	Hammerslough	spoon
	Thomas Norton	Ensko III	
	Thomas Norton	Hammerslough	spoon
	Thomas Norton	Hammerslough	spoon
	T. S. Steele	Ensko III	
	T. Steele & Co	Ensko III	
	Ufford & Burdick	'67 N.H. Cat.	
	James Ward	Ensko III	
	John Ward	Ensko III	
	Ward & Bartholomew	Ensko III	
	Ward & Bartholomew	Graham	
	Ward & Bartholomew	Ensko III	
	Ward & Bartholomew	Hammerslough	ladle
	Ward, Bartholomew & T———	Wethersfield	basin
	William B. North	'67 N.H. Cat.	
	William Cleveland	Yale	spoon
	William Cleveland (or William Cario, Jr.)	Yale	spoon
	William Cleveland	Currier	
	William Clark	Ensko III	
	William Clark	Winterthur	spoon
	William Gurley	Ensko III	
	William Griswold	Hammerslough	spectacles
	William Hamlin	Graham	
	W. Hayes	Graham	
	Wheelers & Brooks with Seymour & Hollister	Currier	

Mark	Name	Source	Object
WHITE	Amos White	Ensko III	
WHITING	Charles Whiting	Ensko III	
WILCOX	Alvan Wilcox	Kossack	spectacles
WILLARD	James Willard	Kossack	spoon
WILMOT	Samuel Wilmot	Yale	spoon
WILMOT	Samuel Wilmot	Kossack	spoon
WING	Moses Wing	Hammerslough	cann
WJ	William B. Johonnot	Ensko III	
WM.JPITKIN	William J. Pitkin	Ensko III	
WᴸL.PITKIN	William L. Pitkin	Ensko III	
W ROGERS	William Rogers	Kossack	spoon
WM.ROGERS & SON	William Rogers & Son	Kossack	spoon
WM.ROOT & BROTHER	W. M. Root & Brother	Kossack	spoon
Woodward	Antipas Woodward	Ensko III	
Woodward	Antipas Woodward	Graham	
W.PITKIN	W. Pitkin	Winterthur	spoon
W.PITKIN C.C.NORTON	W. Pitkin and C. C. Norton	Ensko III	
W.PITKIN H.D.SUMNER	W. Pitkin and H. D. Sumner	Yale	spoon
W.PITKIN NORTON & FREEMAN	W. Pitkin and Norton & Freeman	Kossack	spoon
W.PITKIN ROOT & CHAFFEE	W. Pitkin and Root & Chaffee	Metropolitan	spoon
W ROGERS	William Rogers	Ensko III	
W.TERRY	Wilbert Terry	Hammerslough	spoon
W★W	William Ward (1678–1767)	Graham	
W.W	William Ward (1736–1829)	Ensko III	
W.W. W.W. W.WARD W.Ward	attributed to William Ward, Jr. (1705–1761)	Graham	
W.WARD	William Ward (1736–1829)	Yale	spoon
W.WARD	William Ward (1736–1829)	Yale	spoon

Mark	Name	Source	Object
	William Ward (1736–1829)	'67 N.H. Cat.	
	Elijah Yeomans	Winterthur	spoon
	Ebenezer Young	Ensko III	
	Zebul Bradley	Winterthur	spoon
	Z. Bradley & Son	Kossack	spoon
	Zebulon Stanton	Yale	spoon

Selected Bibliography

(Arranged chronologically within each category)

GENERAL BACKGROUND

Sir Charles J. Jackson, *English Goldsmiths and Their Marks,* 2nd. edition, London, Macmillan, 1921. Chapters I to V inclusive describe the historical background and working methods of English goldsmithing. This is the authoritative reference for English hallmarks.

Seymour B. Wyler, *The Book of Old Silver,* New York, Crown, 1937. A useful single source surveying the historical background of European, British, and American goldsmithing, with an index of marks of these countries.

Gerald Taylor, *Silver,* Baltimore, Penguin, 1956. Although it is devoted to British silver, this paperback discusses the forms and styles which also appear in America. The Introduction and chapter on Sources and Working are especially useful for general background to the whole subject of goldsmithing.

Denis Diderot, *L'Encyclopédie, ou Dictionnaire Raisonné des Sciences, des Arts et des Métiers,* in facsimile edition of plates (with captions) as *A Diderot Pictorial Encyclopedia of Trades and Industry,* 2 vols., New York, Dover, 1959. Sections on Gold, Silver, and Jewellery, dealing with eighteenth century French practice.

AMERICAN GOLDSMITHING

E. Alfred Jones, *The Old Silver of American Churches,* Letchworth, (England), privately printed for the National Society of Colonial Dames of America, 1913. A comprehensive early reference work by an English specialist. It should be consulted for additional details of the genealogy of the donors of church silver illustrated in the present work.

C. Louise Avery, *Early American Silver,* New York, Century, 1930. An excellent and still valuable early history of the subject.

John Marshall Phillips, *American Silver,* New York, Chanticleer, 1949. An authoritative historical survey by the late curator of the Garvan collection at Yale.

Colonial Silversmiths, Masters & Apprentices, catalogue of an exhibition at the Museum of Fine Arts, Boston, 1956, written by Kathryn C. Buhler, Assistant Curator of Decorative Arts, a recognized authority on American silver. Her introductory

essay, pp. 12–48, is concerned especially with the influences of one generation of silversmiths upon another through the apprenticeship system.

Masterpieces of American Silver, catalogue of an exhibition at the Virginia Museum of Fine Arts, Richmond, 1960. A second invaluable work written by Kathryn C. Buhler of the Museum of Fine Arts, Boston. Her introduction, pp. 8–44, deals with the early craftsmen, the important silversmithing centers, tools and techniques, and the various forms and their uses.

Peter J. Bohan, *American Gold, 1700–1860,* New Haven, Yale University Art Gallery, 1963. Illustrated monograph accompanying the only exhibition devoted to American gold objects, including an introductory essay and a catalogue of 147 pieces.

Peter J. Bohan, "Early American Gold," *Antiques* magazine, Vol. LXXXVII December, 1965, pp. 812–819. An abbreviated form of the exhibition monograph's introductory essay, but with more illustrations.

BIOGRAPHY AND MARKS—AMERICAN SILVERSMITHS

Stephen G. C. Ensko, *American Silversmiths and their Marks,* New York, Robert Ensko Inc., Vol. III, 1948. Still the most complete reference for marks, although it has been supplemented by a number of new studies of silver produced in certain cities and states. Vol. I, 1927, and Vol. II, 1937, contain the marks and names of some men not included in Vol. III.

Ralph M. & Terry H. Kovel, *A Directory of American Silver, Pewter and Silver Plate,* New York, Crown, 1961. A recent reference which would be greatly improved by judicious cross-checking, editing, and new illustrations of marks and pieces. Contributes new data, especially for the nineteenth century, but should be used with reservations as to the accuracy of its information. It has a good bibliography for American silver. The work is a compilation in one volume of information extracted from all the prior sources listed in its bibliography.

Henry N. Flynt & Martha Gandy Fales, *The Heritage Foundation Collection of Silver, With Biographical Sketches of New England Silversmiths, 1625–1825,* Old Deerfield, Mass., The Heritage Foundation, 1968. Although this book does not deal with Connecticut silver to any considerable degree, it should be regarded as the authoritative source for biographical and genealogical information about Connecticut silversmiths.

CONTEMPORARY NEWSPAPER ADVERTISEMENTS

George Francis Dow, *The Arts & Crafts in New England, 1704–1775,* Topsfield, Mass., Wayside Press, 1927. Advertisements, mainly from Boston newspapers. Silver references pp. 41–72; for Connecticut silver pp. 48 and 68 only.

SWORDS

Philip Medicus, "American Silver-Hilted Swords," Parts I and II, *Antiques* vol. XLVI, p. 264, September 1944, and p. 342, October 1944. Explains the particular vocabulary used for describing swords, and the various types and styles encountered in America.

Herman Warner Williams, Jr. "American Silver-Hilted Swords," *Antiques,* vol. LXVII, p. 510–13, June 1955. More technical information and Connecticut swords by Bontecou, Terry, Ward & Bartholomew.

John K. Lattimer, "Sword hilts by early American silversmiths," *Antiques,* vol. LXXXVI, pp. 196–199, Feb. 1965. A review of the changing styles of pommels.

Harold L. Peterson, *The American Sword 1775–1945,* New Hope, Pennsylvania, Robert Halter, The River House, 1954.

ORNAMENT

Franz Sales Meyer, *Handbook of Ornament,* New York, Dover, 1957. A paperback republication of the 1892 fourth edition. Contains a wealth of information, technical terms, and drawings of ornamental forms categorized by type, rather than by historical period.

Alexander Speltz, *The Styles of Ornament,* New York, Dover, 1959. A paperback republication of the 1910 English translated edition. A compilation of both Western and Oriental ornament arranged by historical period.

PLATED SILVER

Larry Freeman and Jane Beaumont, *Early American Plated Silver,* Watkins Glen, N.Y., Century House, 1947. A detailed history of the plated silver industry and its products, including the Meriden Brittania Company, Rogers Brothers, Wallace, and other Connecticut firms.

Earl Chapin May, *A Century of Silver, 1847–1947,* New York, McBride, 1947. A history of the various Connecticut plated silver firms, especially Rogers Bros., which eventually were amalgamated in the formation of the International Silver Co. in 1898.

CONNECTICUT—HISTORICAL BACKGROUND

Albert E. Van Dusen, *Connecticut,* New York, Random House, 1961. An illustrated history from the seventeenth century to the present, by the State Historian.

W. Storrs Lee, *The Yankees of Connecticut,* New York, Henry Holt, 1957. A more informal religious, social, and economic history.

CONNECTICUT SILVER—GENERAL BOOKS AND EXHIBITION CATALOGS

George Munson Curtis, *Early Silver of Connecticut and its Makers,* Meriden, International Silver Co., 1913. The first work devoted to the silver of a single state, still invaluable especially for its biographical information about the silversmiths.

Early Connecticut Silver, 1700–1830, exhibition catalogue, Connecticut Tercentenary, New Haven, Gallery of Fine Arts, Yale University, 1935. The first exhibition of Connecticut silver alone. John Marshall Phillips, curator of the Garvan collection, assembled 166 pieces and wrote the catalogue and Introduction.

Silver by Early Connecticut Makers, a mimeographed catalogue of an exhibition

at the Wadsworth Atheneum, Hartford, 1954. Philip Hammerslough organized the show and prepared the catalogue of 109 items.

Early Silver by New Haven Silversmiths, catalogue of an exhibition at the New Haven Colony Historical Society, 1967, prepared by a committee under the chairmanship of John Devereux Kernan.

Philip H. Hammerslough, *American Silver Collected by Philip H. Hammerslough,* Hartford, privately printed, Vol. I, 1958; Vol. II, 1960; Vol. III, 1965; supplements to Vol. III, 1965 and 1967. Mr. Hammerslough's collection includes many Connecticut pieces, all of which are again illustrated in the present volume.

CONNECTICUT SILVERSMITHS—BOOKS AND ARTICLES

Albert C. Bates, *An Early Connecticut Engraver and His Work,* Hartford, Conn., 1906. A book about Richard Brunton, engraver and jeweler of Boston and Providence, who during the 1780's apparently received metal from the Connecticut clockmaker and silversmith Jacob Sargeant in return for engraving services. He came to Suffield, Connecticut c. 1790 and was confined from 1799 to 1801 in the Connecticut State Prison at Newgate for counterfeiting paper money and coins.

Gladys R. Lane, "Rhode Island's Earliest Engraver," *Antiques,* vol. VII, p. 133, March 1925. William Hamlin, who was apprenticed in Middletown, Connecticut.

Lawrence C. Wroth, *Abel Buell of Connecticut,* Acorn Club of Connecticut, 1926. Buell was a silversmith, typefounder, engraver, and inventor. (See also the 1955 book by Hugo & Harlow mentioned below).

Penrose R. Hoopes, *Connecticut Clockmakers of the Eighteenth Century,* Hartford, Conn.: Edwin Valentine Mitchell; New York: Dodd, Mead & Co., 1930. Some of these men also made or engraved silver (see Biographical Index, *passim.*).

Penrose R. Hoopes, *The Shop Records of Daniel Burnap,* Connecticut Historical Society, Hartford, 1958. Burnap is known principally as a clockmaker, but he also worked as a silversmith.

Florence Thompson Howe, "Jacob Sargeant, Goldsmith and Clockmaker," *Antiques,* vol. XIX, p. 287, April 1931. Sargeant worked in Hartford.

Mabel C. Weaks, "Captain Elias Pelletreau, Long Island Silversmith, Part I," *Antiques,* vol. XIX, p. 365, May 1931. Pelletreau worked in Connecticut during the Revolution.

Penrose R. Hoopes, "Some Minor Connecticut Clockmakers," *Antiques,* vol. XXVIII, p. 104, September 1935. Discusses Samuel Canfield, Joel Allen, Isaac Marquand, Phineas North, Antipas Woodward, and Elijah Yeomans, all of whom also worked in silver.

Elizabeth B. Potwine, "John Potwine, silversmith of Massachusetts and Connecticut," *Antiques,* vol. XXVIII, p. 106, September 1935. Potwine was one of the early silversmiths working in Hartford.

Gordon Bodenwein, "New London, Connecticut, Silversmiths," *Old-Time New England* (The Bulletin of the Society for the Preservation of New England Antiquities), Boston, vol. XXXIII, pp. 57–60, April 1943.

Gregor Norman-Wilcox, "American Silver Spice-Dredgers," *Antiques,* vol. XLV, p. 80, February 1944. Mentions work of John Benjamin and John Potwine.

"Aner Bradley, Colonial Silversmith," *Antiques,* vol. LXV, p. 148, February 1954. Bradley, brother of Phineas, worked in Watertown.

Newton C. Brainard, "Isaac Sanford," *The Connecticut Historical Society Bulletin,* Hartford, Oct. 1954, p. 122. Sanford worked in Hartford.

Philip H. Hammerslough, "A Master Craftsman of Early Guilford," *The Connecticut Historical Society Bulletin,* Oct. 1954, pp. 123–128. About the silversmith Samuel Parmelee.

E. Harold Hugo & Thompson R. Harlow, *Abel Buell, a Jack of All Trades & Genius Extraordinary,* Meriden, Conn., 1955. (See also the 1926 book by Wroth, mentioned above). This was a keepsake printed by Meriden Gravure Company for the Columbiad Club, of which both authors are members.

Ada R. Chase, "Two 18th-Century Craftsmen of Norwich," *The Connecticut Historical Society Bulletin,* July 1960, pp. 84–88. Nathaniel Shipman, Jr. goldsmith and clockmaker, and Felix Huntington, cabinetmaker.

Philip A. Johnson, "The Silversmiths of Norwich," *Antiques,* vol. LXXIX, p. 70–1, June 1961. Lists over twenty men or firms working from c. 1750 to c. 1830.

Ada R. Chase, "Joseph Carpenter, Jr., Silversmith and Clockmaker," *Antiques,* vol. LXXXV, p. 695–697, June 1964. Biographical article; he worked in Norwich.

Philip A. Johnson, "The Silversmiths of Norwich," *Craftsmen & Artists of Norwich,* exhibition catalogue, Society of Founders of Norwich, 1965.

Phyllis Kihn, "Frederick Oakes, Hartford Jeweler and Gentleman Farmer," *The Connecticut Historical Society Bulletin,* Jan. 1967, pp. 1–15.

Ruth C. Page, "Colonel James Ward, Silversmith and Entrepreneur," *The Connecticut Historical Society Bulletin,* Oct. 1968. Ward worked in Hartford.

OTHER BOOKS AND ARTICLES OF INTEREST

Thomas Hamilton Ormsbee, "The Craft of Spoonmaker," *Antiques,* vol. XVI, p. 189, September, 1929. Entire process of converting coins into finished spoons.

Walter C. Hunter, "The Spoon as a Funerary Souvenir," *Antiques,* vol. XIX, p. 302, April 1931.

Harold E. Gillingham, "John Fitch: Jack of Many Trades," vol. XXXV, p. 73, February 1939. An interesting account of a craftsman who maintained a shop in Trenton, N.J. while he traveled with a pack of silver and tools on his back throughout the surrounding countryside.

"The Ornamentation of Silver: a Pictorial Demonstration," *Antiques,* vol. XLI, p. 41, January 1942. Illustrated discussion of tools and methods used in ornamenting silver.

Kenneth Scott, "Colonial Silversmiths as Counterfeiters," *Antiques,* vol. XXVII, Jan. 1955.

Owners of Pieces Illustrated

THE WHEREABOUTS of several of the pieces illustrated in this volume is unknown. The names of the last-known owners are given below, together with dates that indicate either the most recent exhibition of the pieces or the most recent publication of pictures of them.

PRIVATE OWNERS
Alfred Bingham
the late Mark Bortman
Maxwell Brainard
Mrs. William B. Church (1947)
Edwin N. Dodge (1935)
Mrs. Harold G. Duckworth
Dr. H. W. Erving
Robert Graham
Philip Hammerslough
Mr. and Mrs. James H. Halpin
Mr. and Mrs. Philip Johnson
Mr. and Mrs. John Devereux Kernan
Alan R. Kossack
Frederick C. Kossack
Dr. John K. Lattimer
Israel Sack, Inc.
Mr. and Mrs. Samuel Schwartz
Mr. and Mrs. Edgar H. Sittig
Mr. and Mrs. Henry H. Townshend, Jr.
Edward Fenno Verplanck (1935)
Mrs. Carl J. Viets (1913)
Joseph Wadsworth
Hermann Warner Williams, Jr.

CHURCHES
The Berkeley Divinity School, New Haven
The Center Congregational Church, Meriden

The Church of Christ, Congregational, Milford
The Congregational Church, East Haven
The Congregational Church, Middlebury
The Congregational Church, Weston
The Congregational Ecclesiastical Society of Greens Farms
The First Church of Christ, Congregational, Clinton
The First Church of Christ, Middletown
The First Church of Christ, New London
The First Church of Christ, Wethersfield
The First Congregational Church-United Church of Christ, Branford
The First Congregational Church, Derby
The First Congregational Church, East Windsor
The First Congregational Church, Guilford
The First Congregational Church, Stamford
The First Congregational Church, Suffield
The Kensington Congregational Church
St. Andrew's Church, Northford
Trinity Church, Southport
Trinity Church-on-the-Green, New Haven
The United Congregational Church, Bridgeport
The United Congregational Church, New Haven

MUSEUMS AND HISTORICAL
 SOCIETIES
The Art Institute of Chicago
The Connecticut Historical Society,
 Hartford
The Henry Francis du Pont Winterthur
 Museum
The Los Angeles County Museum of Art
The Lyman Allyn Museum, New London
The Metropolitan Museum of Art,
 New York City
The Museum of Fine Arts, Boston
The New Haven Colony Historical Society

The New-York Historical Society, New York
 City
The Sterling and Francine Clark Art
 Institute, Williamstown
Wadsworth Atheneum, Hartford
Yale University Art Gallery, New Haven

ORGANIZATIONS
Mary Clap Wooster Chapter, Daughters of
 the American Revolution Inc., New
 Haven
St. John's Lodge, Free & Accepted Masons,
 Middletown

PICTURE CREDITS

THE AUTHORS wish to acknowledge with special gratitude the services of Frank N. Beaudin of Meyers Studio, Incorporated, in Hartford, Connecticut, who photographed many of the pieces illustrated in this volume.

Some of the illustrations were made from photographs supplied by churches, museums or private collectors without identifying the photographer. Other photographers are listed below with the numbers of the plates made from their photographs:

E. Irving Blomstrann, New Britain, Connecticut: 20, 30, 35, 40, 43, 45, 50, 51, 105, 111, 125

Richard Croteau, Waterbury, Connecticut: 15, 37, 56, 59, 82, 117, 121, 129, 153, 158, 166, 177, 180, 181

E. De Cusati, Yale University Art Gallery, New Haven, Connecticut: 8, 9, 10, 16, 22, 23, 36, 38, 48, 54, 62, 69, 71, 77, 92, 98, 99, 120, 128, 133, 156, 159, 161, 162, 164, 165, 171, 172

W. Edwin Gledkill: 31

Allan Ludwig: 1, 6, 7, 12, 13, 14, 25, 26, 27, 28, 47, 49, 55, 57, 72, 75, 88, 97, 112, 114, 115, 127, 155, 157, 163, 170, 175, 183

Israel Sack, Incorporated, New York City: 169

Charles R. Schulze, New Haven, Connecticut: 176

Taylor & Dull, New York City: 29, 58

Index of Silversmiths Whose Work Is Illustrated

PIECES MADE by silversmiths in partnership have also been indexed under the separate names of each partner.

Early Connecticut Silver, 1700–1840

was composed in Linotype Baskerville and A.T.F. Typo Script Extended by Connecticut Printers, Inc. Both text and photographs were printed in fine-screen offset by The Meriden Gravure Company, and the binding was done by Russell-Rutter Company, Inc.

Designed by Raymond M. Grimaila